VICTORIAN HOUSES
OF MISSISSIPPI

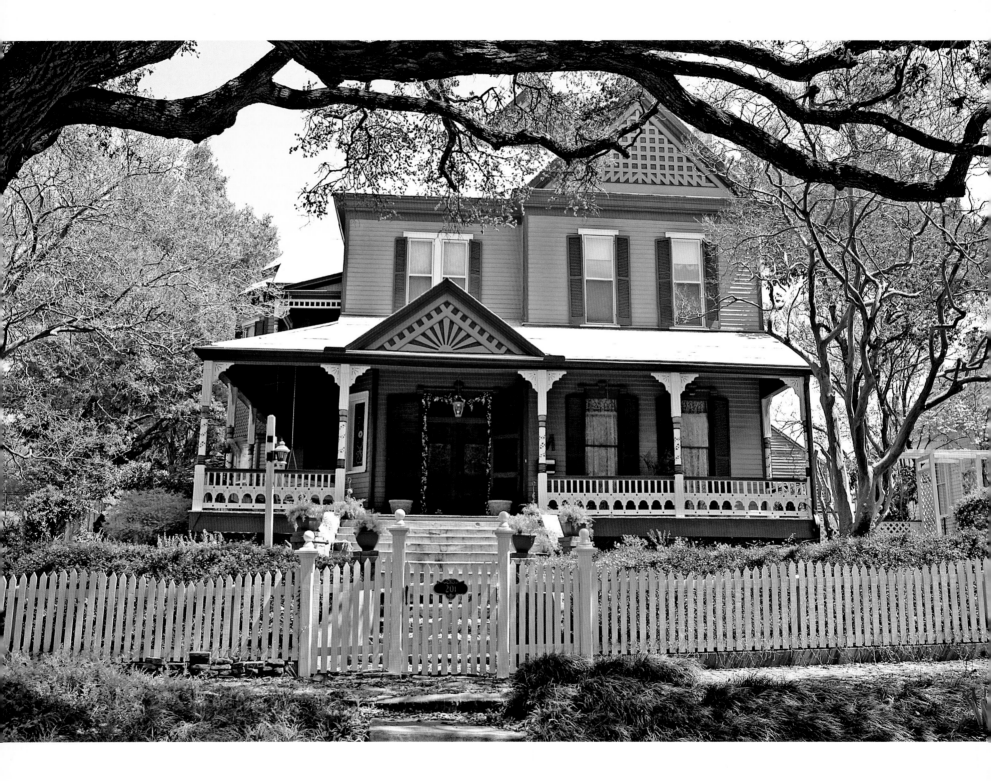

VICTORIAN HOUSES OF MISSISSIPPI

Photographs by Sherry Pace

Text by Richard J. Cawthon

UNIVERSITY PRESS OF MISSISSIPPI JACKSON

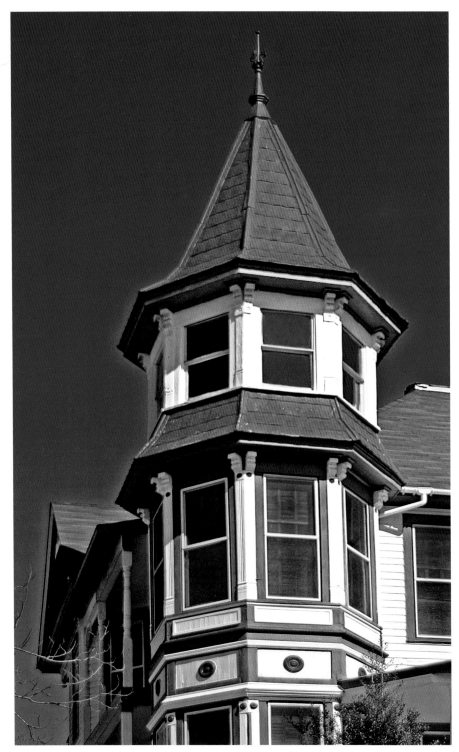

www.upress.state.ms.us

The University Press of Mississippi is a member of the
Association of American University Presses.

First edition 2005
Library of Congress Cataloging-in-Publication Data

Cawthon, Richard J.
 Victorian houses of Mississippi / photographs by
Sherry Pace ; text by Richard J. Cawthon.— 1st ed.
 p. cm.
 Includes index.
 ISBN 1-57806-781-2 (cloth : alk. paper) 1. Historic
buildings—Mississippi—Pictorial works. 2. Dwellings—
Mississippi—Pictorial works. 3. Architecture, Domestic—
Mississippi—Pictorial works. 4. Architecture, Victorian—
Mississippi—Pictorial works. 5. Mississippi—Pictorial
works. I. Pace, Sherry. II. Title.
 F342.C39 2005
 728.8'09762'09034—dc22
 2004028704

British Library Cataloging-in-Publication Data available

Photographer's Preface

I was born in Jackson, Mississippi, and have lived in Madison County since 1983 with my husband, John, and our daughter, Hope. I have had a passion for photography since I was very young. For the past decade I have been especially involved with outdoor photography, and architecture is one of my areas of interest. With the idea of putting together a book that had some aspect of architecture as its subject, I took an assortment of photographs and met with Richard Cawthon at the Mississippi Department of Archives and History to ask for suggestions and get a clear direction for such a project. Richard saw the Victorian-period houses in my collection and suggested I focus on those. He compiled a list of houses, and I began traveling around Mississippi to see them.

Since the list did not reflect the current condition of the houses, I had to investigate to see which ones were worth shooting. Many times after driving long distances, I was disappointed to find boarded-up or neglected houses that must have been quite striking when they were in their prime. Some houses had been torn down or destroyed by fire. But I was truly impressed with the ones that had been restored or were undergoing that process. I loved the beautiful spindlework, gable ornamentation, unusual dormers, and varied pastel colors found on many of the houses, and I came to appreciate and respect the craftsmanship of the artisans who had worked on them. I was received warmly across the state, and I enjoyed sharing the excitement felt by the owners of the houses that were being photographed.

My purpose here is to offer a photographic sampling of Victorian-period houses; I am not attempting to present an architectural digest. Richard Cawthon wrote the captions and an essay in which he explains the various styles and historical background of the period, citing examples in the book. The data for the captions came from files at the Historic Preservation Division of the Mississippi Department of Archives and History. If it was available, information includes the name of the house, the street and town or city where it is located, and the date of construction. (Exact addresses are omitted out of respect for the owners' privacy.)

The time I spent making these photographs, looking at Mississippi through the eye of a camera

lens, was very special to me. I hope that all who see the book will be amazed by the beauty of Mississippi's architecture. I encourage everyone to move beyond the highways and into the less-traveled areas where the wonders of our state await us.

ACKNOWLEDGMENTS

I would first like to thank God for allowing me to use the talent He has given me so that I could share the photographs in this book with you. None of this would have been possible without the help of John, my wonderful husband of twenty-seven years. I thank him for always being my driver wherever we have traveled and for inspiring and encouraging me to pursue my dream. I am truly blessed to have him for my husband. I want to thank my daughter, Hope, and my sister, Sally, for their interest in my work over the years. Thanks also go to Donna, Eris, Chris, and Terry for their continuing support. I want to honor the memory of Will for being my friend and challenging me to publish my photography. Special thanks go to Craig Gill, editor-in-chief at the University Press of Mississippi, and Richard Cawthon, chief architectural historian for the Mississippi Department of Archives and History. Thanks to all for the help in making this book possible.

Late Victorian Residential Architecture in Mississippi

Richard J. Cawthon

Mississippi is widely known for its antebellum architecture, particularly the Greek Revival mansions of the 1840s and 1850s. The state's architectural legacy from the later years of the nineteenth century has received far less attention, but deserves recognition in its own right. This book is a photographic celebration of the residential architecture of the post–Civil War era—the Victorian houses of Mississippi.

The word "Victorian," in its most specific sense, refers to the years of the reign of Victoria as queen of England from 1837 until her death in 1901, a span of sixty-four years. However, when "Victorian" is used in reference to architecture in the United States, especially in the South, it customarily pertains to the buildings constructed during the latter half of Queen Victoria's reign, from the end of the Civil War in 1865 to the first few years of the twentieth century (continuing for a few years past Queen Victoria's death because of the persistence of popular architectural tastes). The architecture of this period should properly be called "Late Victorian," but in common usage it is simply "Victorian."

American residential architecture during the Late Victorian period was quite diverse—from the log cabins of the frontier to the palatial mansions of the railroad barons to the innovative early designs of architects whose careers would flourish in the first half of the twentieth century. Even if the subject is limited to the "popular" residential architecture of the period—the houses built for educated middle-class and upper-middle-class townspeople—Victorian architecture still embraces a wide range of styles and forms. Indeed, the very idea of architectural "style" was essentially a Victorian innovation. Until the 1840s, residential design in the United States tended to follow a single main sequence of successive tastes—from "Early Colonial" to Georgian to Federal to Greek Revival. But by the 1840s, the idea came to be accepted that several different styles could be fashionable at the same time, and that one could choose among them, or even

combine several different styles in one building. During the 1840s and 1850s, three very different styles were in vogue at the same time—Greek Revival, Gothic Revival, and Italianate. After the Civil War, the Greek Revival style persisted to some extent, and the Gothic Revival and Italianate remained popular. The Second Empire style first appeared just before the Civil War, and it spread in popularity into the 1870s. By the 1870s and early 1880s, the Italianate style began to display characteristics similar to the Renaissance Revival furniture of the period. The later development of the style is sometimes called High Victorian Italianate, while the Gothic Revival underwent stylistic shifts to become High Victorian Gothic. The Queen Anne style became widespread by the late 1880s, and by the 1890s it was the most popular style for American houses. Other styles also emerged during the Late Victorian years, including the Stick style, the Shingle style, the Chateauesque, and several styles that would gain popularity after the turn of the century, most notably the Colonial Revival and the Neoclassical Revival.

In Mississippi, the Late Victorian period was a time of major social and cultural changes, and these are reflected in the architecture. As educated upper-middle-class merchants and other townspeople began to exert greater social and economic influence, their homes began to set the new standards of popular architectural taste. The major styles of residential architecture in Mississippi during this period were the Italianate and the Queen Anne styles, and to a lesser extent the Gothic Revival and the Second Empire. The Greek Revival continued to have popularity for some years after the Civil War, though interpreted in a Late Victorian manner. The Shingle style was of only limited popularity in Mississippi.

GREEK REVIVAL

The Greek Revival was introduced into Mississippi in the 1830s and was by far the most popular architectural style in the state through the 1840s and 1850s. Although it had largely faded from popularity elsewhere in the country by the late 1860s, it remained popular in the Deep South, especially in rural areas, into the 1870s or later, during which time it might be called Late Greek Revival. Houses of the Late Greek Revival style in Mississippi often incorporated features from other styles, especially Italianate elements such as bracketed cornices and tall, slender windows, which might be placed in pairs or might be topped with shallow segmental arches. One of the best examples of Late Greek Revival residential architecture in the state is the J. C. Purnell House (1873) in Winona.

GOTHIC REVIVAL

The Gothic Revival arose primarily as a movement in religious architecture, but it became an important style of secular architecture as well, reflecting a mid-nineteenth-century taste for romantic medievalism. Gothic Revival houses typically have steep roofs, with steep front-facing gables, and many have a pointed arch as a prominent feature.

Houses in the Gothic Revival style began to be built in Mississippi in the 1850s. The Gothic Revival was not nearly as popular in Mississippi before the Civil War as the Greek Revival and Italianate styles, but some fine examples were built, such as the Manship House (1857) in Jackson.

After the Civil War the Gothic Revival style retained a degree of stylishness, but it was never widely popular in Mississippi. Among the few

notable surviving Late Victorian Gothic Revival houses in Mississippi are the Taylor-Chandler House (circa 1870–75) in Corinth and the Dr. Joseph M. Bynum House (1876–77) in Rienzi.

ITALIANATE

Like the Gothic Revival, the Italianate style first appeared in Mississippi before the Civil War. By the late 1850s, several exceptionally fine Italianate houses had been built, including Rosedale (circa 1855) in Columbus and Ammadelle (1859–61) in Oxford.

The Italianate style reached its peak of popularity in Mississippi in the 1870s and remained popular into the 1880s. Late Victorian Italianate houses typically have shallow hipped roofs, tall windows with hood molds, and bracketed cornices. The Beck House (1875) in Vicksburg, a brick two-story L-front house with a one-story porch, is one of the state's finest surviving examples of postbellum Italianate residential architecture. Other notable examples are the Baer House (circa 1875) in Vicksburg, Stanhope (1875) in Carrollton, and the Howry-Hull House (Fiddler's Folly) (1878) in Oxford.

SECOND EMPIRE

The Second Empire style was widely used for public, institutional, and residential buildings in the United States between about 1859 and 1885, being most fashionable between 1865 and 1880. The style was not widely used in Mississippi, however, probably because its period of greatest popularity coincided in part with the Reconstruction era, when the state's economy was generally depressed. Neverthe-less, some fine houses expressing the style or showing its influence were erected in Mississippi, and several notable examples remain.

The Second Empire style takes its name from the reign of Napoleon III as emperor of France from 1852 to 1870. During this period, the architecture of Paris was dominated by a style derived from the French baroque architecture of the seventeenth century. The great monumental buildings of the Second Empire style are lavish confections of baroque classicism, but in its more popularized form, as it appeared in American houses, the style is greatly simplified. The most distinctive feature of Second Empire architecture is the mansard roof, which has two slopes on each side, the lower being very steep and the upper almost flat, separated by a molding which is often trimmed with iron cresting. The steep lower slope generally rises the height of a full story and is pierced by elaborate dormer windows. The popularized version of the style essentially combined the Second Empire mansard roof with features otherwise typical of the Italianate style.

The finest surviving Second Empire building in Mississippi is the Christian Schwartz House (Glen Auburn) (1873–75) in Natchez. Its symmetrical composition with a square tower at the front center is characteristic of the purer and earlier homes of the style, as are the quoins at the corners, the iron cresting, and, of course, the mansard roof. Other notable houses in the Second Empire style are the Roberts-Neilson House (circa 1870–75) in Oxford, the Leftwich House (circa 1879) in Aberdeen, and the Johnson-Catchings House (1898) in Woodville.

In some instances a mansard-roofed tower was incorporated into the designs of buildings showing no other features of the Second Empire style. These towers are most often found on larger Italianate houses of the postbellum era as a variation on the

more conventional Italianate tower with its shallow hipped roof. Good examples of Italianate houses with mansard-roofed towers include the Steers-Sykes-Locke House (Azalea Place) (circa 1875) in Columbus, the Lee-Dubard House (1880) in Grenada, and the Christ Church Rectory (1885) in Holly Springs.

QUEEN ANNE

Of all the many styles of architecture to appear in the United States in the later years of the nineteenth century, the most popular and widespread was the Queen Anne style, which dominated the residential architecture of the United States between about 1885 and 1905. The name "Queen Anne" for this style is misleading, for Queen Anne reigned as monarch of England from 1702 to 1714, and the architecture and furnishings of the period of her reign are quite important in their own right. (Indeed, when the term "Queen Anne" is used with regard to furniture, it refers to the early eighteenth century.) The Queen Anne style of architecture of the late nineteenth century, especially as it developed in the United States, was a distinctly Victorian creation, but the name is indicative of its complex architectural lineage.

Victorian Queen Anne architecture had its origins in England in the 1860s when architects began looking to the smaller-scale domestic architecture of the Tudor and Stuart eras, including the Queen Anne period, for their inspiration. In England, this new "Queen Anne Revival" architecture was typically built of red brick trimmed with white-painted wood. It was generally asymmetrical in composition, and featured steep roofs, elaborate chimneys, and a modest amount of loosely classical detailing. It began to be recognized as a stylistic movement in England by about 1873. As it began to be emulated in the United States in the mid-1870s, the movement diverged from its English antecedents, but it retained the name "Queen Anne." Queen Anne architecture began to appear in Mississippi in the 1880s, and by 1890 it had become the dominant style for fashionable residential design.

American buildings in the Victorian Queen Anne style, especially houses built of wood, typically utilized the newest innovations in construction technology: balloon-frame construction, mass production of precut building parts, mail-order plans, and even prefabrication of entire houses. Queen Anne buildings were often showcases for the productivity of the booming American lumber industry, lavishly adorned with machine-made "gingerbread," fine parquet flooring, and ornate interior millwork.

The principal shared characteristics of Victorian Queen Anne houses are: an irregular, asymmetrical shape, which typically has at least one ornamented, front-facing gable, and in many cases a tower; a high roof, typically hipped or pyramidal, with elaborately detailed chimneys; and a variety of textures in the wall surfaces, which, on wooden houses, were often originally highlighted by contrasting shades or colors of paint.

Queen Anne houses can be classified into several stylistic modes on the basis of their decorative detailing. The most important of these in Mississippi can be termed the ornamented masonry, rectilinear, spindlework, and free classical modes of the Queen Anne style.

The ornamented masonry mode is closest to the English Victorian Queen Anne style. Buildings in this mode are typically built of brick and often have molded brick or terra-cotta ornamentation on the

walls. Window sashes, porch posts and railings, and in some cases gable details are typically made of wood. The Thompson-Peeler House (1898) in Kosciusko is one of the few examples of this mode of Queen Anne architecture in Mississippi.

The rectilinear mode was typical of the earlier wooden buildings of the Queen Anne style and is distinguished from later modes by its straight lines and relatively restrained use of carved, jigsawn, or lathe-turned wooden detailing (typically in the Eastlake manner). A notable example is the Frank W. Williams House (circa 1886) in Meridian. Other examples include the Wensel House (1888) in Natchez and the Palmer House (1892) in Blue Mountain.

The spindlework mode became widespread by about 1890 for both brick and wood buildings, but it is more commonly seen in wood. It is distinguished by extensive use of lathe-turned ornament, including porch posts, balustrades, and open friezes trimming broad verandas. The spindlework mode often has circular or curved features, including round turrets and gazebo-like extensions of the veranda. The majority of the larger Queen Anne houses in the state are built in the spindlework mode. One of the finest of these is the J. A. McLeod House (1897) in Hattiesburg. Among the many other notable examples are the George W. Copley House (1886) in Crystal Springs, the Brielmaier House (circa 1895) in Biloxi, the Scherck House (1896) in Brookhaven, and the W. D. Hughes House (1899) in Pascagoula. The Keyhole House (1890s) in Natchez is an especially fine brick Queen Anne house with spindlework detailing.

The free classical mode became popular by about 1900 for both brick and wood buildings. It is characterized by the use of classical detailing instead of the spindlework and Eastlake trim that characterize other modes. This is most evident on porches, which typically have slender classical columns instead of lathe-turned or chamfered posts. The classical features are used only for the building's details, however. Otherwise, the building retains the characteristic asymmetrical shape and other features of the style. Notable Queen Anne houses in the free classical mode include the L. D. Herrick House (1899) in Pascagoula, the David Brown House (1900) in Kosciusko, and the Dunn House (1890s) in Hattiesburg.

SHINGLE STYLE

The Shingle style was essentially a variation on Queen Anne and Colonial Revival design that was most popular in northeastern states. Its most readily recognized characteristic is the cladding of exterior walls in wooden shingles. Although many Queen Anne houses have some shingled wall surfaces, the true Shingle style was quite rare in Mississippi during the Victorian period, and very few examples survive, most notably the Adolph Rose House (1897) in Vicksburg.

STYLISTIC COMBINATIONS
AND VERNACULAR VARIATIONS

Much of the exuberance of Mississippi's Late Victorian architecture was a result of the enthusiasm and inventiveness of local builders, who adopted and adapted popular styles to suit their own tastes and those of their clients. It was quite common during this period for builders to combine features of two or more popular architectural styles into a single design, or to apply decorative elements in their

own distinctive manner. A very large proportion of Late Victorian houses defy classification into any of the more formally recognized architectural styles.

One of the most fascinating exercises in stylistic combination is the Bishop Charles B. Galloway House in Jackson, designed and built by local builder W. J. McGee and completed in 1889. It is an impressive and well-preserved two-story wood-frame house that combines Second Empire, Eastlake, Queen Anne, and Gothic Revival features into a remarkably cohesive design. The Dr. R. W. Rea House (1874) in Wesson combines Greek Revival, Italianate, and Gothic Revival elements. Victoria (1885) in Aberdeen has both Gothic Revival and Italianate features.

Local builders often applied factory-made wooden trim (millwork) to houses of traditional vernacular forms to give them a Late Victorian flavor. Belle Fleur (circa 1870) in Vicksburg, for example, illustrates the application of Italianate brackets and distinctive openwork porch supports (locally known as pierced columns) to a traditional hip-roofed galleried cottage. Pierced columns can be seen on many other houses in Vicksburg as well, and also on the Brock-Foster House (circa 1870–80) in West and Dogwood Place (1871) in Crystal Springs.

In many instances older houses were remodeled to impart a Late Victorian appearance, as in the case of the Captain William Ray House in Carrollton, which was originally built around the 1830s, but was remodeled in a Late Victorian manner in 1875. The Senator Edward Cary Walthall House in Grenada was built in 1856, but was remodeled after it was acquired by Walthall in 1871.

Soon after the turn of the twentieth century, tastes in residential architecture began to change in Mississippi. By that time the Gothic Revival, Italianate, and Second Empire styles had already gone out of fashion. Some houses continued to be built in the Queen Anne style, especially in the free classical mode, but the Queen Anne style gradually gave way to a more deliberate use of classical elements, as popular tastes shifted to the Colonial Revival and Neoclassical styles. Other new styles began to gain popularity, including the Mission style and the Craftsman style. By about 1910, the Queen Anne style had fallen from fashion, and Mississippians were embracing the architectural tastes of the new century.

The Victorian houses of Mississippi are an important part of the state's rich and diverse architectural legacy. Many are significant examples of nineteenth-century architectural tastes. Some are important for their association with the individuals and families who have dwelt in them. Many are important as landmarks in their communities, helping to convey a sense of place and a sense of historical continuity. And, as the photographs in this book attest, each of the Victorian houses of Mississippi is a distinctive and fascinating building in itself, deserving to be recognized, appreciated, and preserved.

VICTORIAN HOUSES
OF MISSISSIPPI

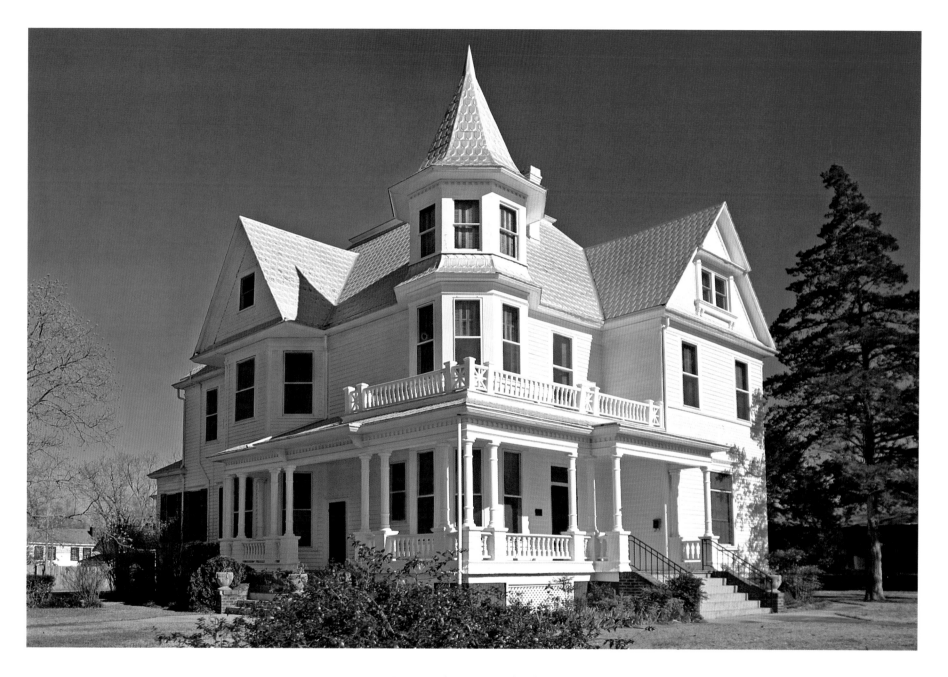

ABERDEEN

The Sanders House on College Place is one of Aberdeen's many fine Queen Anne houses.

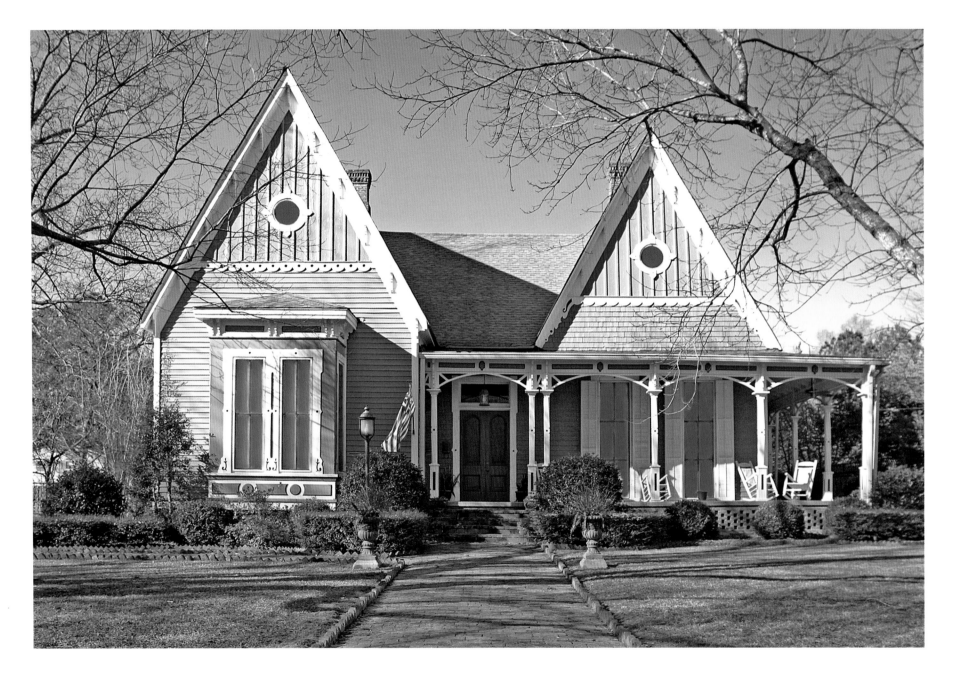

ABERDEEN

Victoria (1885) on South Franklin Street has an eclectic design combining
Gothic Revival and Italianate elements.

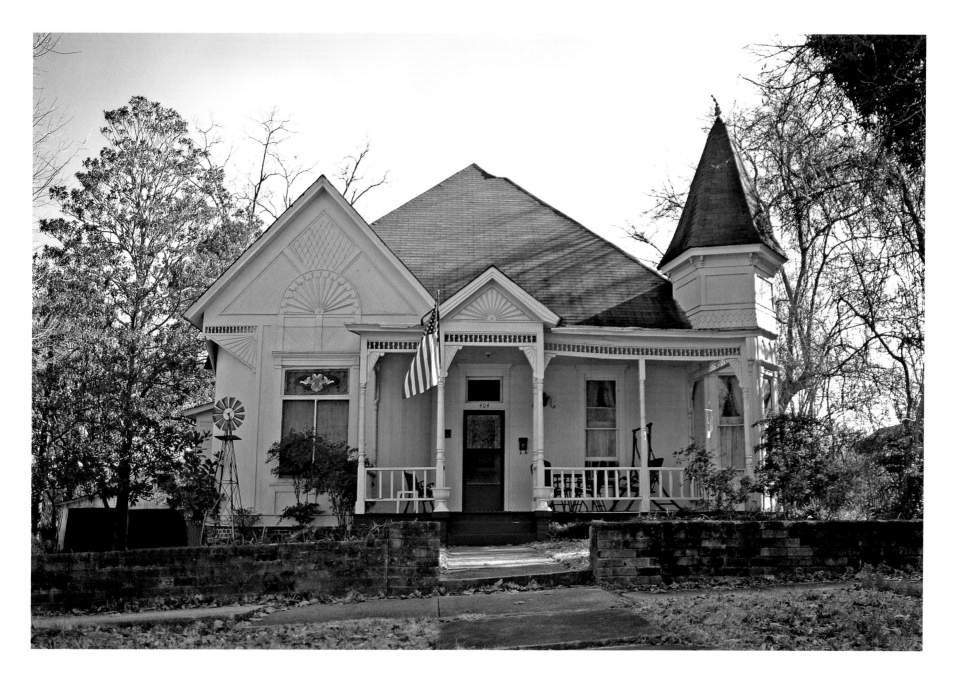

ABERDEEN

This Queen Anne cottage on South Franklin Street exhibits a rich variety of textures and patterns
on its wall surfaces. The gable ornamentation is particularly distinctive.

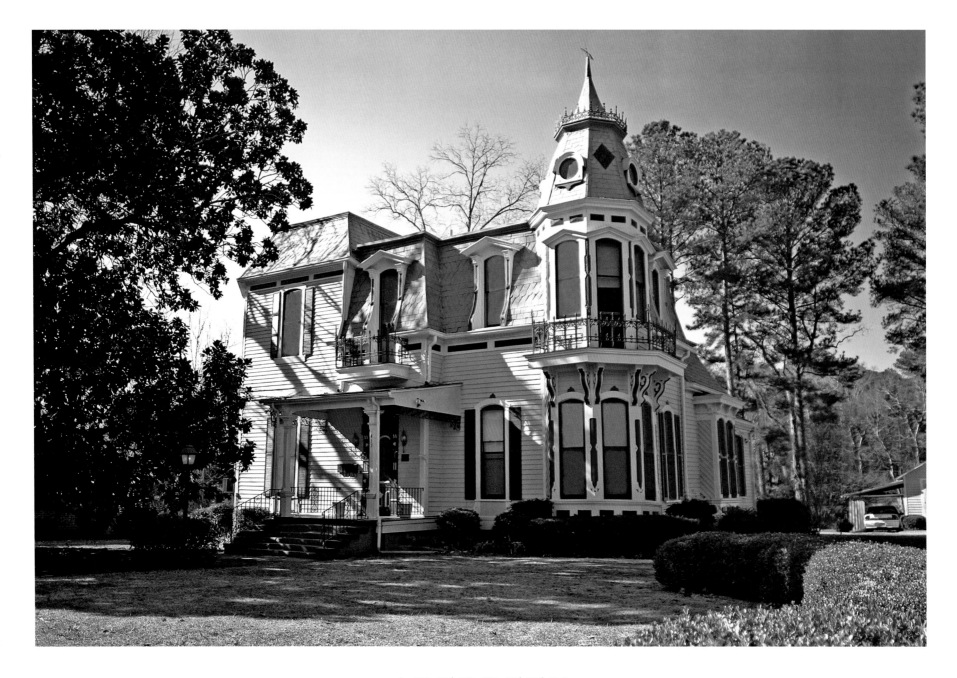

ABERDEEN

The John C. Wicks House on South Franklin Street is an ornate example of the Second Empire style.

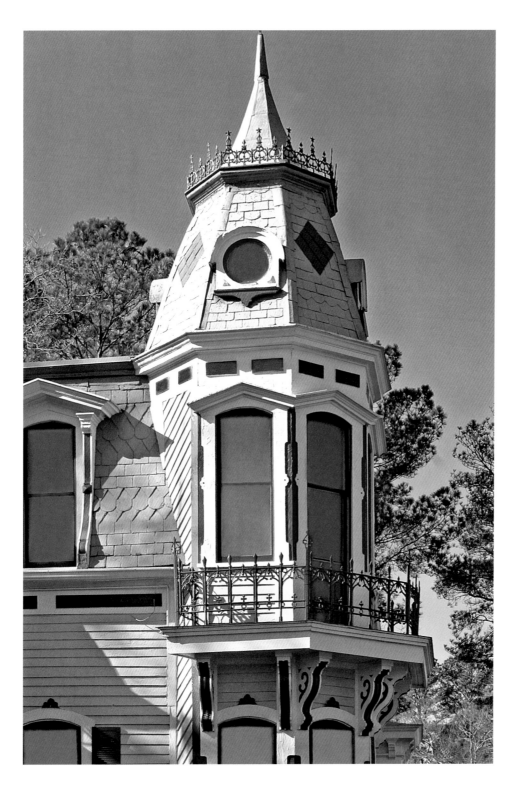

ABERDEEN

The octagonal corner tower is the most distinctive
feature of the Wicks House.

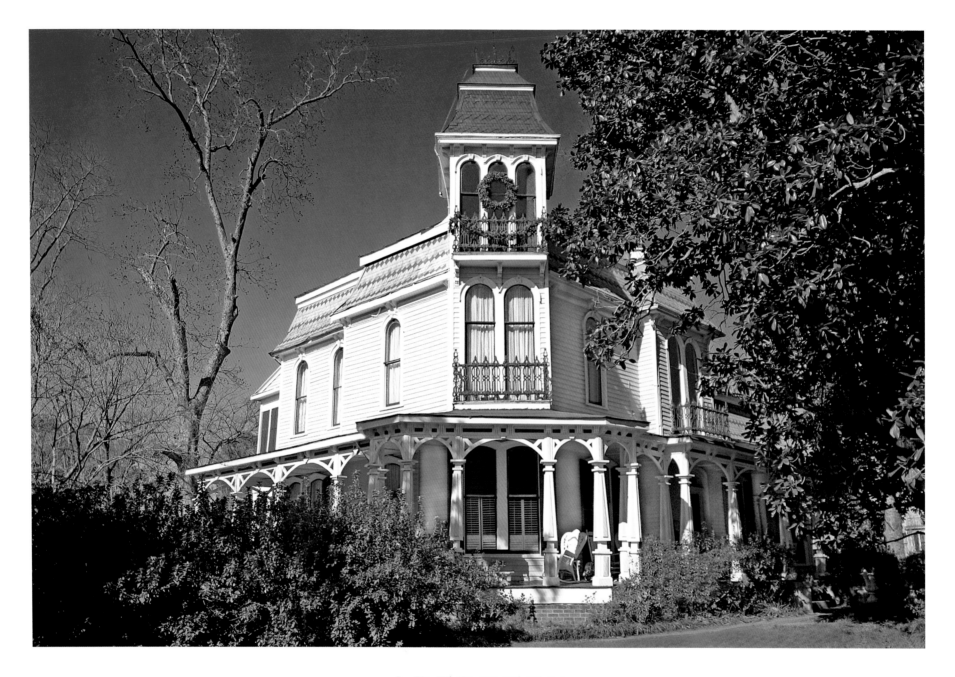

ABERDEEN

The Leftwich House (Bella Vida) on South Franklin Street is a notable example
of Second Empire residential architecture.

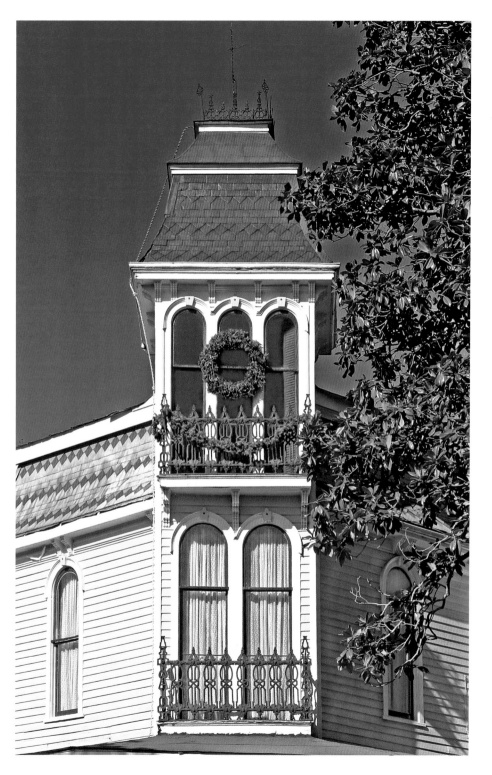

ABERDEEN

The most prominent feature of the Leftwich House
is its diagonally placed square tower with a distinctive
double-tiered mansard roof.

9

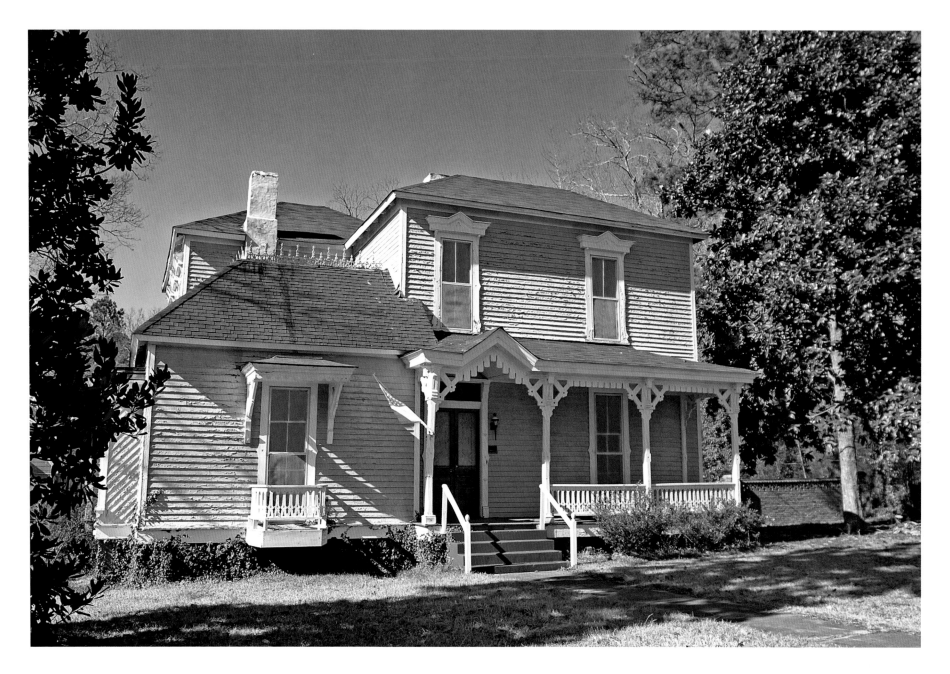

ABERDEEN

The Charles Eckford House (1884) on South Franklin Street has unusual Stick style ornamentation.

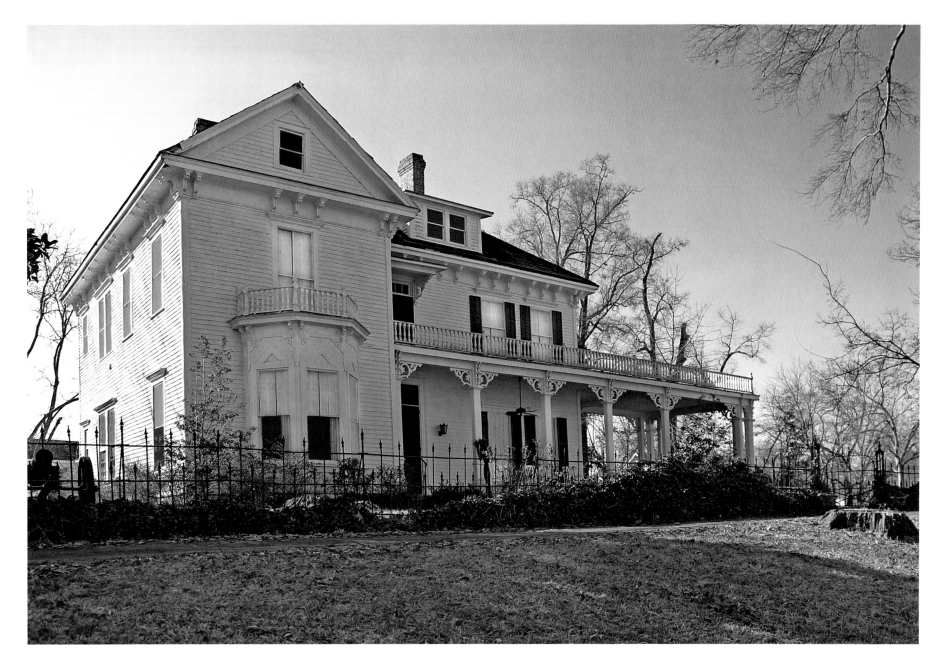

ABERDEEN

Greenleaves (Roy-Watkins House) on Washington Street is an eclectic
Late Victorian house with Italianate features.

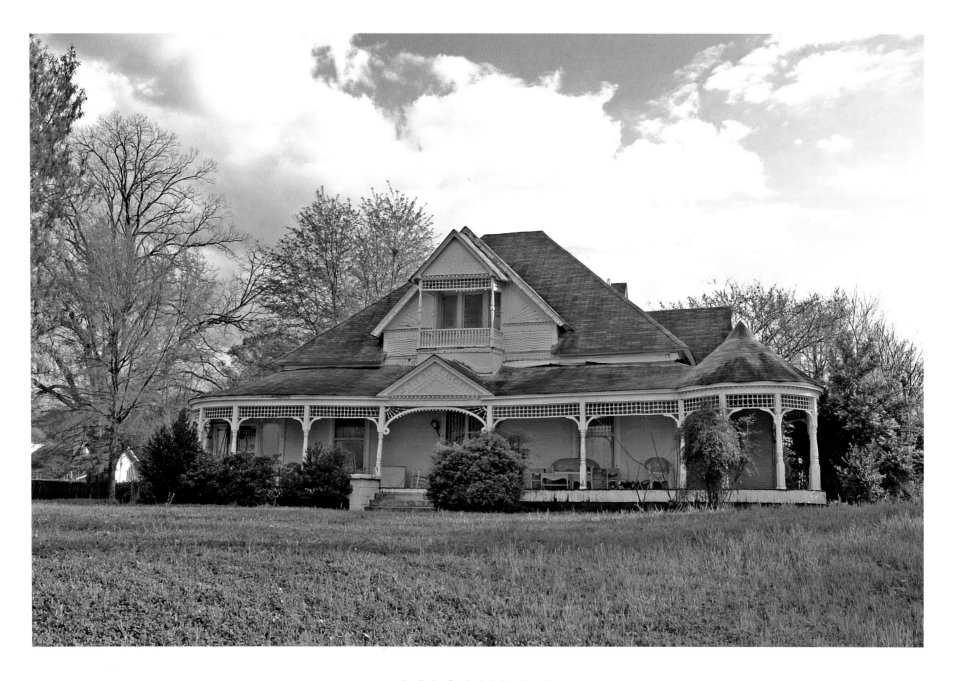

ANGUILLA

The McKinney House, at the corner of Front and Holland streets, has a broad veranda
trimmed with spindlework and an elaborately patterned front gable.

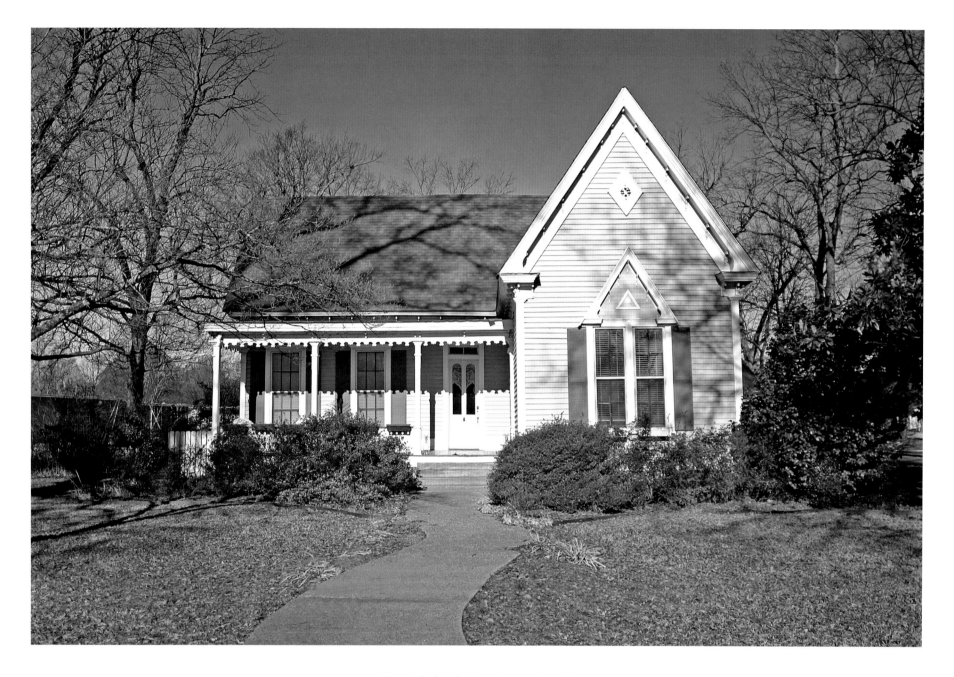

BATESVILLE

The Lee House (circa 1888) on Booth Street is one of many fine Late Victorian houses in and around Panola
County that were built by Andrew Johnson, an architect and contractor who lived in Sardis.

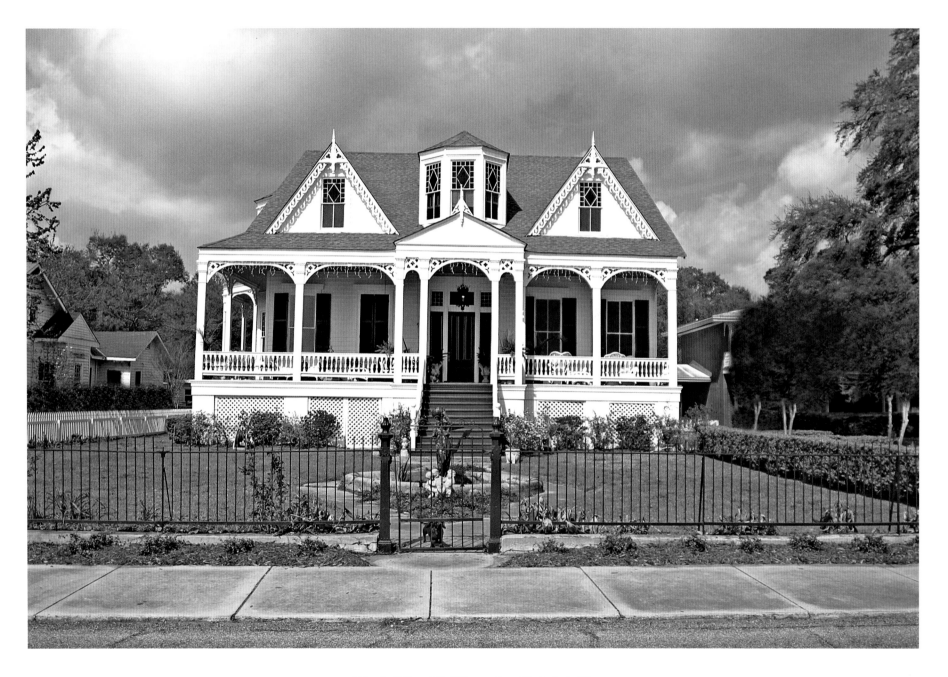

BAY ST. LOUIS

The Telhaird-McDonald House on North Beach Boulevard has an eclectic design
featuring prominent paired gables.

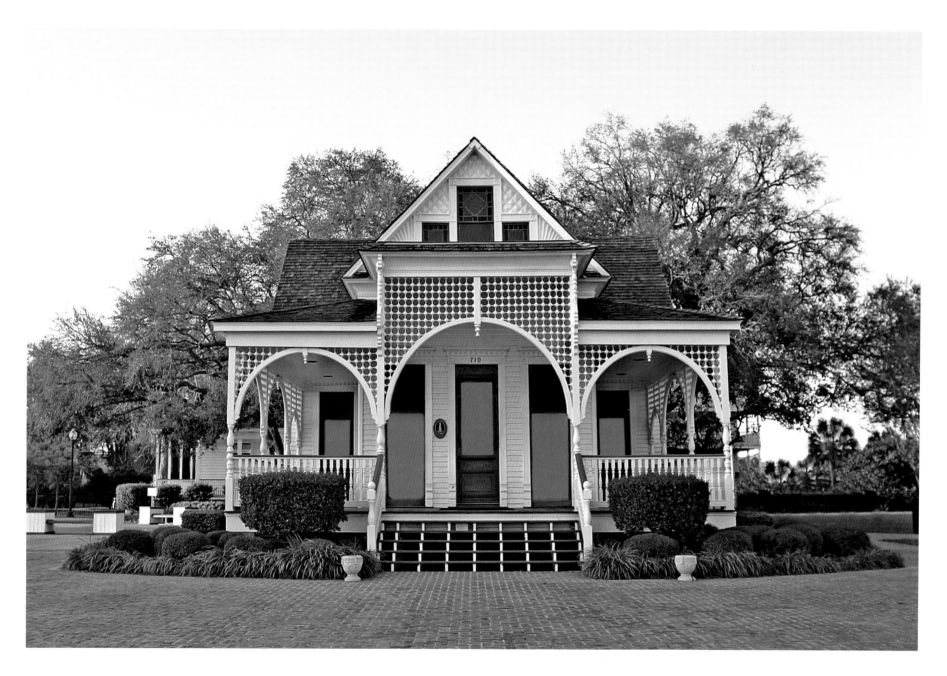

BILOXI

The Paul W. Brielmaier House (circa 1895) was moved to the public green in 1986 and
restored to become the Biloxi Visitors Center. It is open to the public.

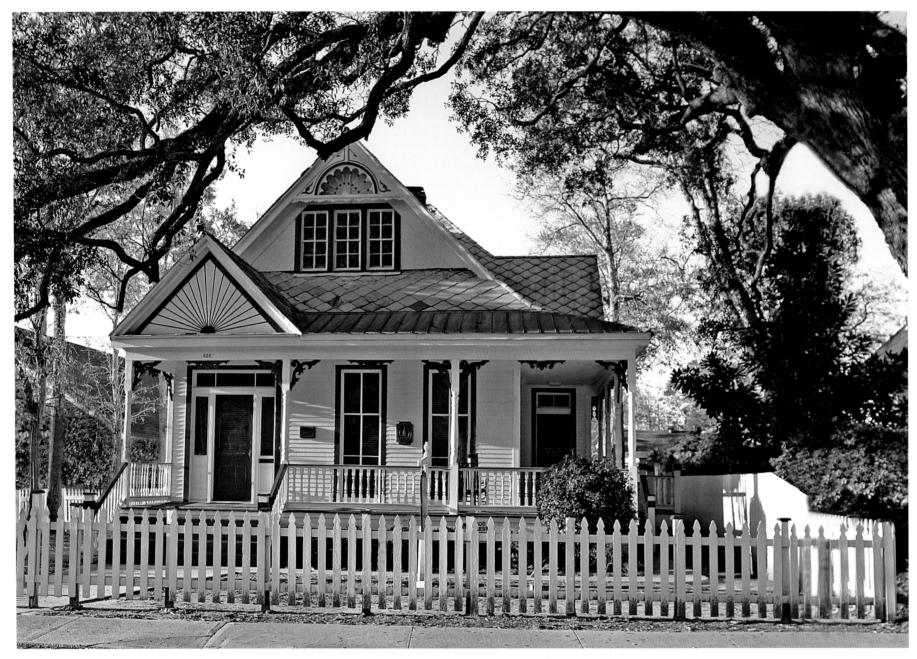

BILOXI

This charming Queen Anne cottage is located on Howard Avenue east of downtown Biloxi.

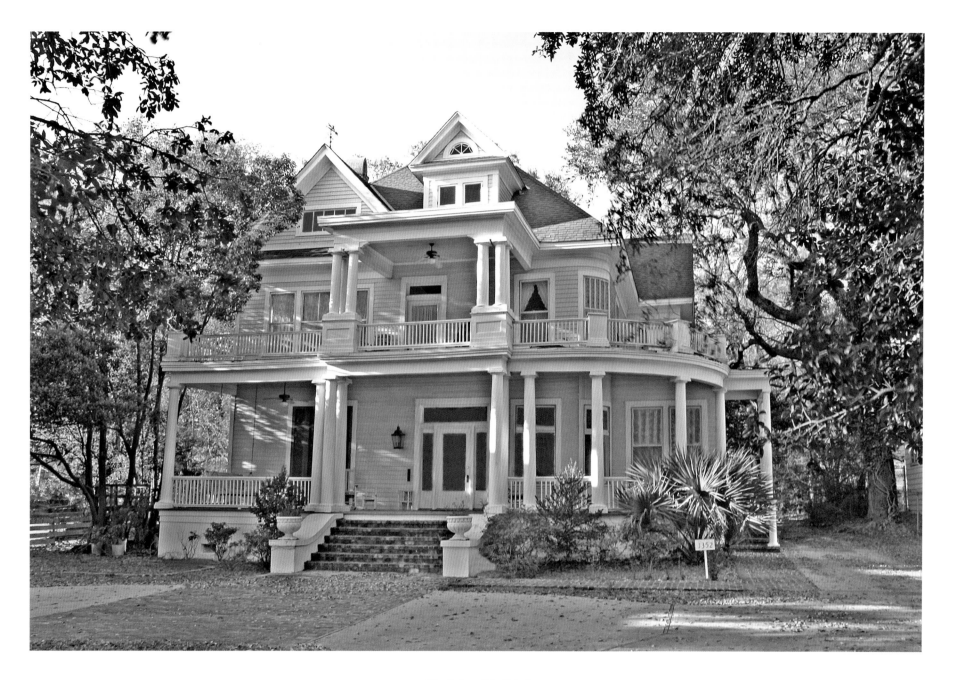

BILOXI

This house on Beach Boulevard is a locally notable example of the free
classical mode of the Queen Anne style.

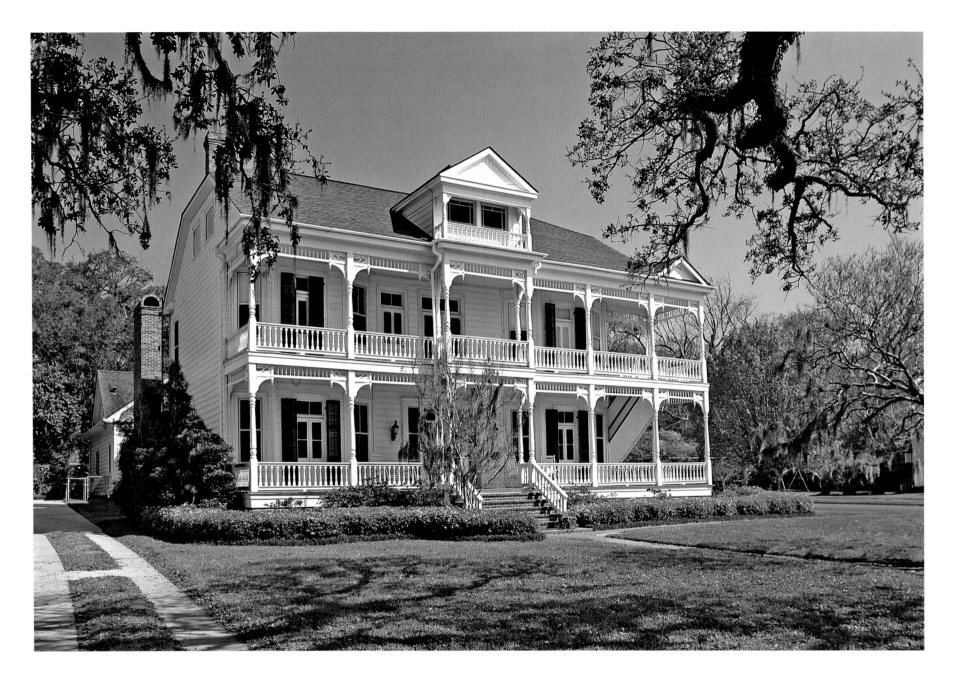

BILOXI

Ornate spindlework adorns this double-galleried house on Beach Boulevard.

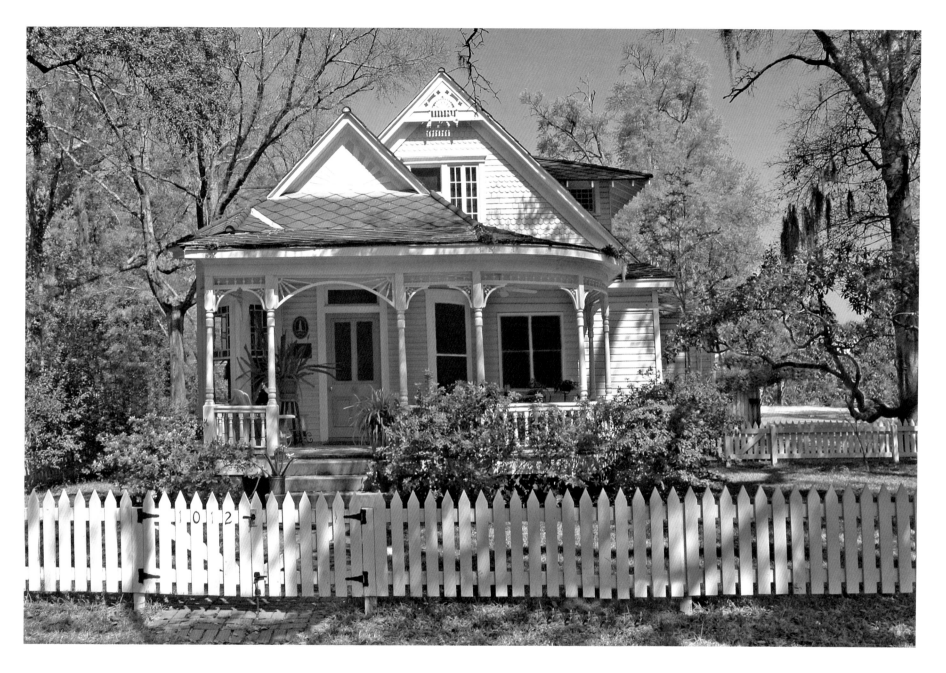

BILOXI

Another of Biloxi's many Queen Anne cottages is the Thomas E. Suter House
(circa 1886) on Tullier Court.

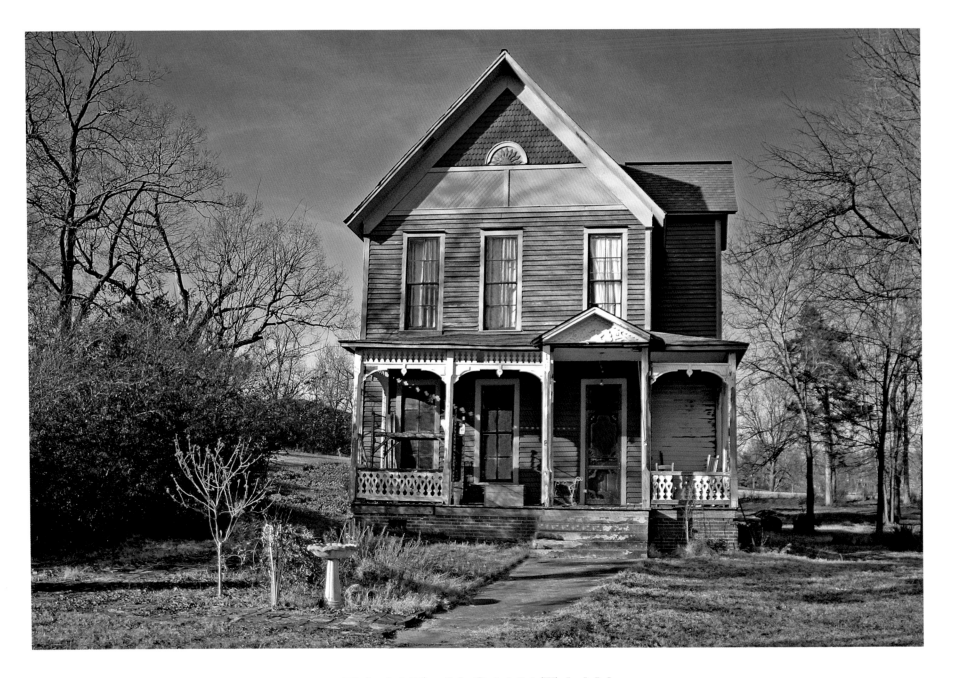

BLUE MOUNTAIN

The Queen Anne textures and millwork of the Palmer House (1892) on West Main Street
in Blue Mountain are accentuated by contrasting paint colors. During the Late Victorian
period, houses were often painted in combinations of several different colors
and shades in order to draw attention to their detailing.

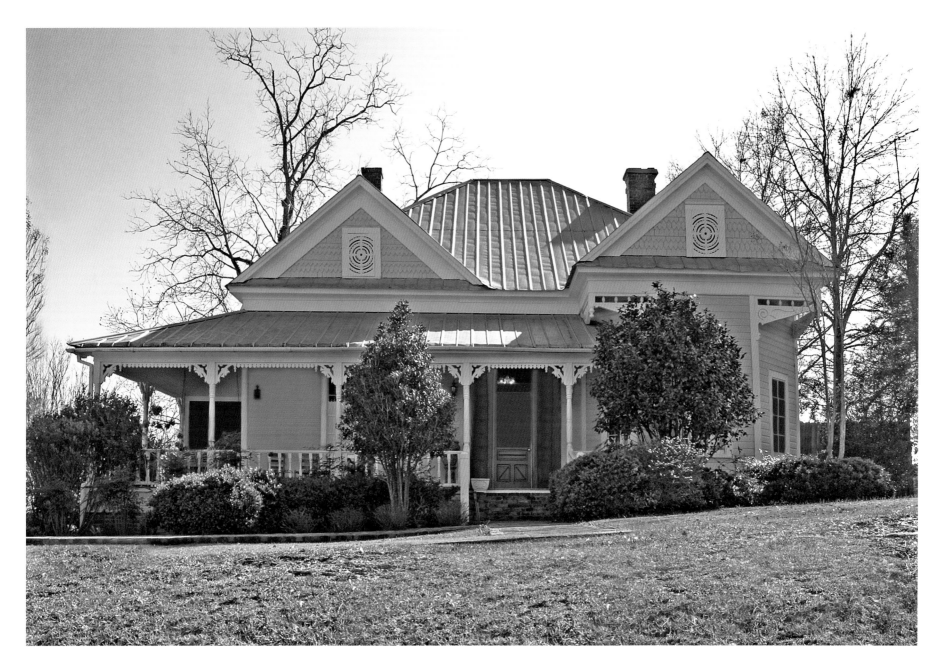

BOGUE CHITTO

The Foxx-Cox House, at the corner of Monticello and Morgan streets, is a well-preserved
Queen Anne cottage.

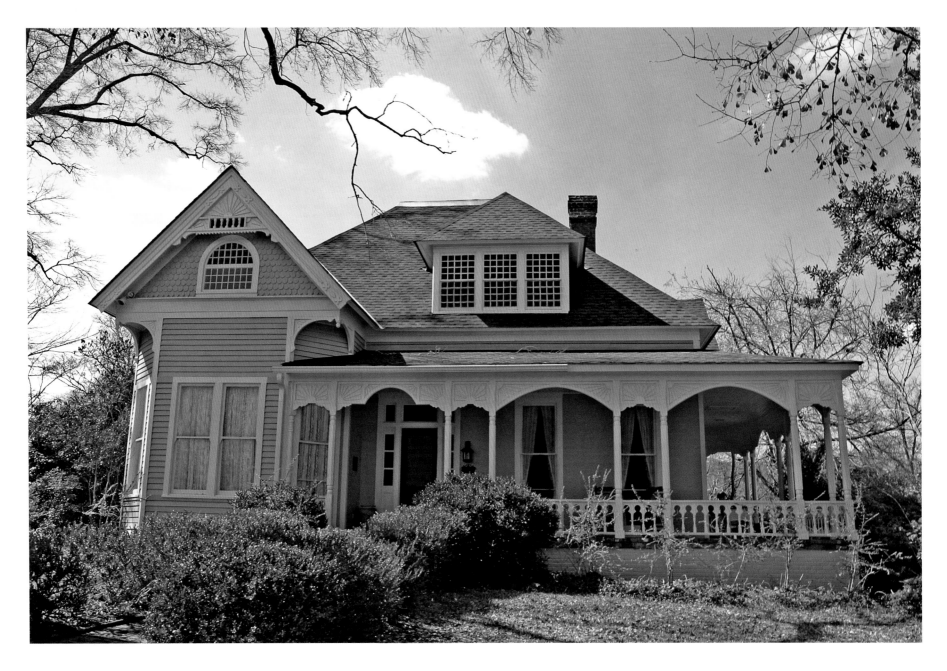

BROOKHAVEN

The W. F. Jobes House on South Jackson Street is one of several fine Queen Anne houses in Brookhaven.

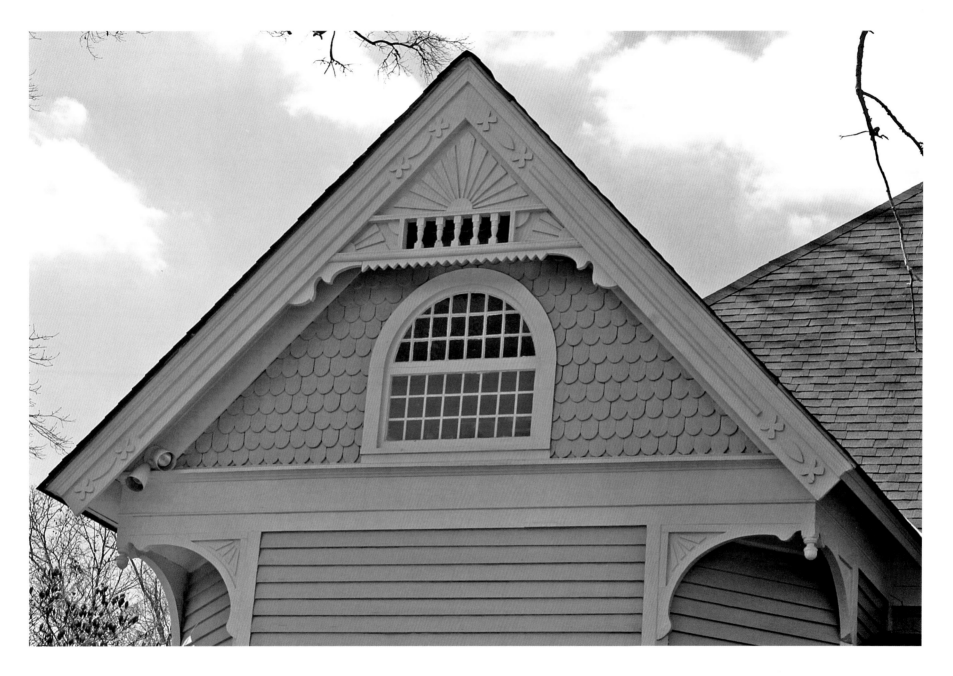

BROOKHAVEN

Queen Anne–style features include the ornamented gable clad in "fish-scale" imbricated shingles
and the curved brackets in the angles of the chamfered corners below.

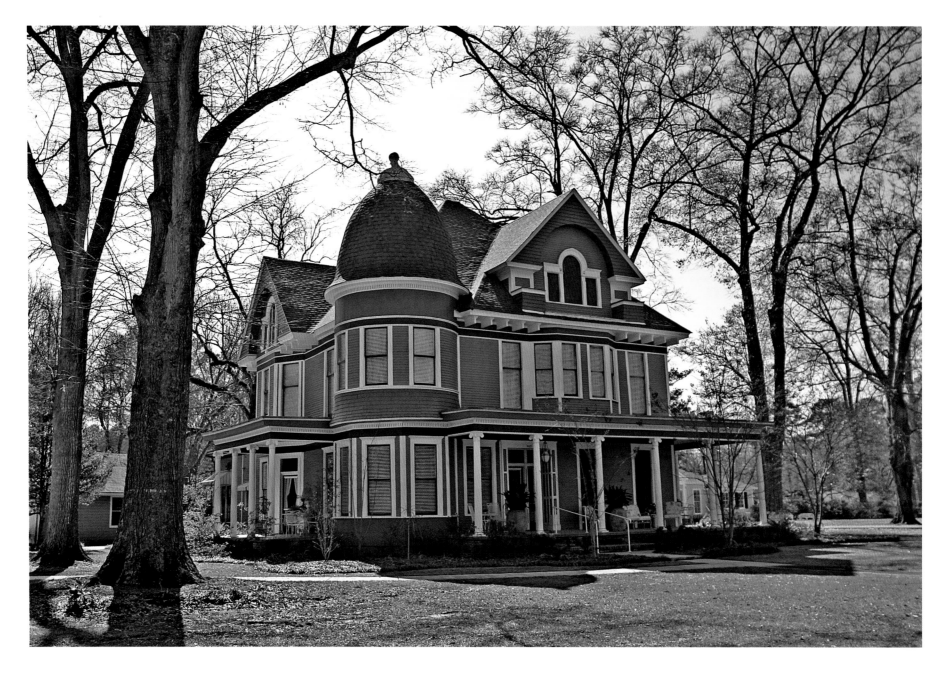

BROOKHAVEN

A Queen Anne house with free classical features, the Sproles House on Natchez Avenue is distinguished
by a round corner tower with a bell-shaped dome.

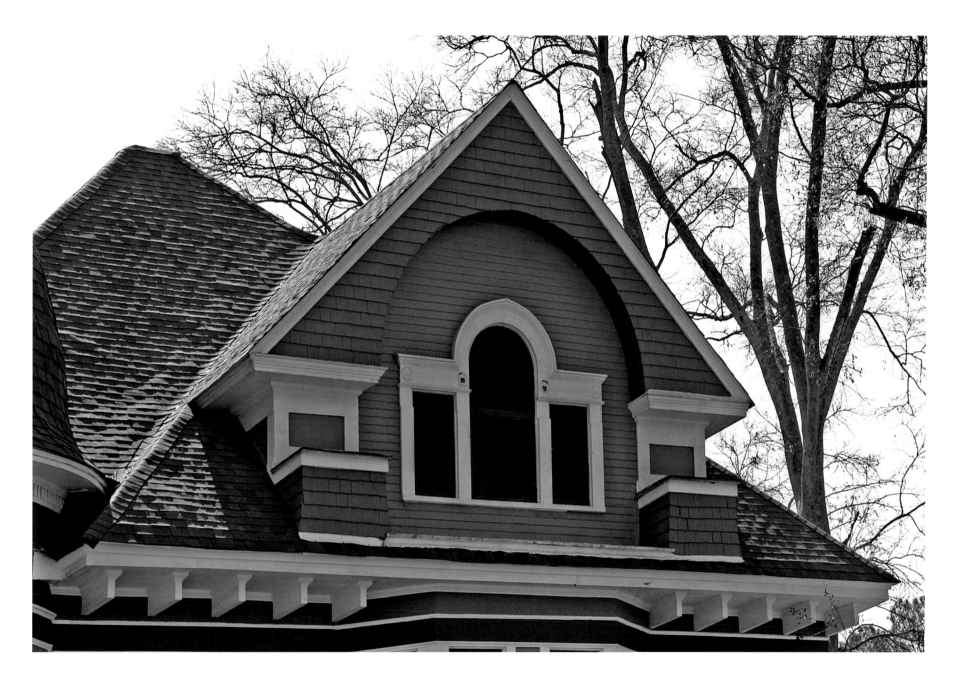

BROOKHAVEN

The gable is ornamented by a Palladian window—a tripartite design consisting of a round-arched
center opening flanked by lower, flat-topped openings.

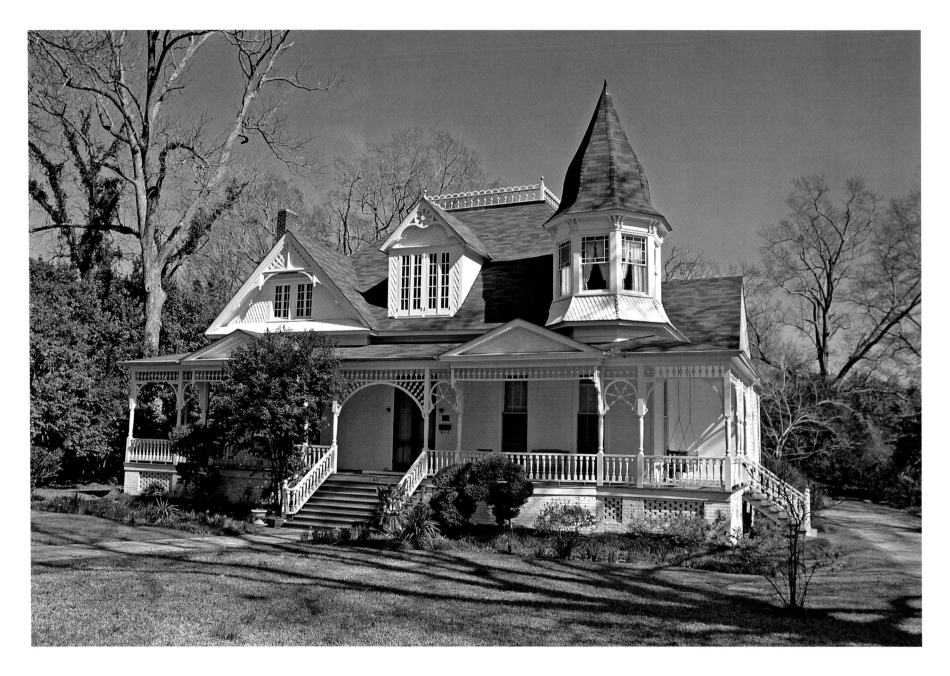

BROOKHAVEN

The Scherck-Jones House on Whitworth Avenue, built in 1896, is notable for the lavish
spindlework detailing on its veranda.

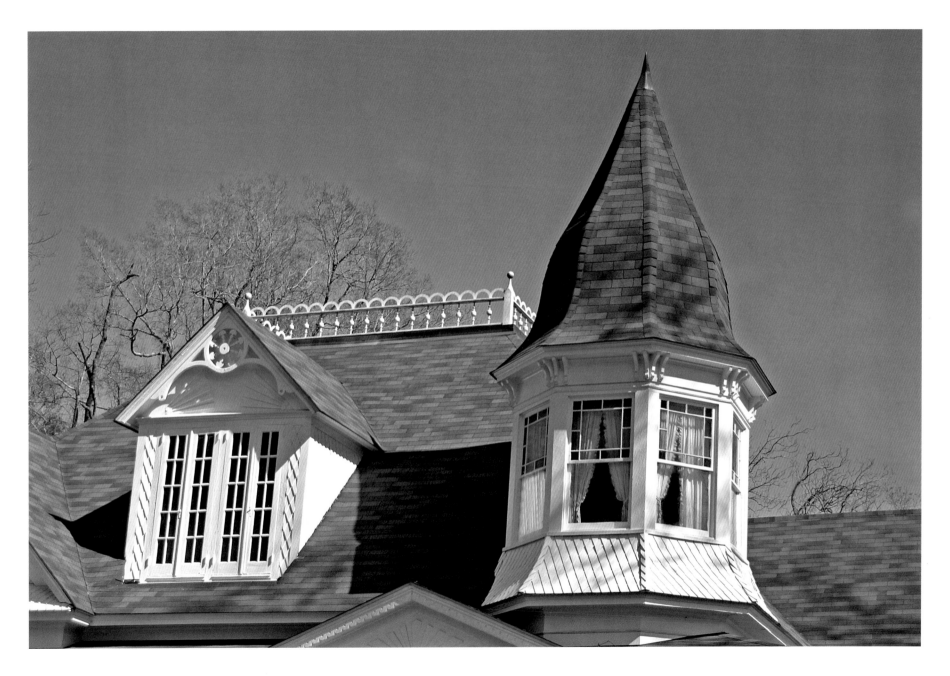

BROOKHAVEN

The most distinctive feature of the Scherck-Jones House is its octagonal turret capped by a pointed,

bell-shaped roof. The upper sashes of the turret's windows have colored glass borders.

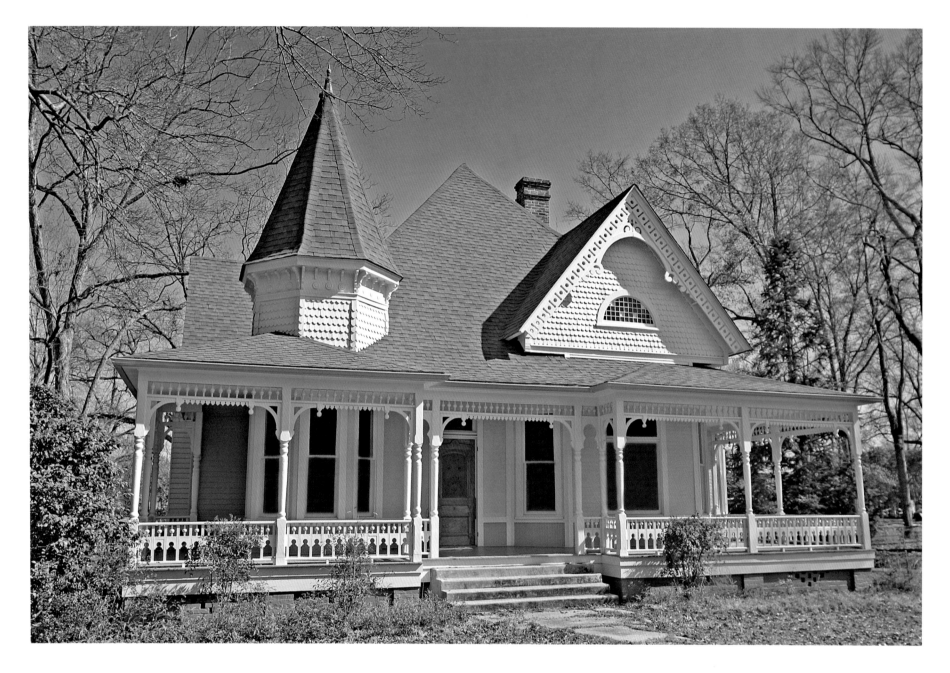

BROOKHAVEN

This fine Queen Anne house, also on Whitworth Avenue, is given a rich
surface texture by the imbricated wood shingle siding in a "fish-scale" pattern
on the front gable and the octagonal tower.

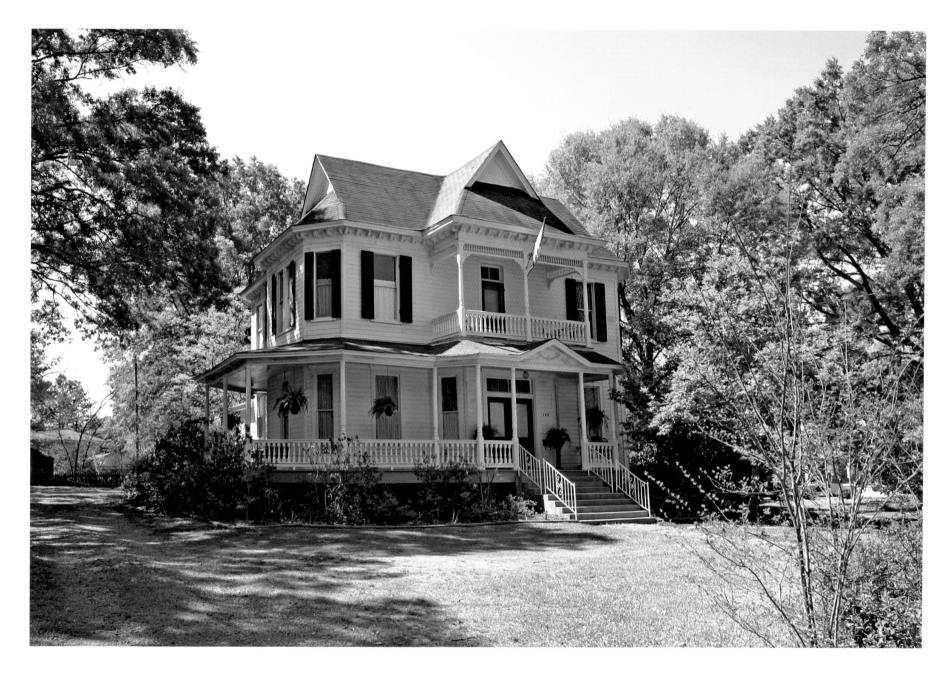

CANTON

The Charles F. Smith House on Semmes Avenue was built about 1899.

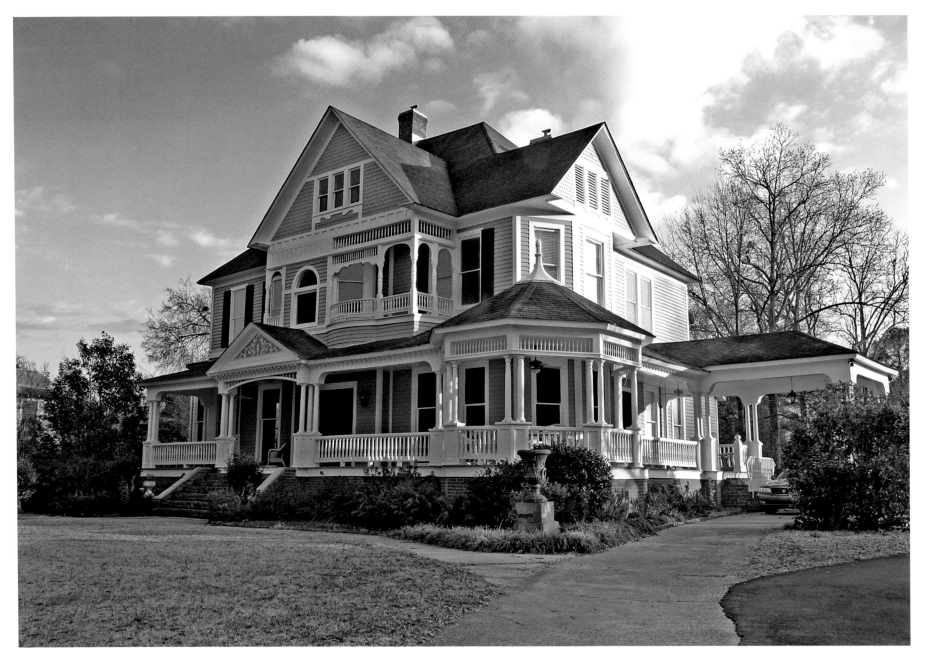

CANTON

The Judge W. H. Powell House (1896–98), located on East Peace Street, is a fine
Queen Anne house displaying both spindlework and free classical features.

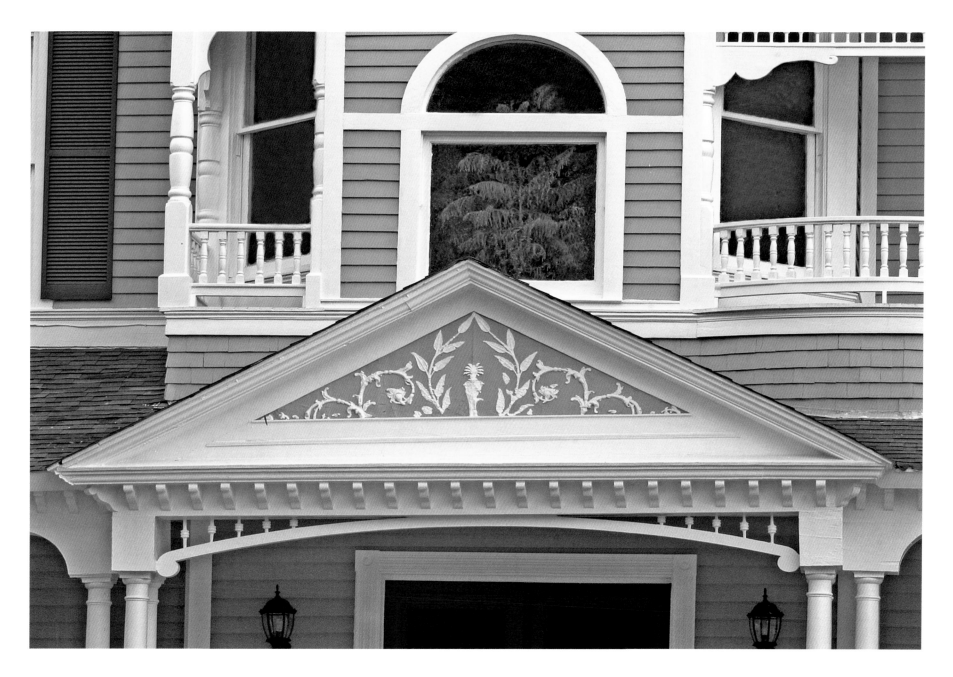

CANTON

The fine detailing of the Powell House is evident in the pediment of the veranda.

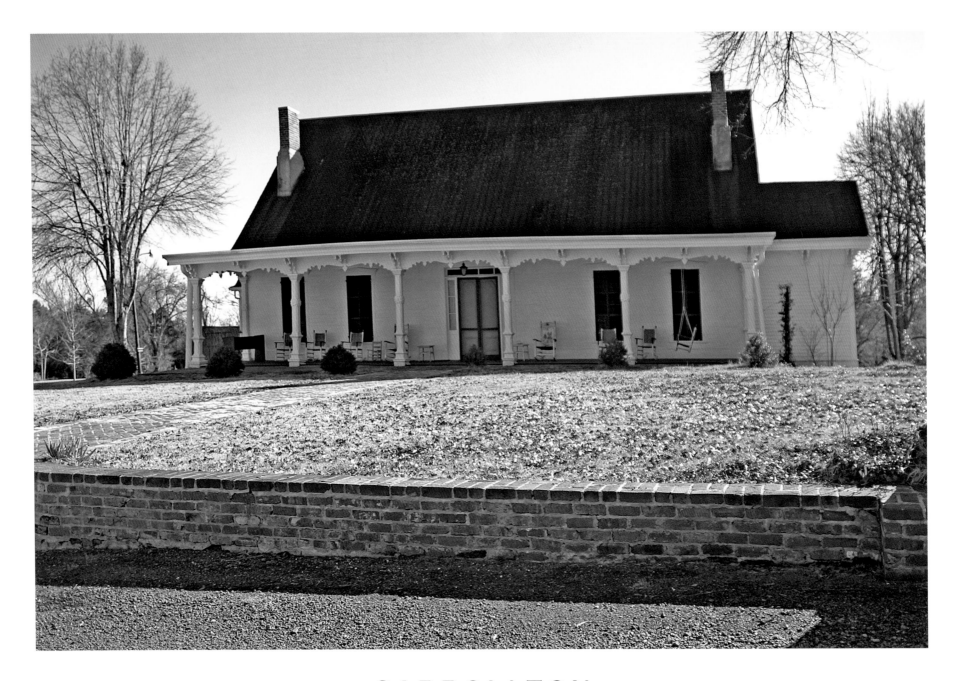

CARROLLTON

The veranda of the Colonel William Helm House on Stonewall Street was added about 1874.

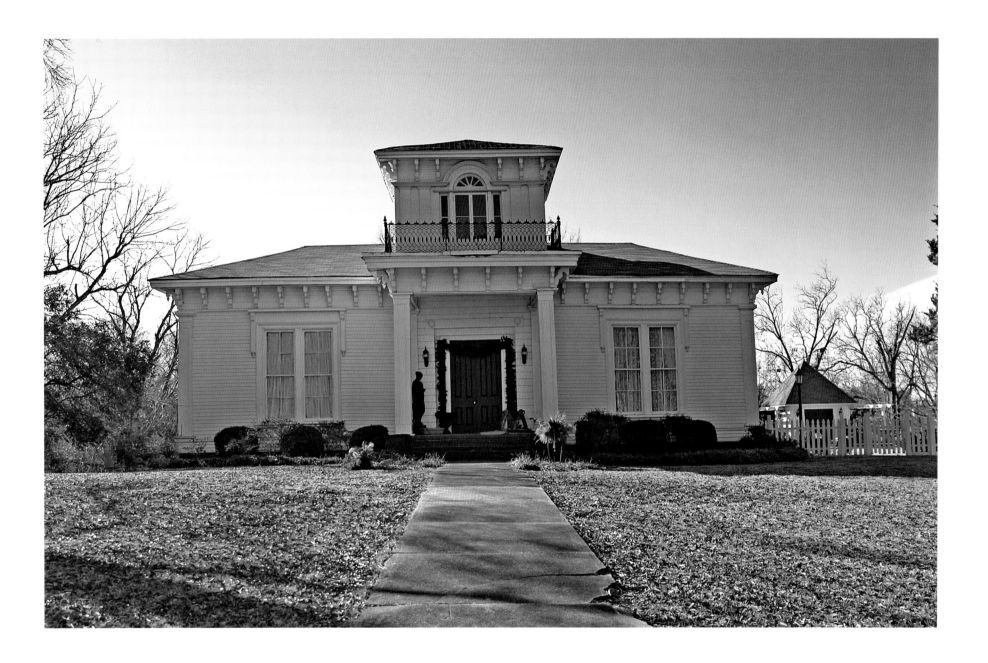

CARROLLTON

Stanhope (1875) on Lexington Street in Carrollton was designed by James Clark Harris.

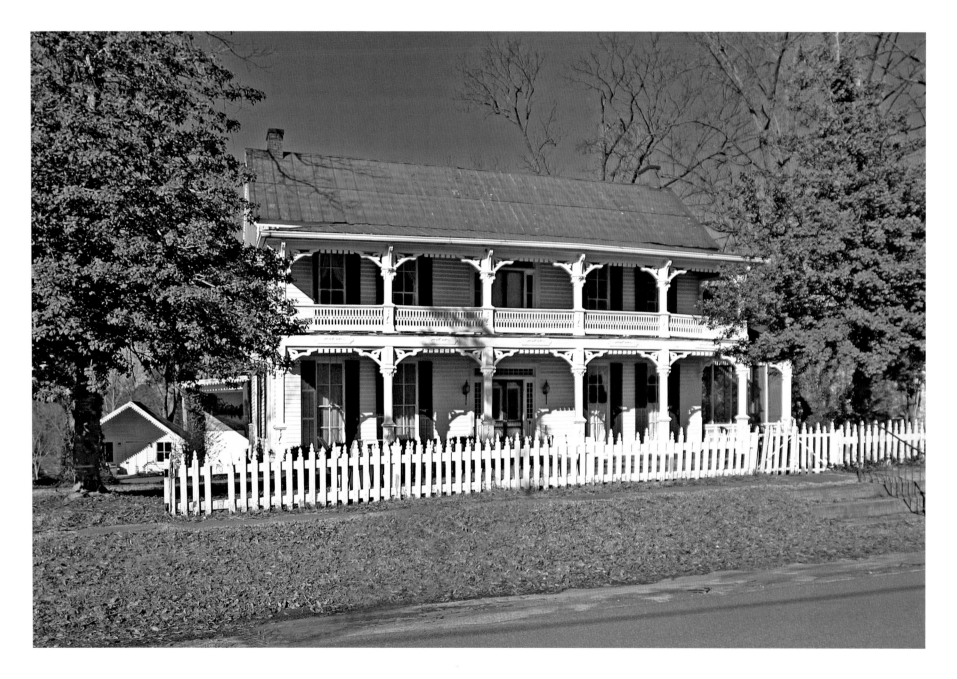

CARROLLTON

The Captain William Ray House in Carrollton, which was originally built around the 1830s,
was remodeled in a Late Victorian manner in 1875.

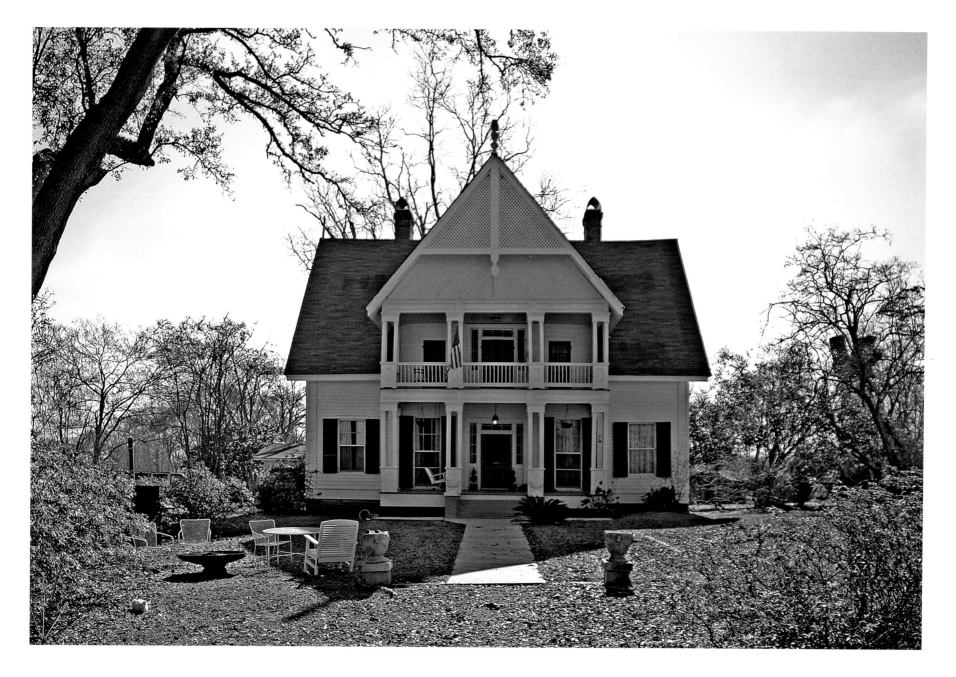

CENTREVILLE

The Rogers House on South Laurel Street in Centreville exhibits characteristics of the Stick style.

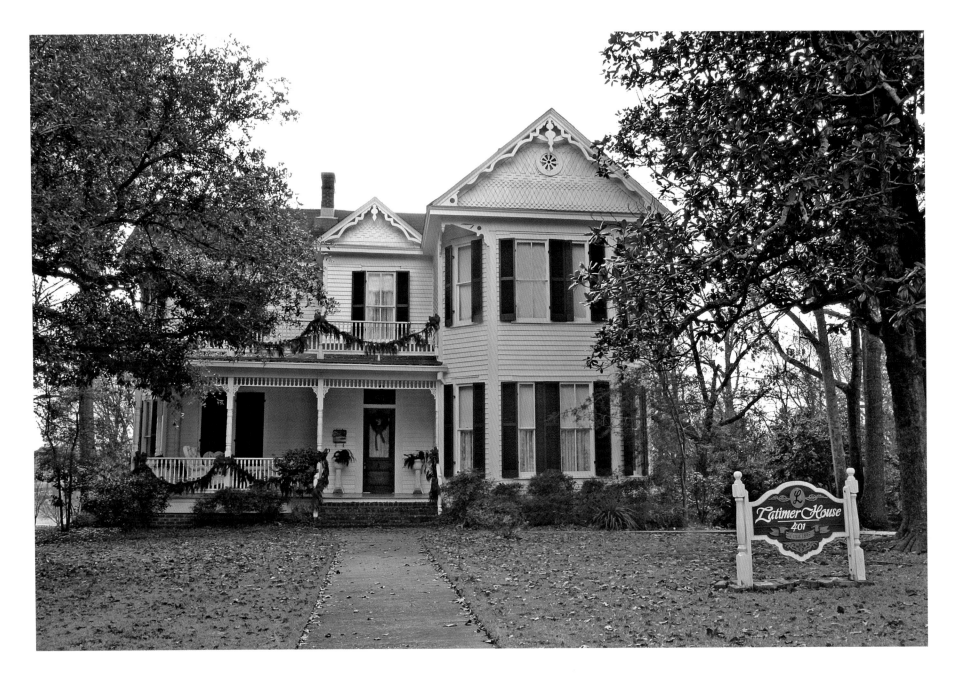

CLINTON

Elaborate patterns of shaped shingles adorn the gables of the Latimer House (Twin Oaks)
on West Madison Street, built about 1895.

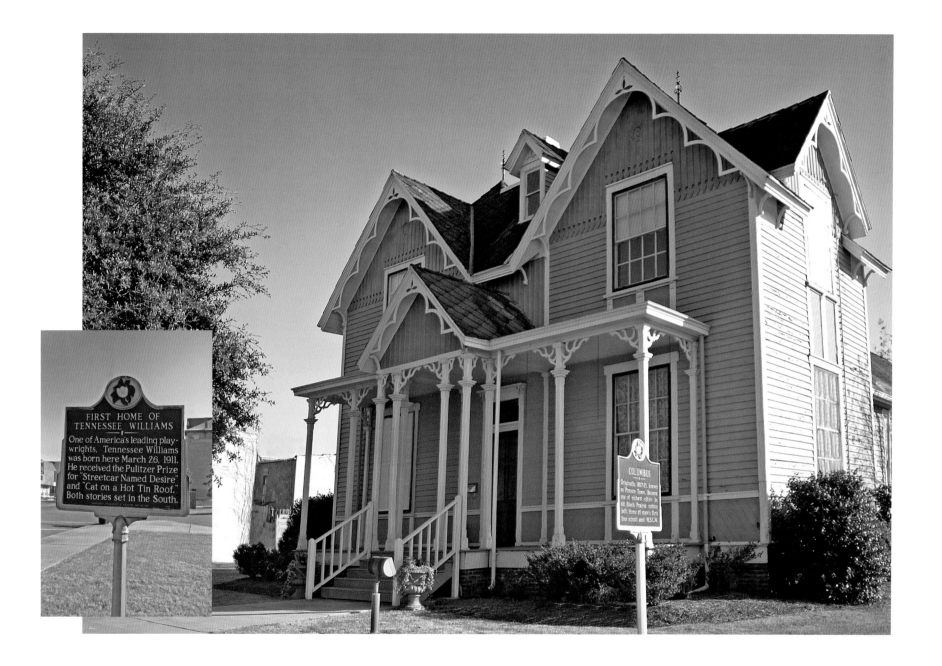

COLUMBUS

The former rectory of St. Paul's Episcopal Church was moved to its present location on Main Street
in 1995 to become the visitors center for Columbus. It is open to the public. Acclaimed playwright
Tennessee Williams resided in this house for the first three years of his life while his grandfather,
the Reverend Walter E. Dakin, was rector of St. Paul's Church.

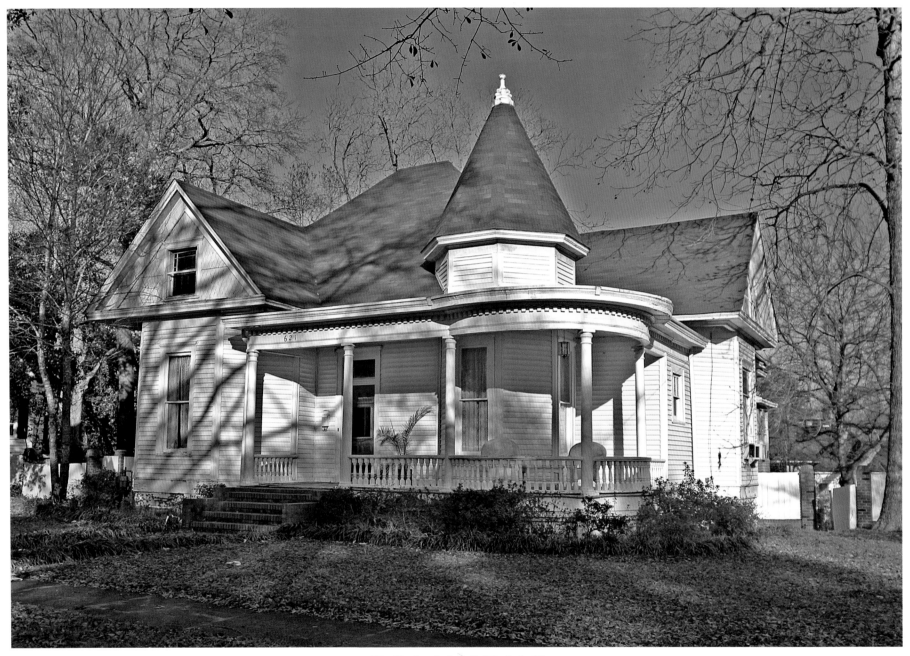

COLUMBUS

The Boyd House on Second Street South is a well-preserved Queen Anne cottage.

COLUMBUS

The octagonal spire is topped by a finial.

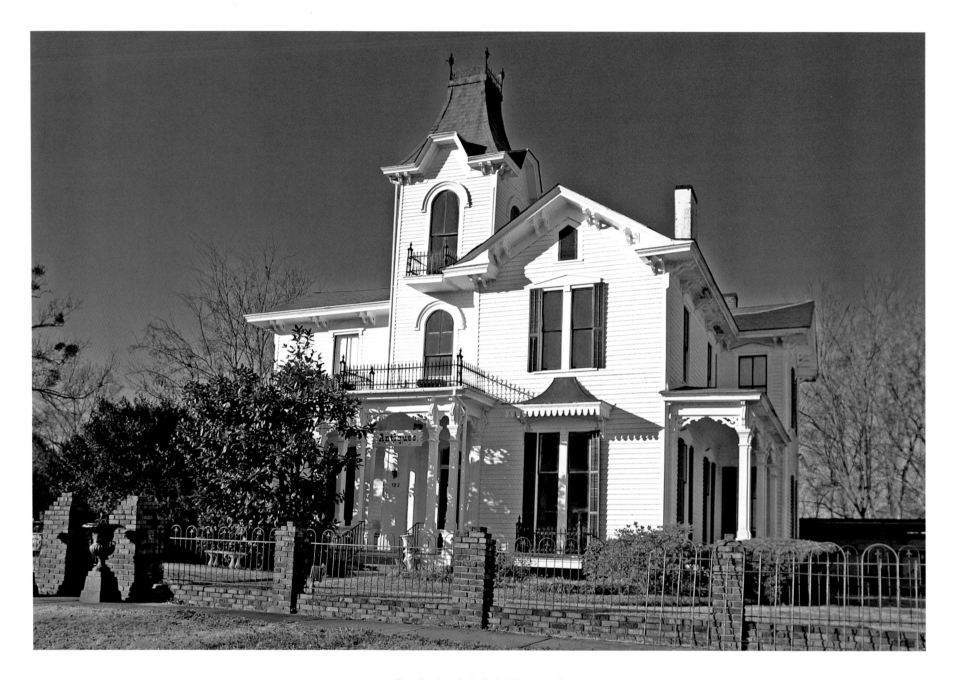

COLUMBUS

This Italianate villa on Third Street South has a mansard-roofed tower.

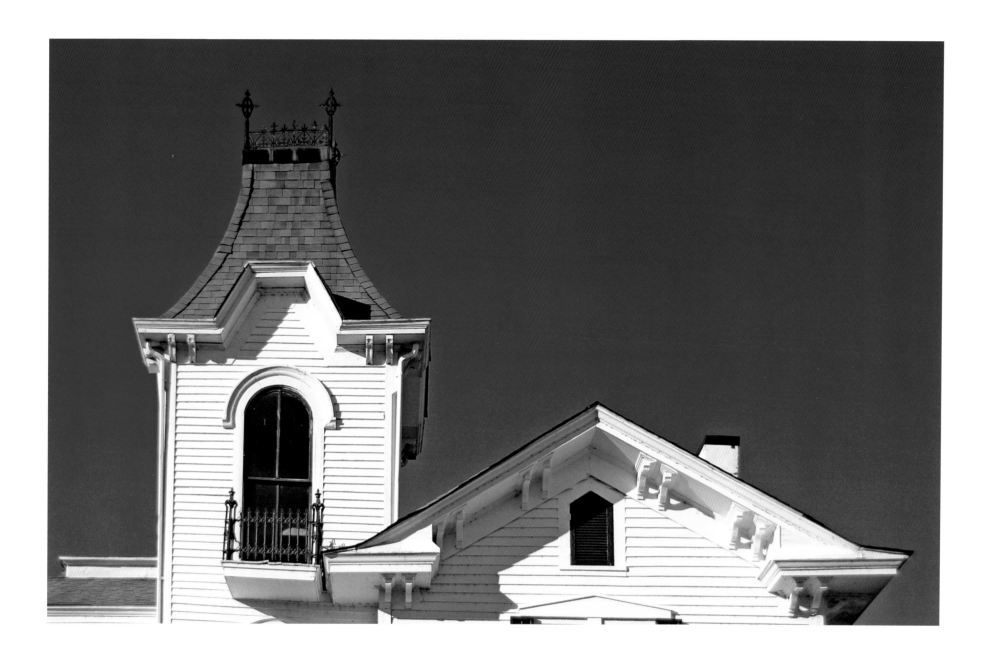

COLUMBUS

The mansard roof of the tower has concave curving sides and is trimmed with metal cresting.

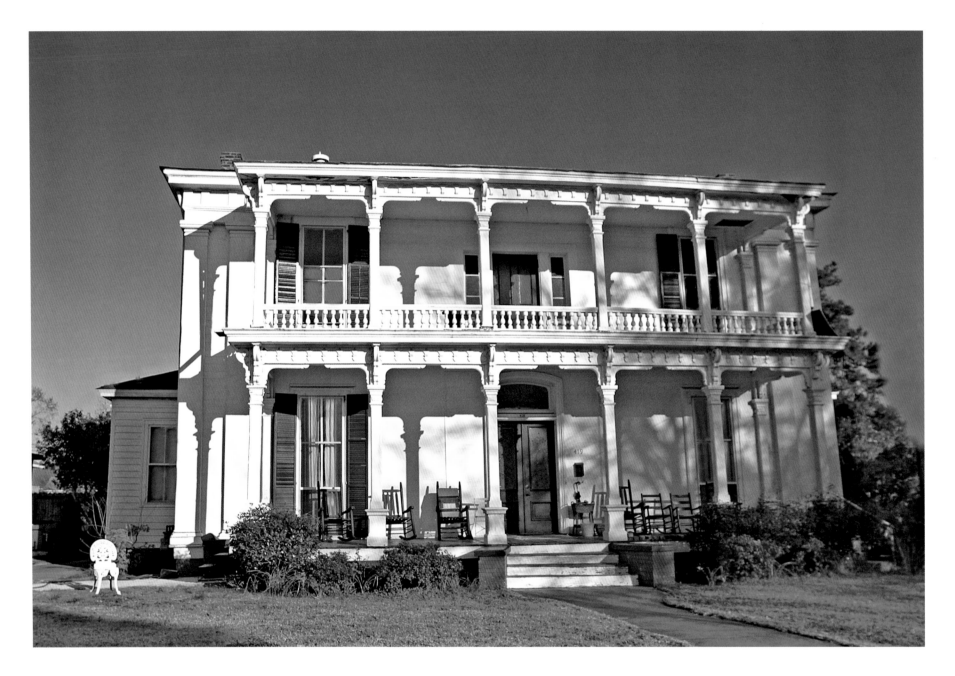

COLUMBUS

An Italianate double-tiered gallery graces this house on Third Street South.

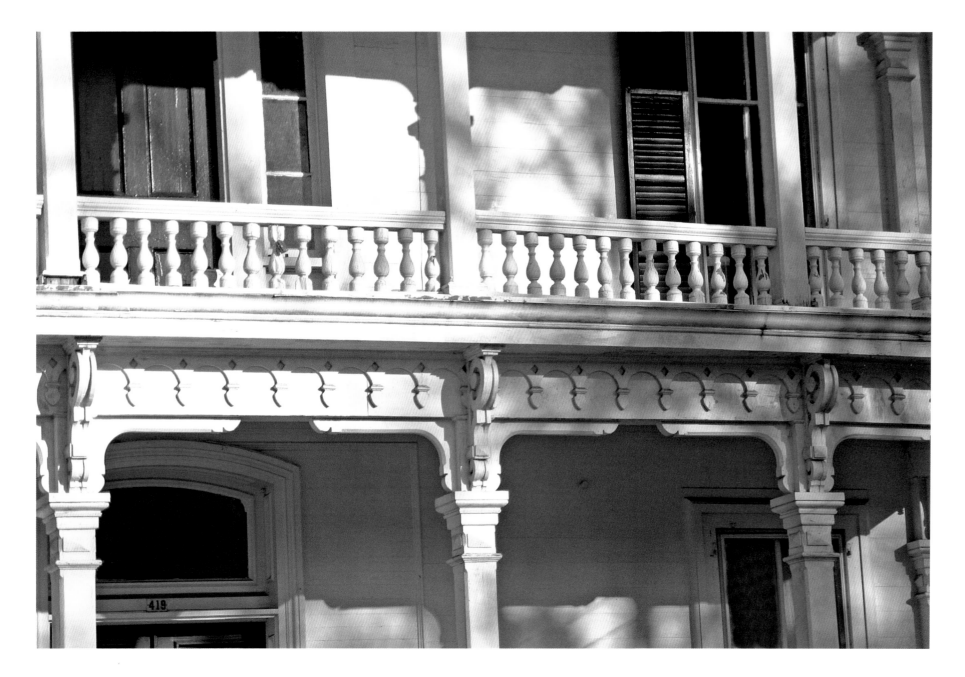

COLUMBUS

The cornice of the lower gallery and the balustrade above display ornate millwork.

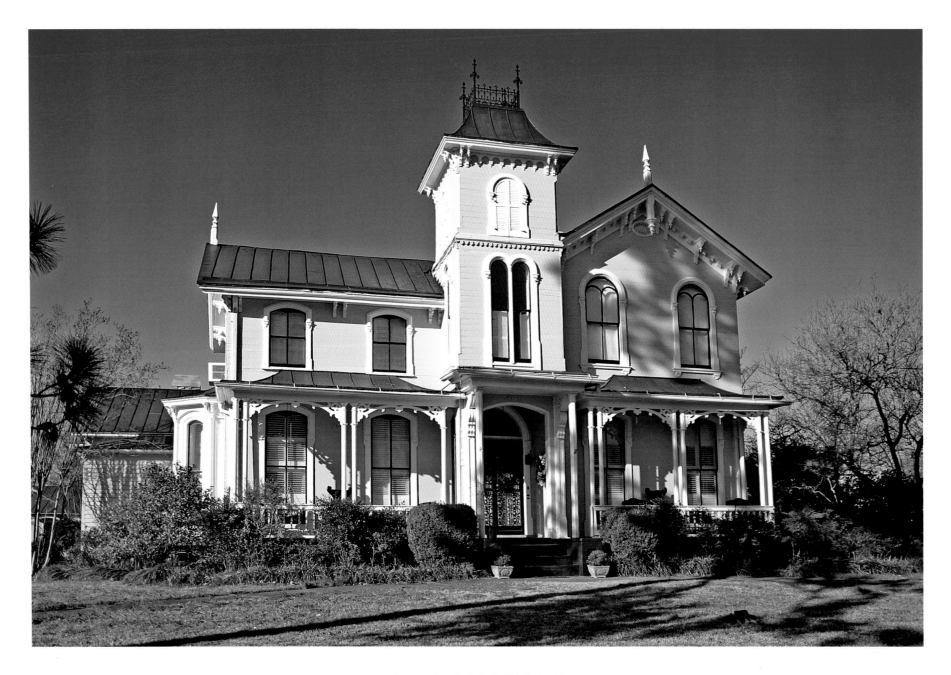

COLUMBUS

The Steers-Sykes-Locke House (Azalea Place) on Third Street South is a fine example
of an Italianate house with a mansard-roofed tower.

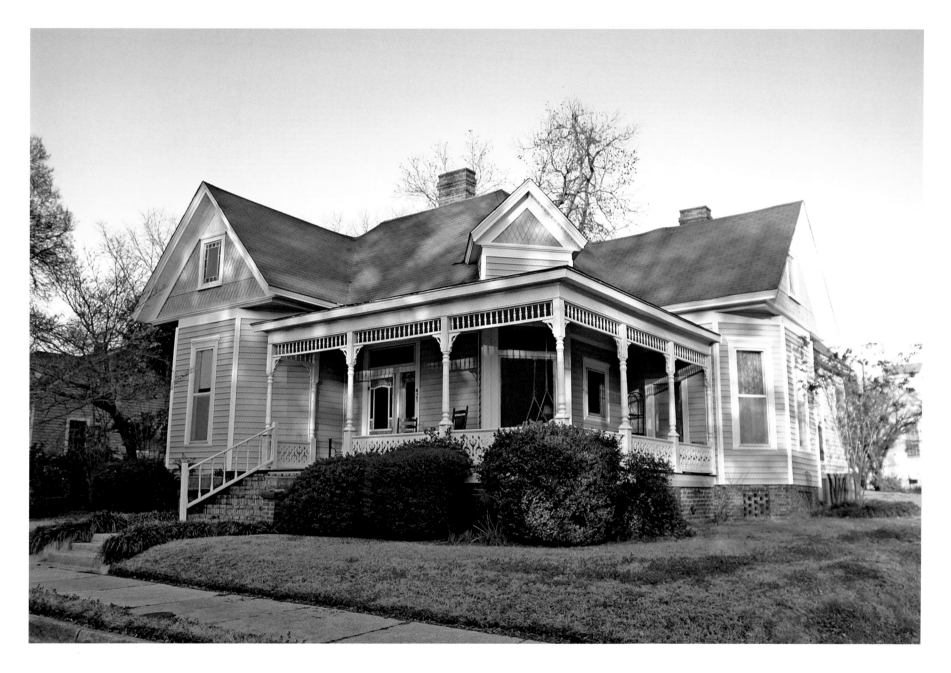

COLUMBUS

This Queen Anne cottage is located on Fourth Street South in Columbus.

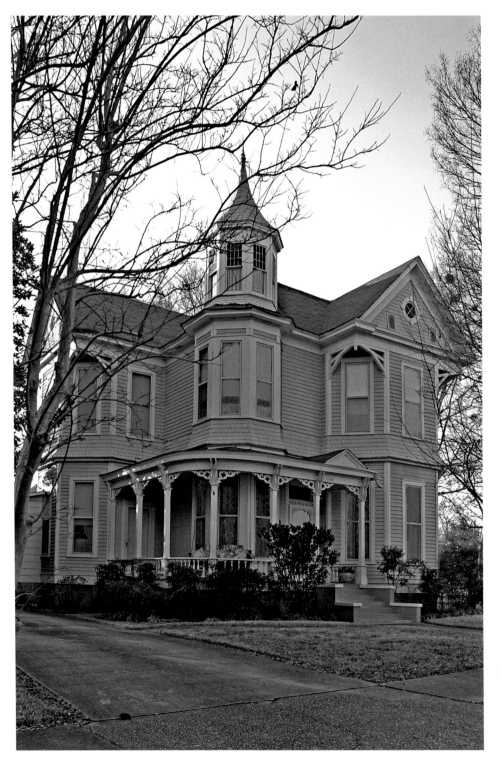

COLUMBUS

This turreted Queen Anne house on Third Street South
is one of many fine Late Victorian houses in Columbus.

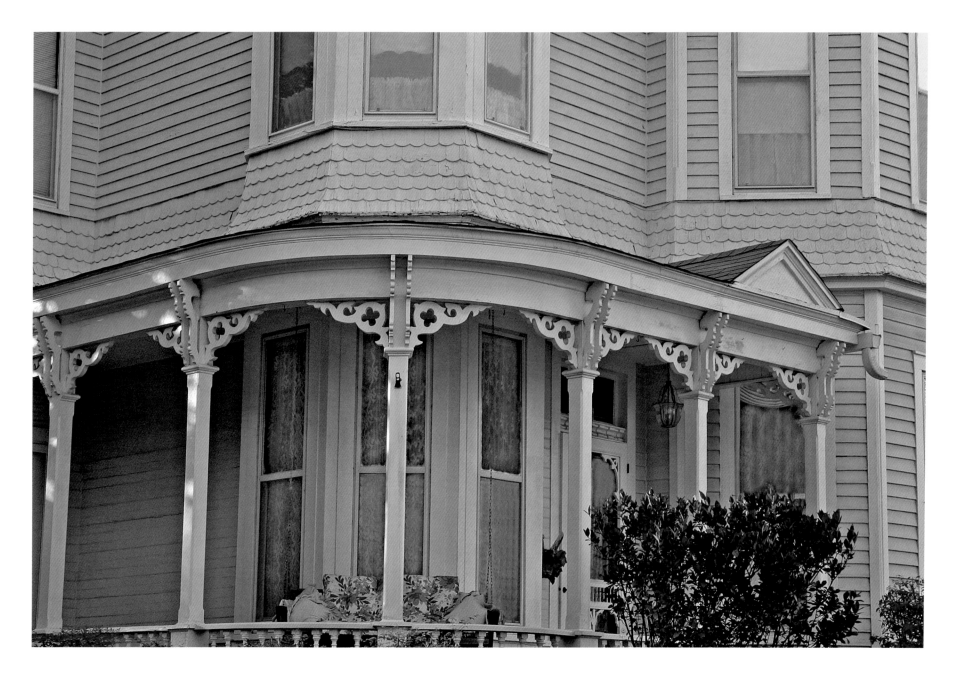

COLUMBUS

The veranda is embellished by a bracketed cornice.

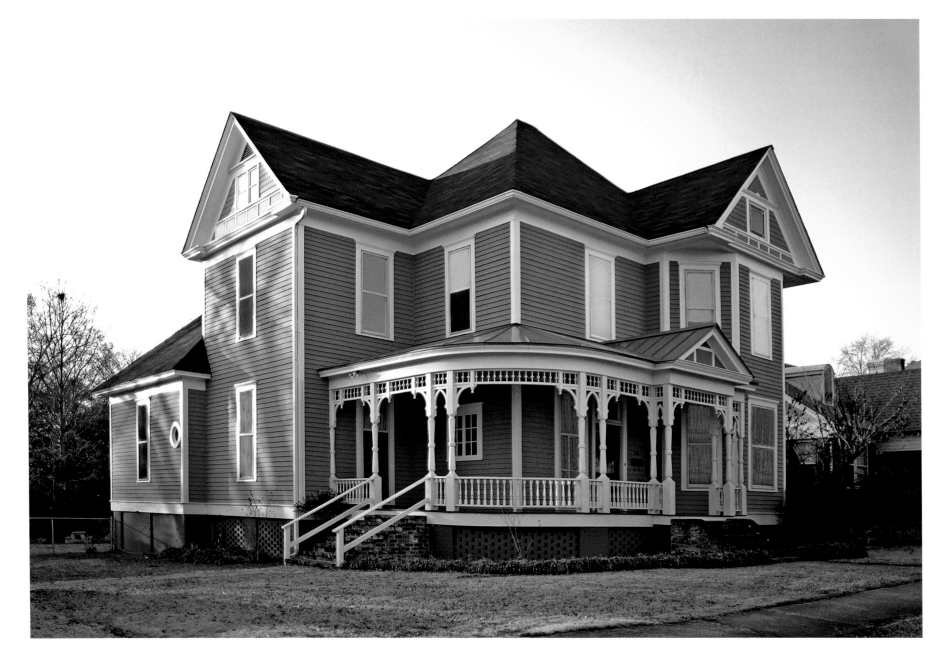

COLUMBUS

Many of Mississippi's Queen Anne houses have spindlework-trimmed verandas that wrap around
a front corner, as can be seen on this one on Fourth Street South in Columbus.

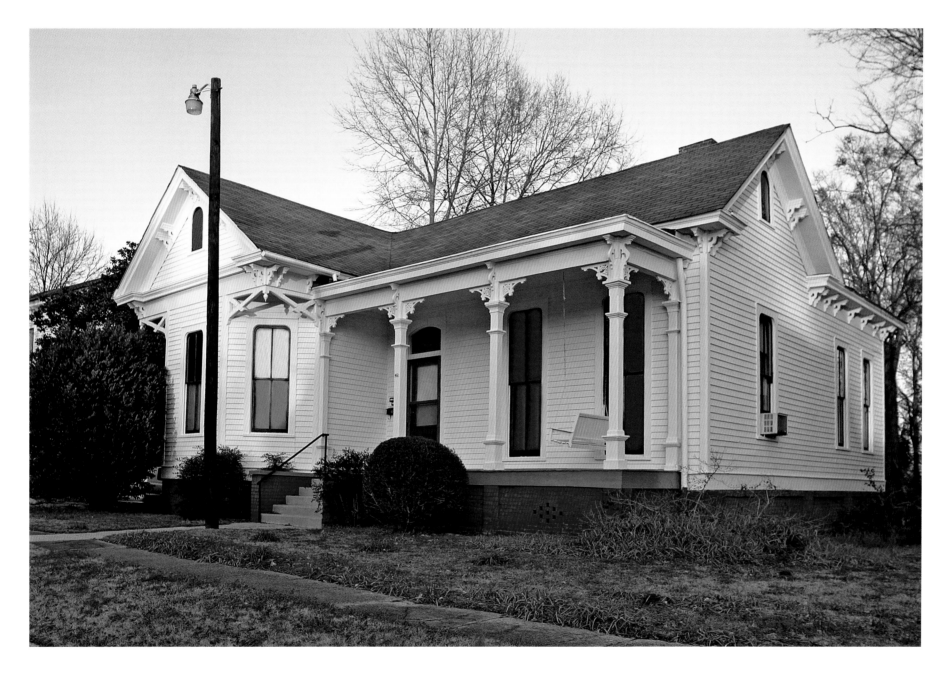

COLUMBUS

This Italianate L-front cottage is located on Seventh Street South.

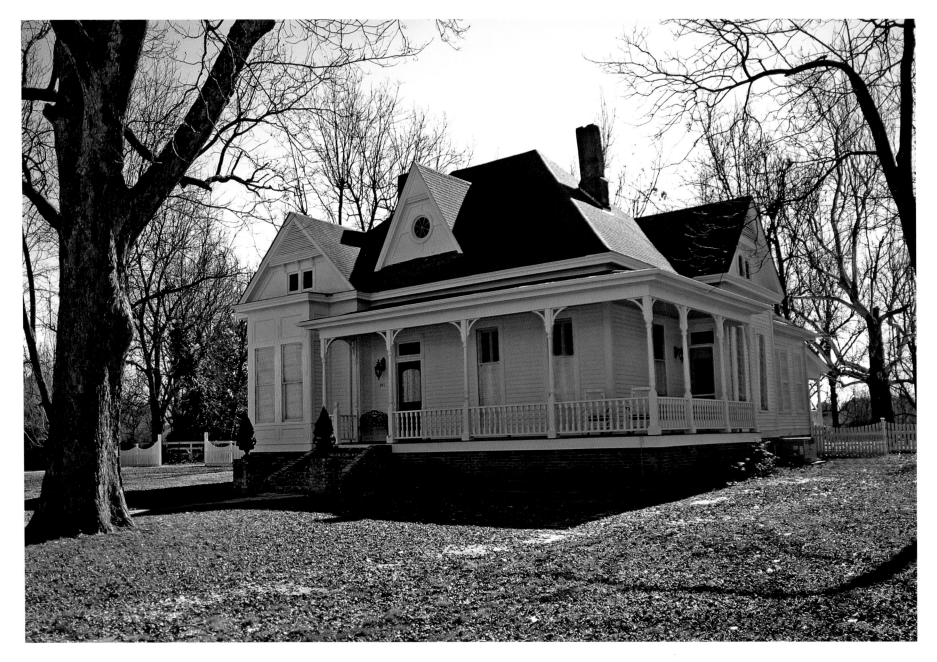

COMO

The Tait-Taylor House (1892) on Oak Avenue is one of many houses in north Mississippi that were
designed and constructed by Andrew Johnson, a talented and prolific builder and architect
who was born and educated in Sweden.

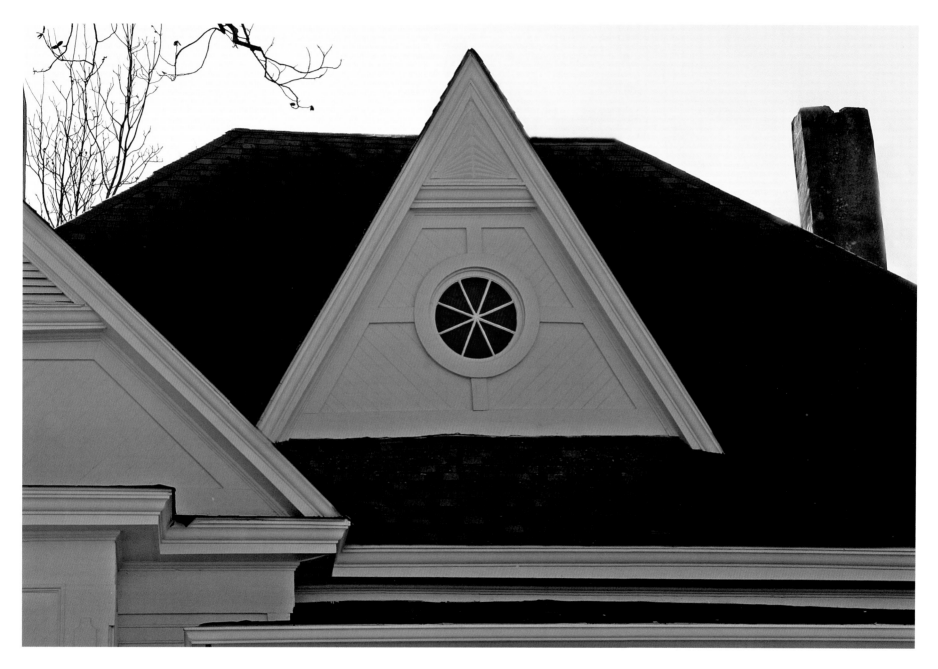

COMO

A round window adorns this small decorative gable (called a "gablet") on the Tait-Taylor House.

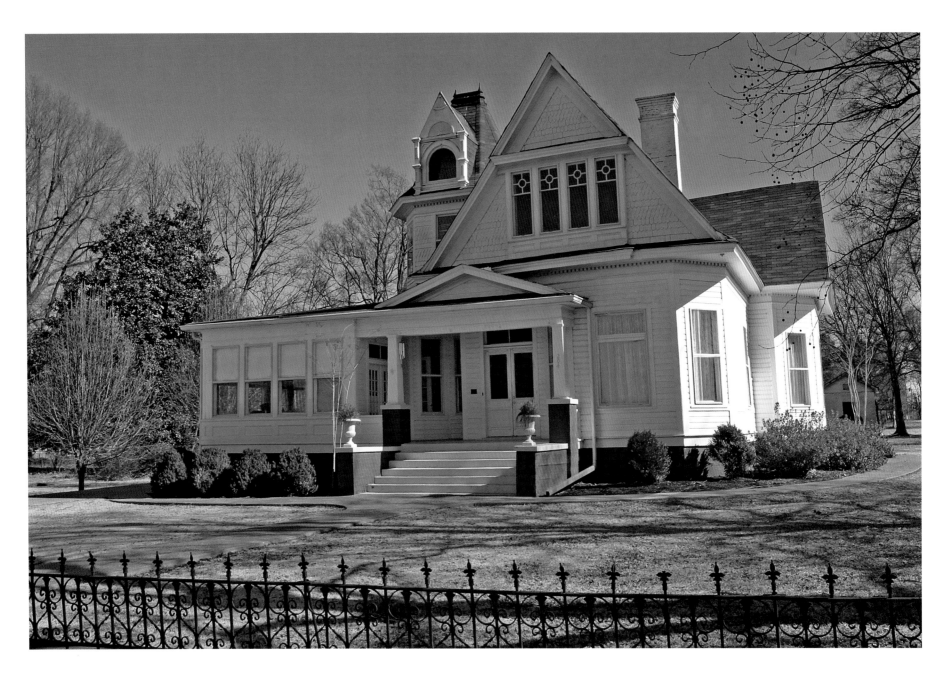

COMO

The dominant feature of the Wardlaw-Swango House, on Sycamore Street, is its tower,
which is more Chateauesque than Queen Anne in style. The tapered Craftsman style columns
on the porch are an early twentieth-century modification.

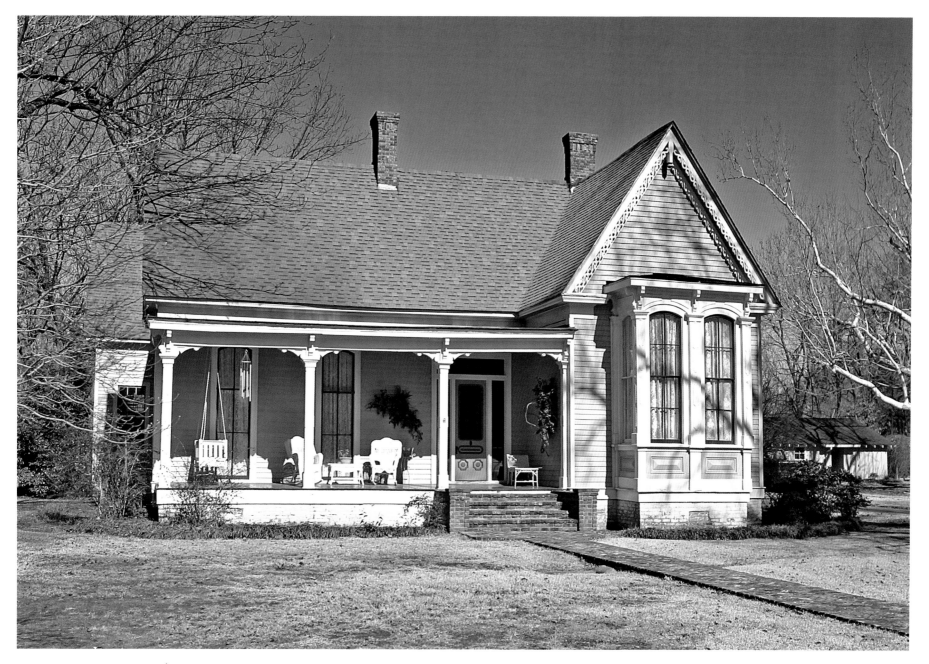

COMO

The Taylor-Falls House on Pointer Avenue, an L-front cottage designed
and built by Andrew Johnson, is largely Italianate in style, but the steep front-facing gable
with decorative vergeboards is a Gothic Revival feature.

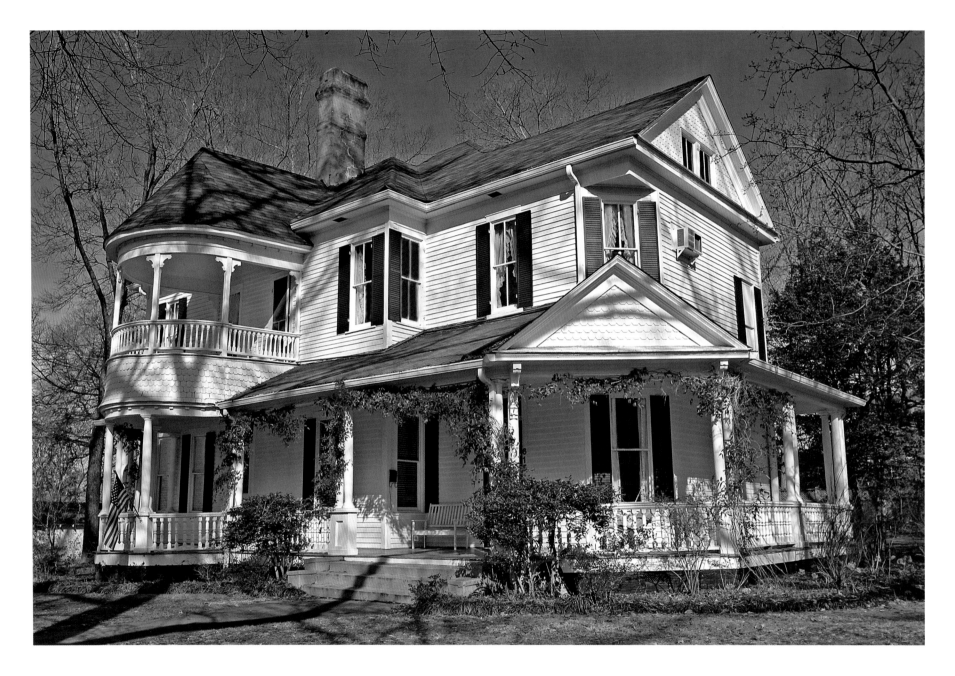

CORINTH

The Jones-Biggers House, a fine Queen Anne house at the corner of Taylor
and Second streets, was built in 1892 for Dr. Paul Tudor Jones.

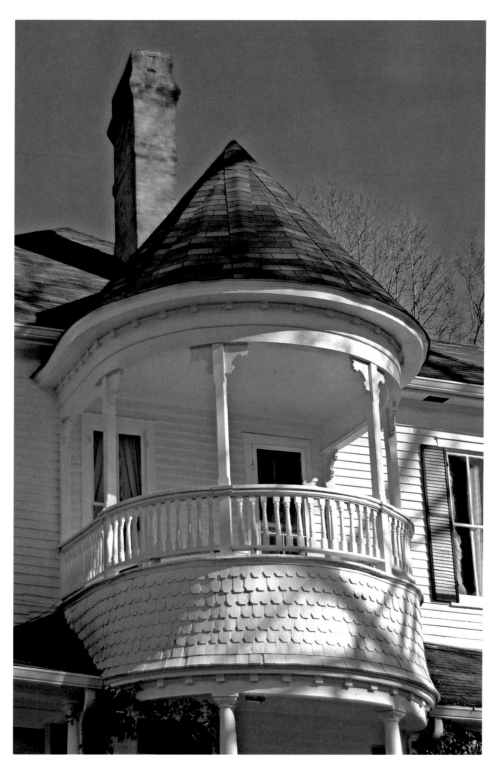

CORINTH

An eye-catching feature of the Jones-Biggers House is
the semicircular upper-story porch.

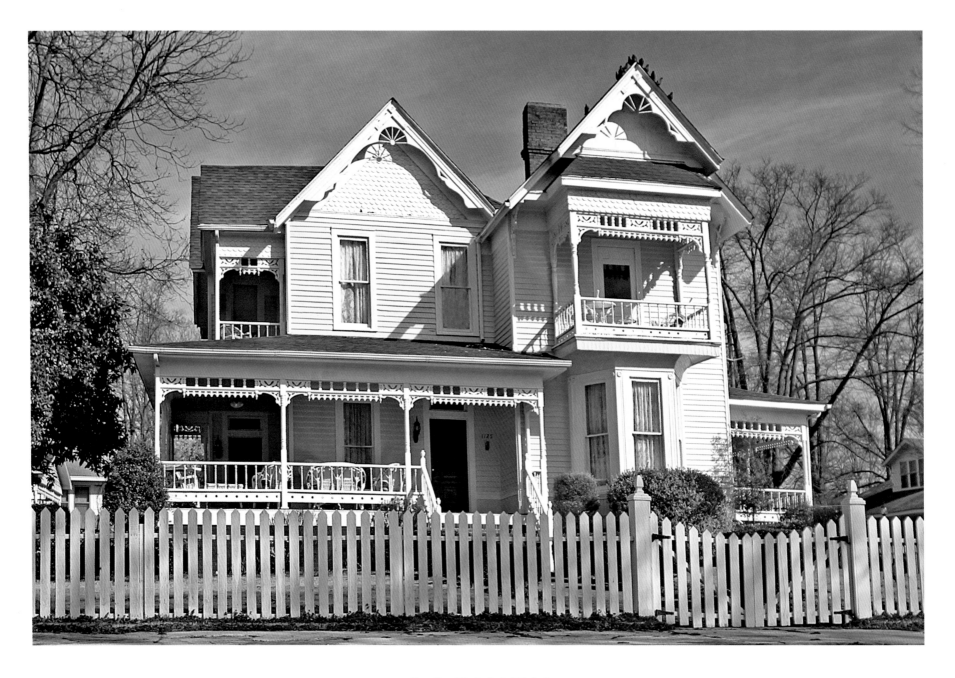

CORINTH

The Samuel D. Bramlitt House (1892) on Cruise Street is another of Corinth's notable Victorian houses.

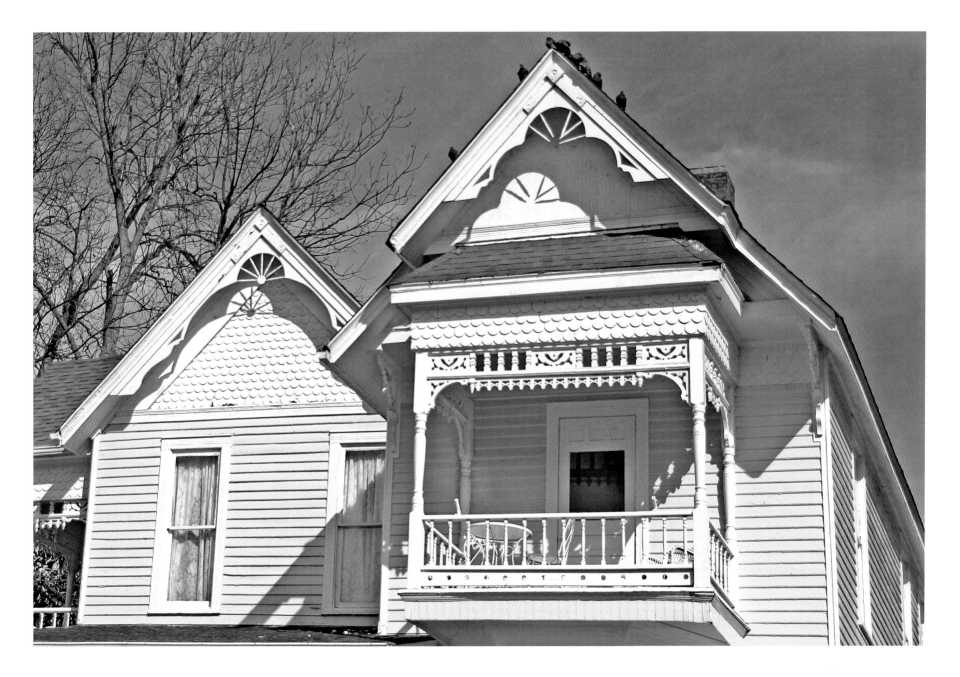

CORINTH

The balcony under the main gable exhibits elaborate millwork.

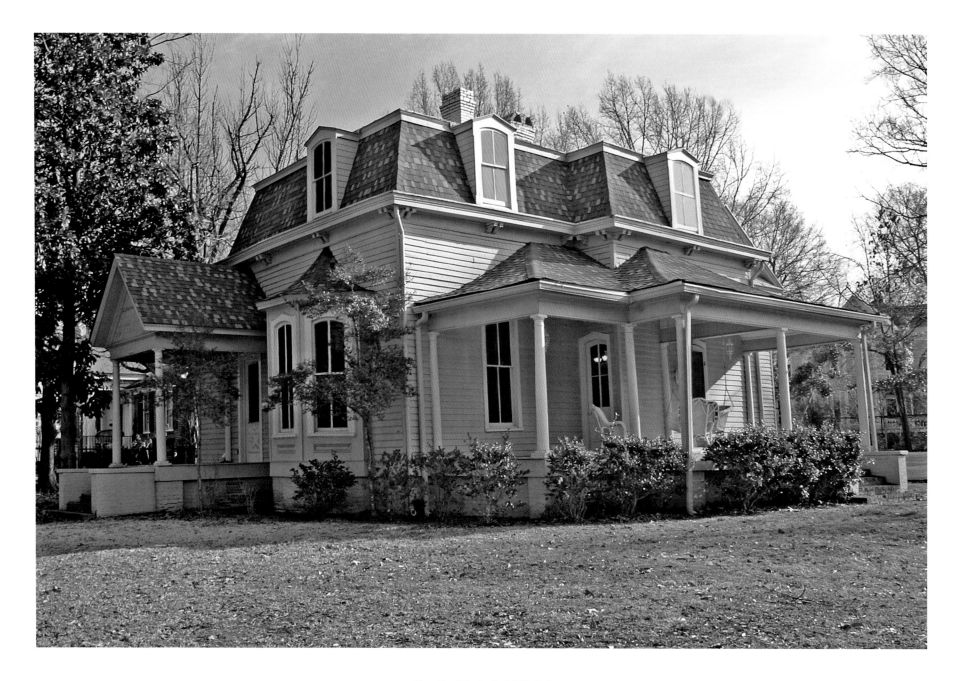

CORINTH

The Boone House on Fillmore Street has the mansard roof that characterizes the Second Empire style.

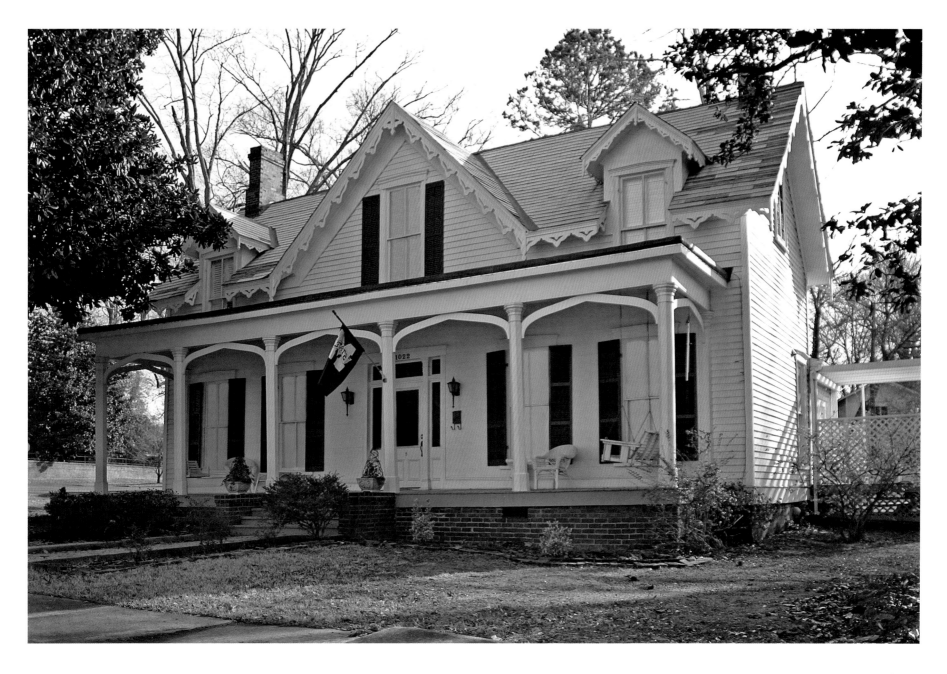

CORINTH

Octagonal columns with Tudor-arched spandrels and jigsawn vergeboards at the eaves impart a Gothic Revival
character to the Taylor-Chandler House (circa 1870–75) on Fillmore Street.

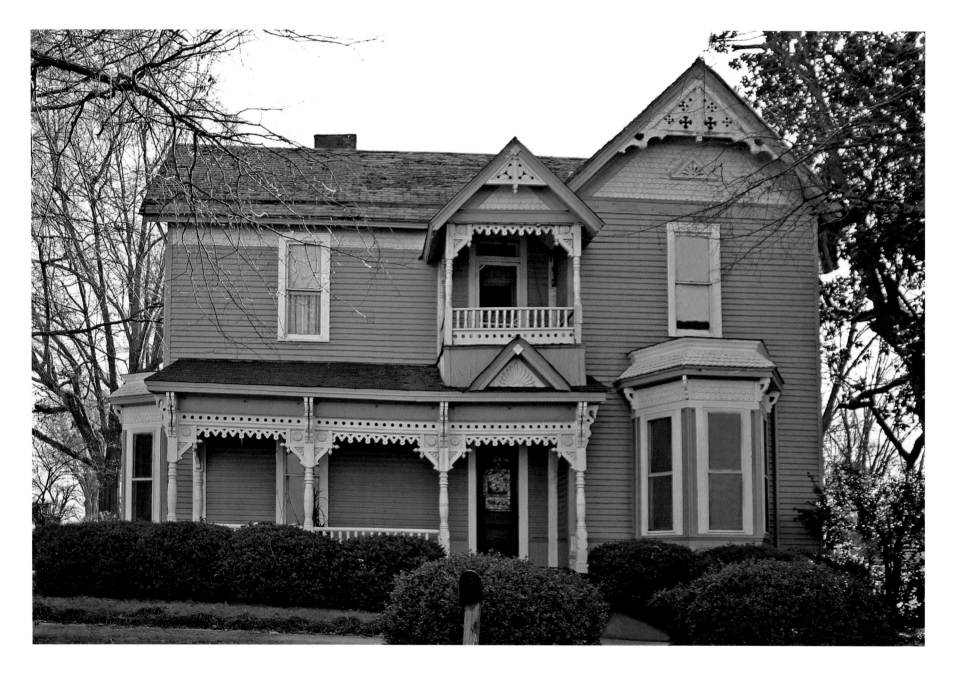

CORINTH

The W. G. Kimmons, Sr., House (Kimmonwych) on Madison Street in Corinth is an L-front house
with Eastlake detailing on the porch, balcony, and gables.

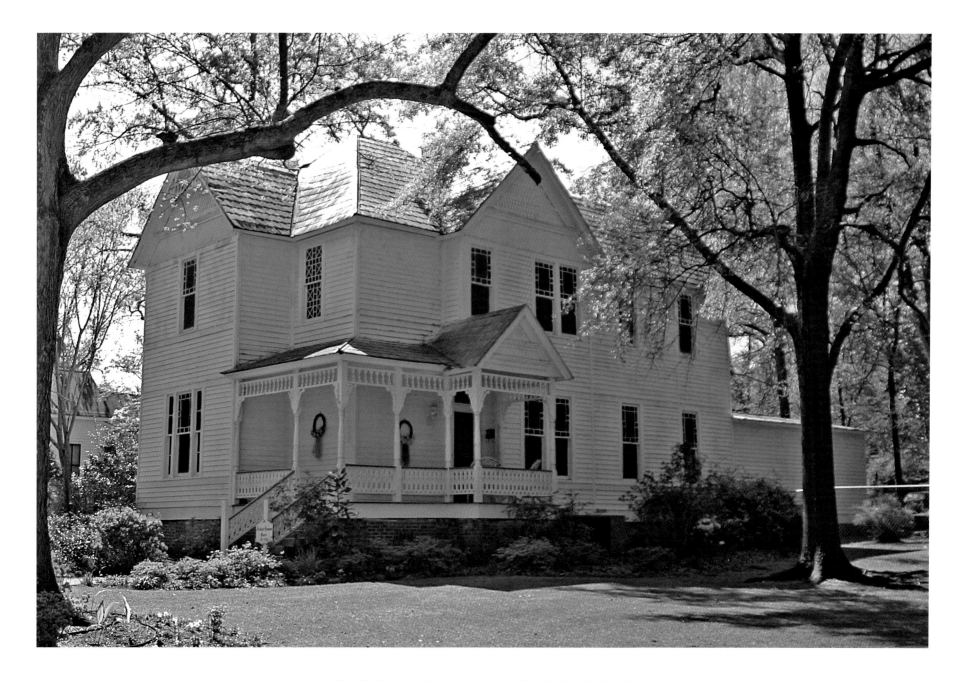

CRYSTAL SPRINGS

The Jenkins-Dawson House on East Georgetown Street illustrates the rectilinear mode of the Queen Anne style.

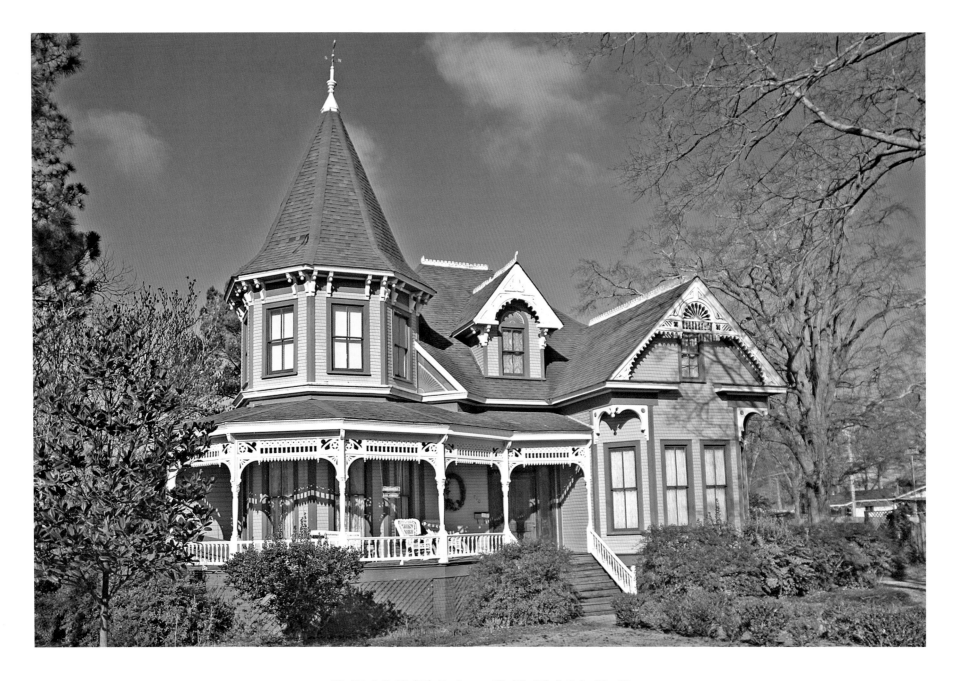

CRYSTAL SPRINGS

The George W. Copley House (1886) on Copley Street in Crystal Springs is an
ornate example of the Queen Anne style.

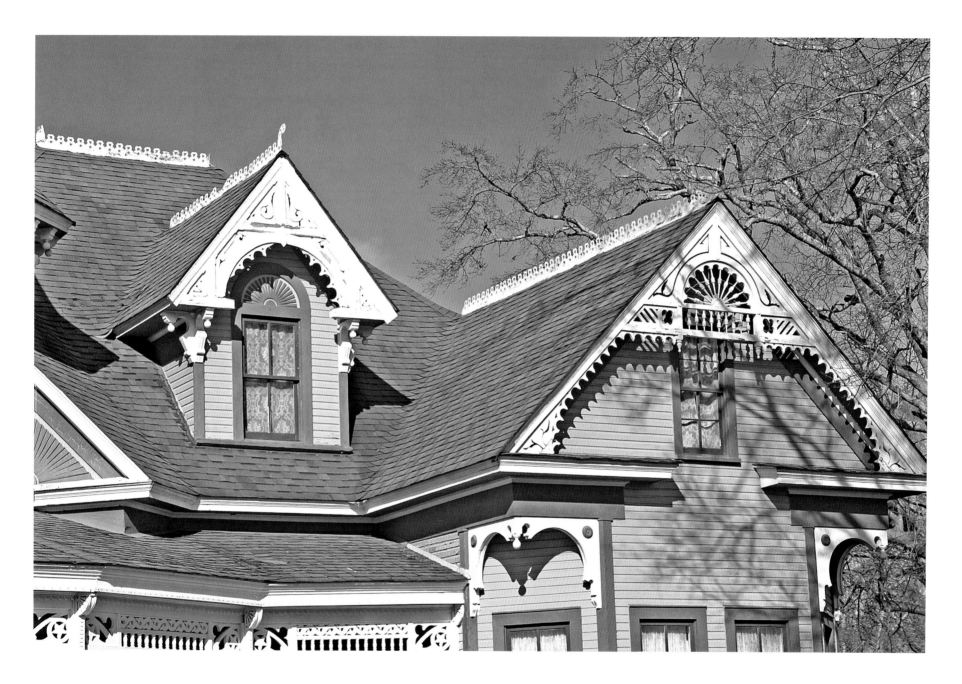

CRYSTAL SPRINGS

The Copley House has elaborately ornamented gables and metal cresting on the roof ridges.

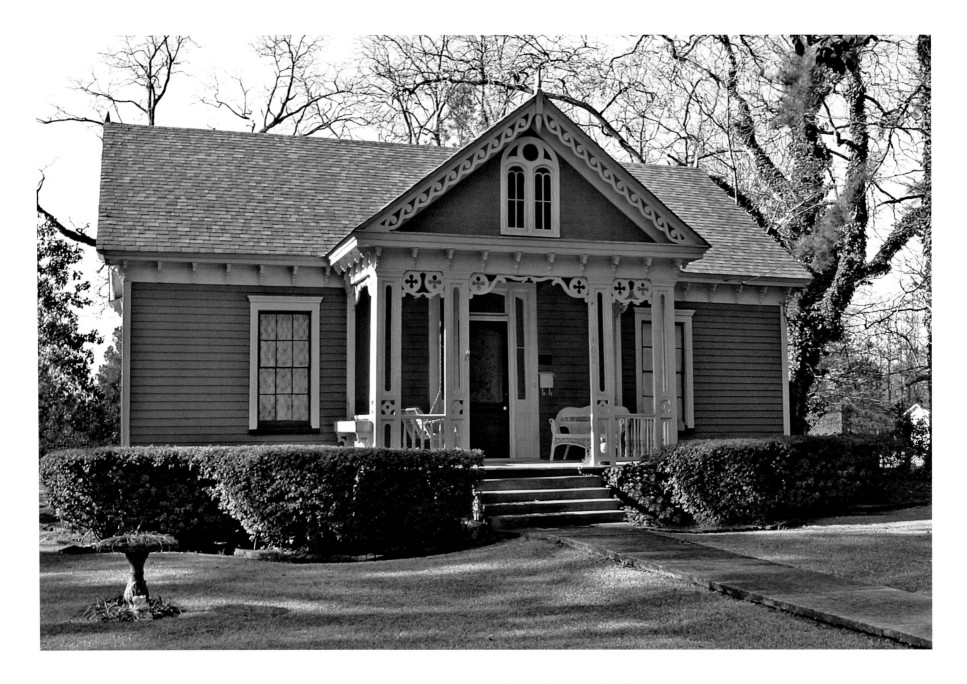

CRYSTAL SPRINGS

Dogwood Place (1871) on West Marion Street is a picturesque cottage with Italianate and Gothic Revival features.

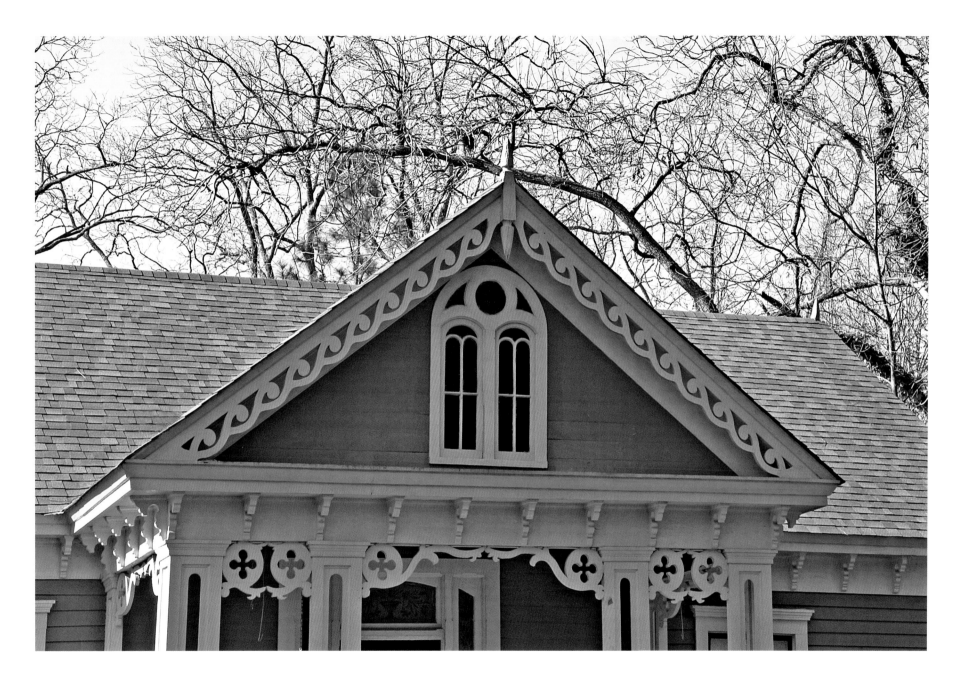

CRYSTAL SPRINGS

The front gable of Dogwood Place contains a round-arched Italianate window.

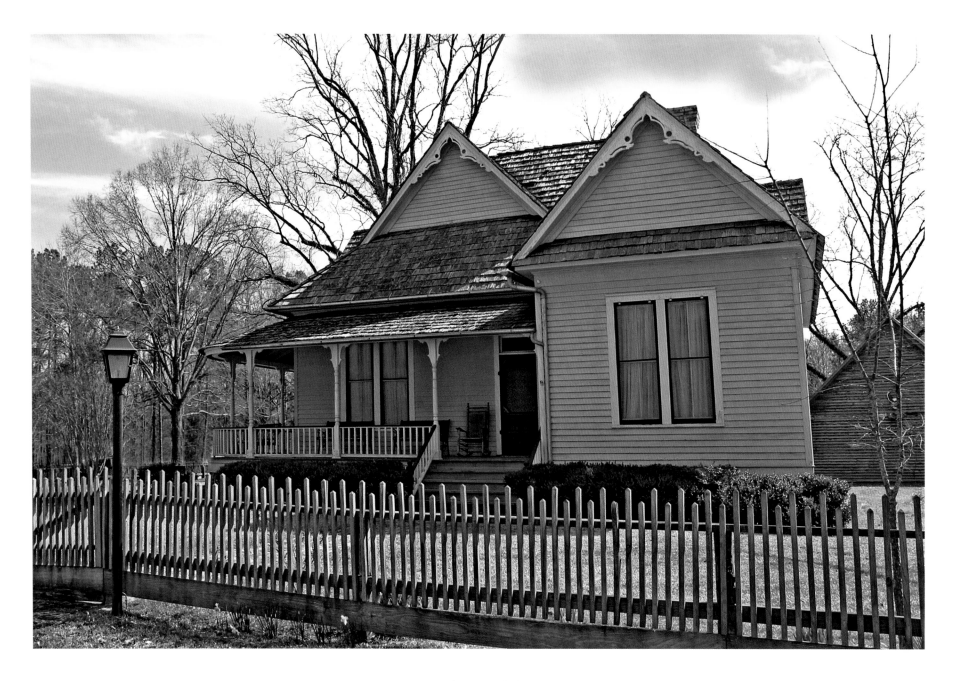

DESOTO

The C. V. Akin House is a well-preserved Queen Anne cottage in the small community of DeSoto in Clarke County.

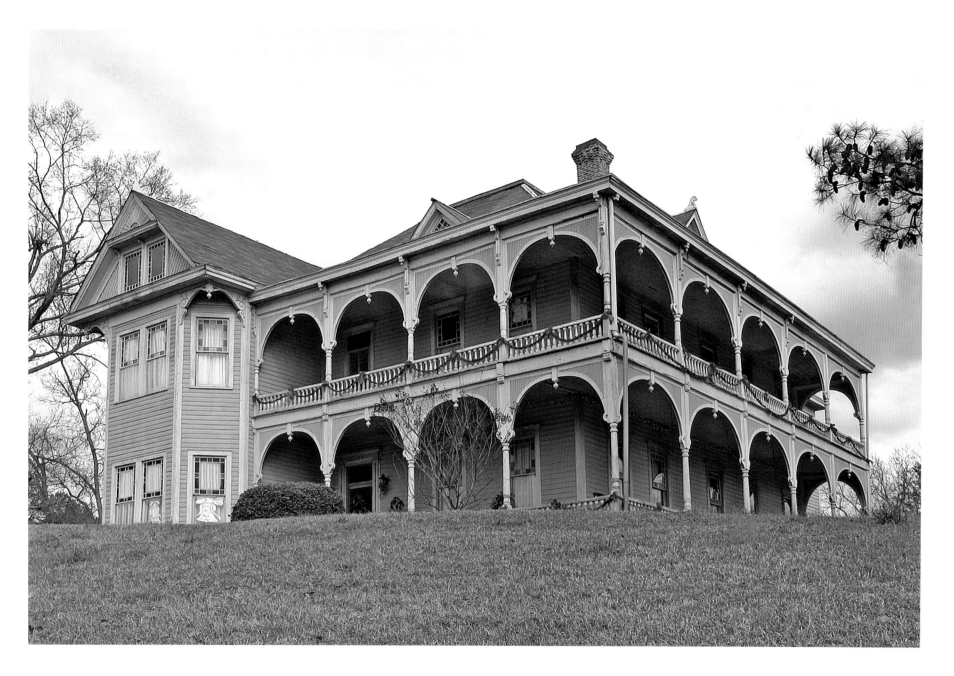

EDWARDS

An arcaded double-tiered veranda adorns the A. J. Lewis House, at the corner
of South Magnolia and Lewis streets in Edwards.

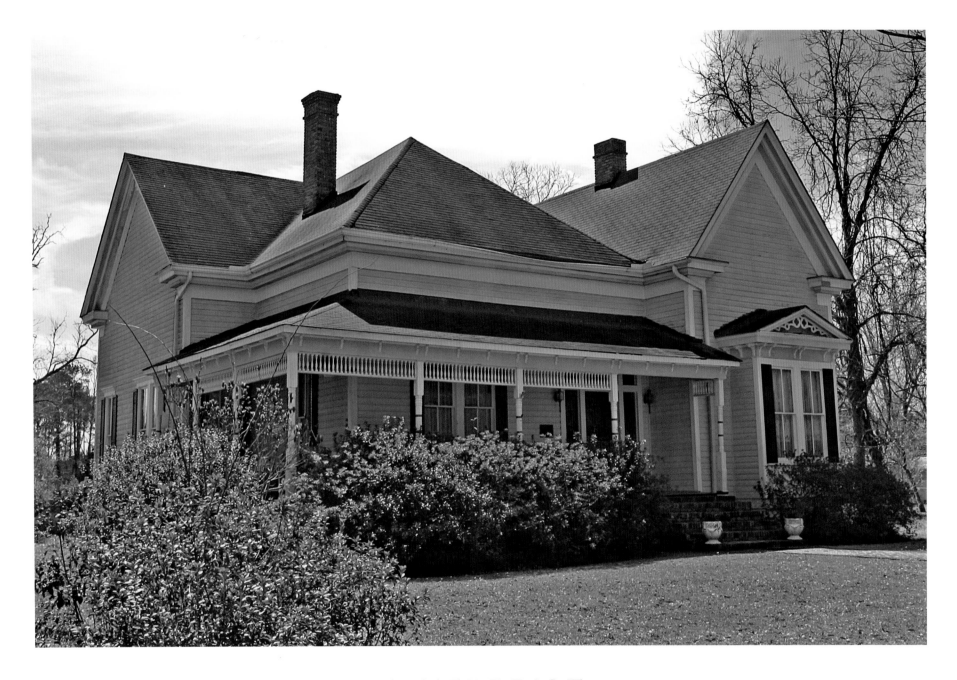

ENTERPRISE

The Noah Moore House on Main Street in Enterprise was built about 1895.

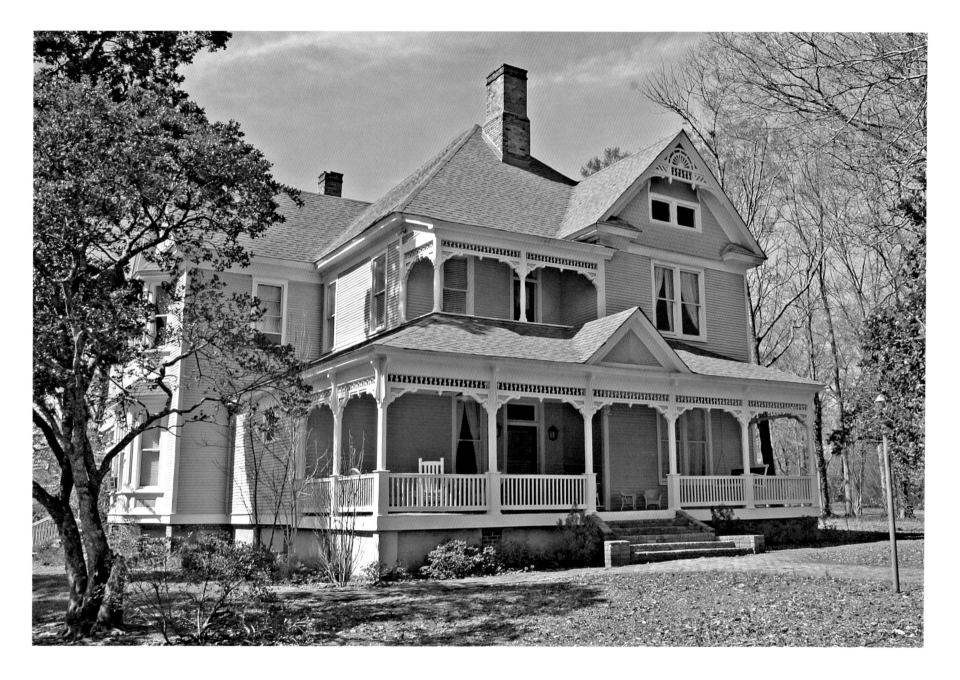

FERNWOOD

The Phillip Henry Enochs House (Fernwood House) is a fine Queen Anne residence
located in Fernwood in Pike County.

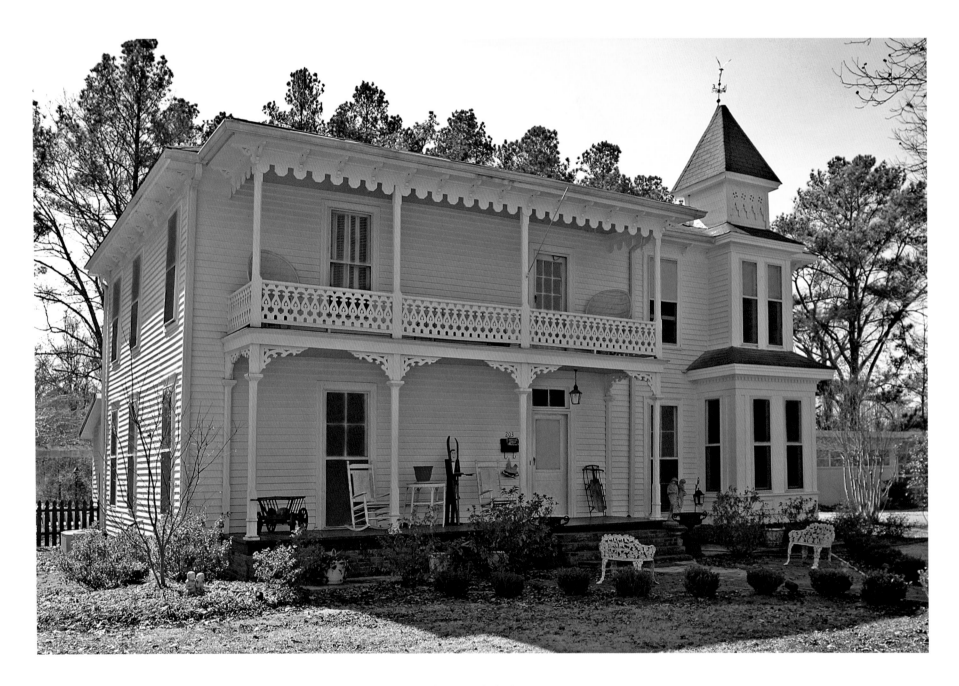

FULTON

The Baldridge-Orr House on East Owens Street in Fulton is an antebellum house that
was remodeled in an eclectic Late Victorian manner in 1887.

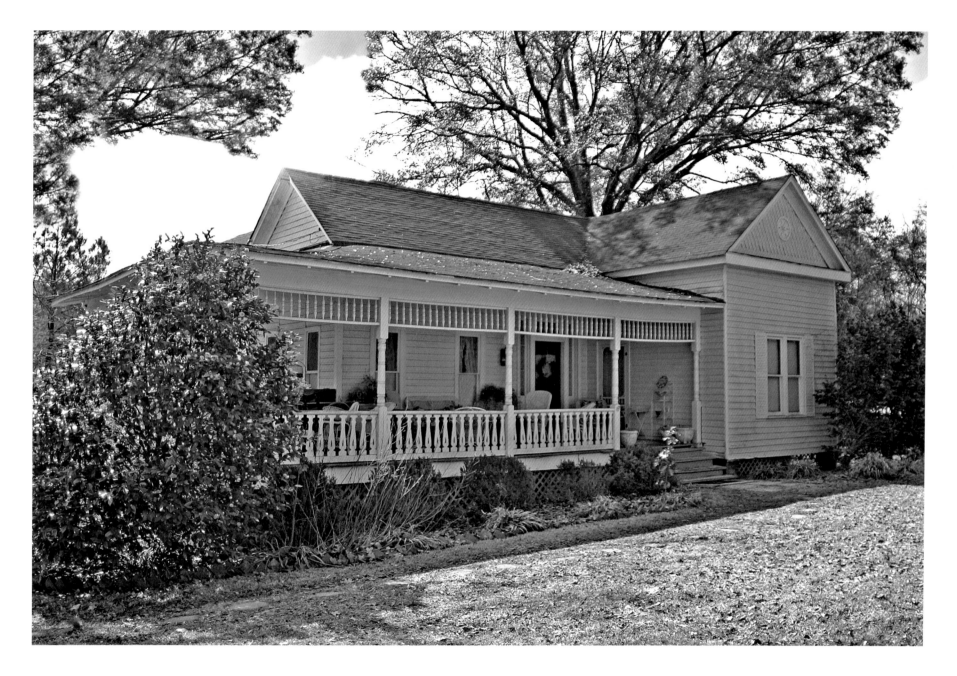

GALLMAN

The tiny community of Gallman in Copiah County contains several well-preserved Late Victorian houses, including
the J. E. Lilly House, an L-front cottage that was built about 1896.

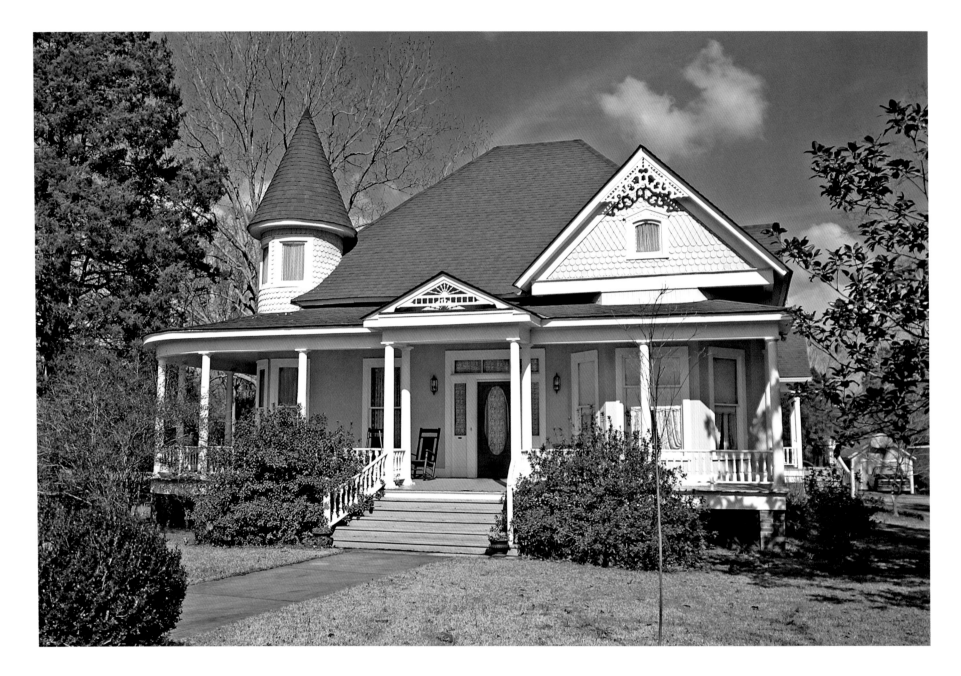

GALLMAN

The W. W. Alford House (Mulgrove) is a Queen Anne cottage with free classical columns on its veranda.

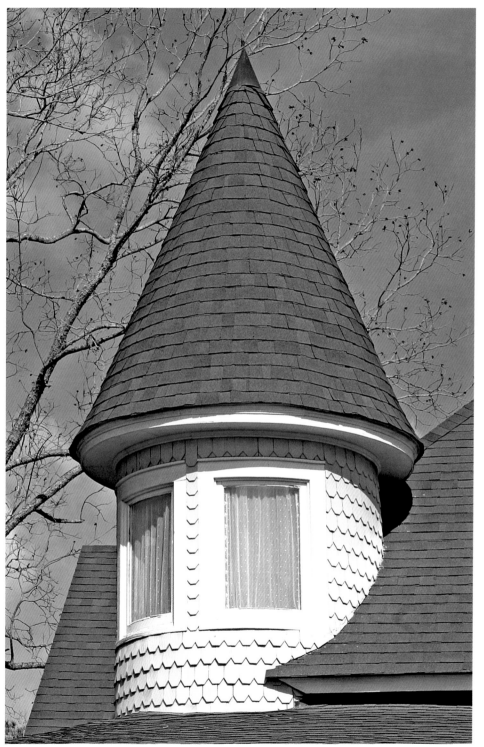

GALLMAN

The round turret of the Alford House is clad in wooden
shingles affixed in a "fish-scale" pattern.

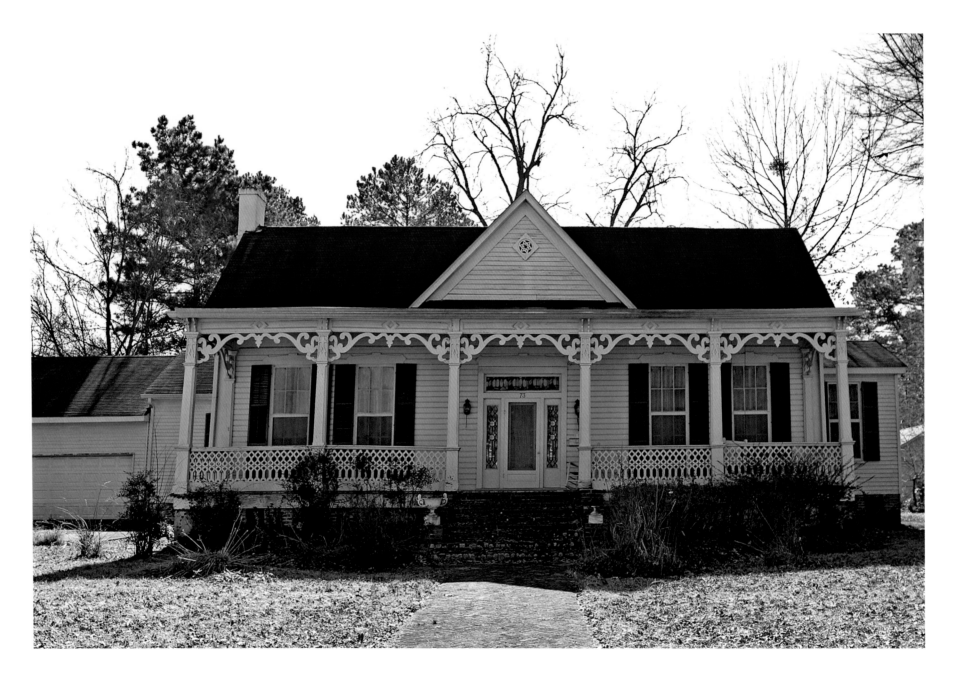

GRENADA

The Senator Edward Cary Walthall House in Grenada was built in 1856, but was remodeled
after it was acquired by Walthall in 1871.

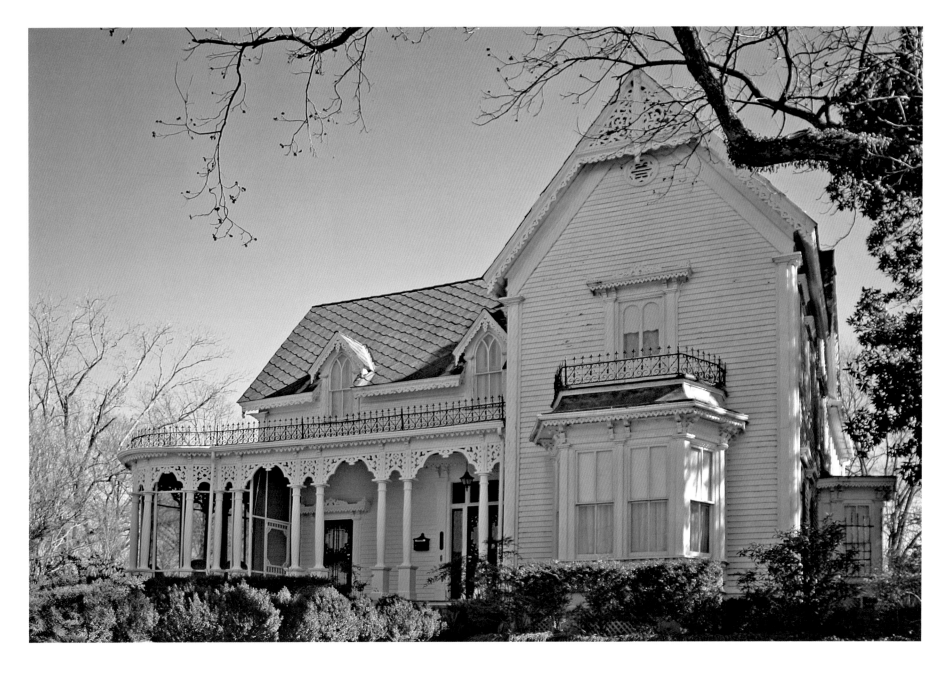

GRENADA

The Lake-Crowder House on South Main Street is an L-front house with Gothic Revival features.

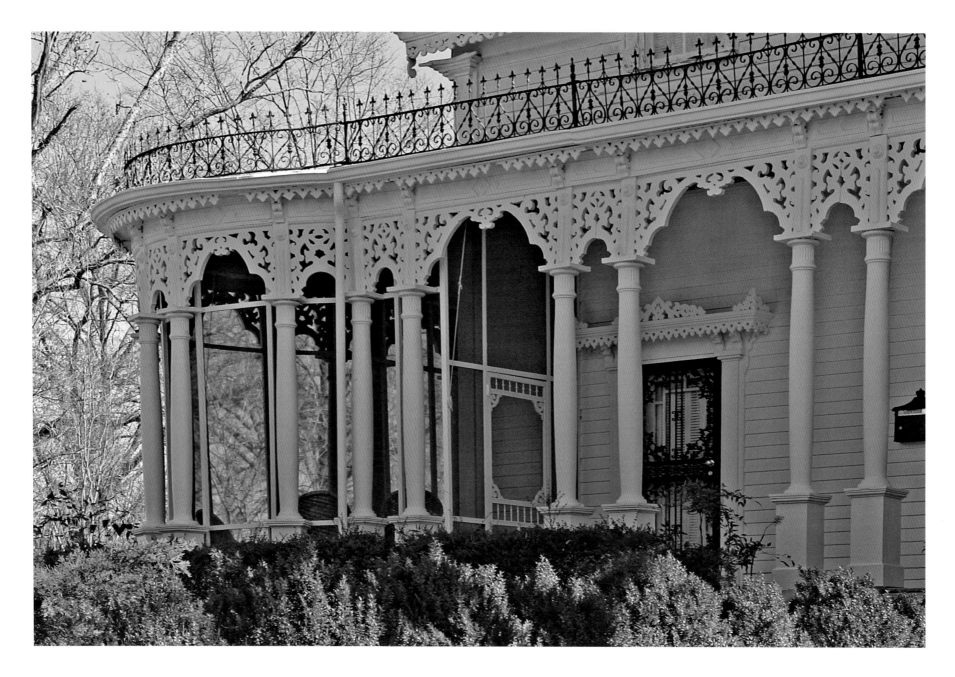

GRENADA

The spandrel ornamentation on the veranda of the Lake-Crowder House has a complex filigree pattern.

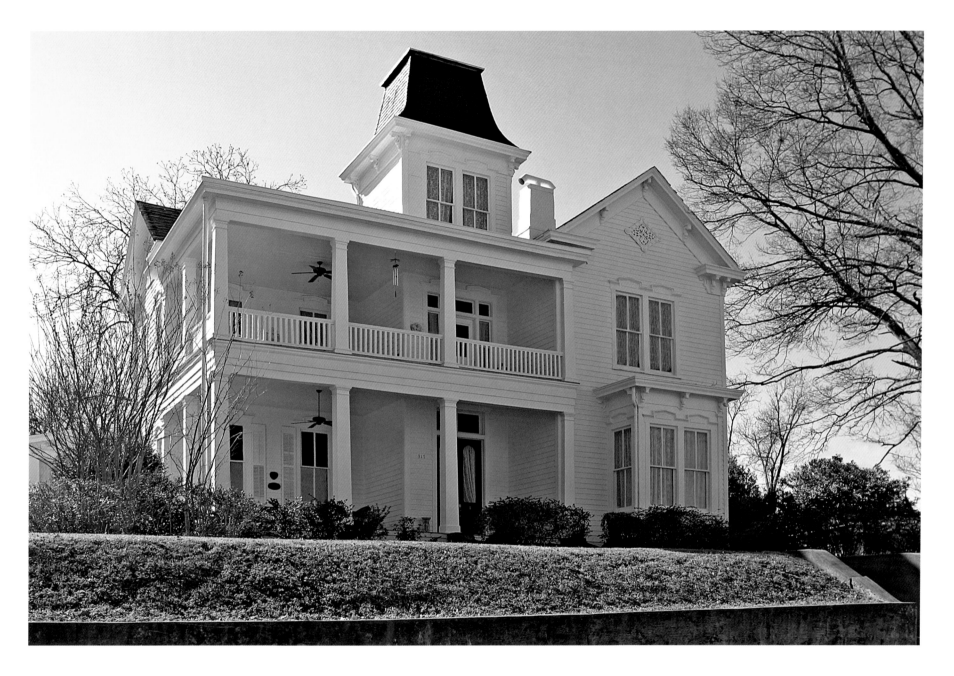

GRENADA

The Lee-Dubard House on Third Street in Grenada has a mansard-roofed square tower.

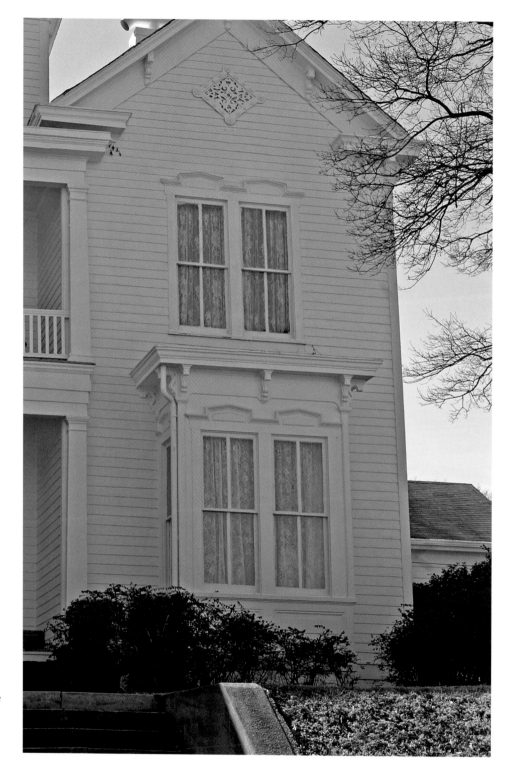

GRENADA

Below the front-facing gable of the Lee-Dubard House
is a rectangular projecting window bay.

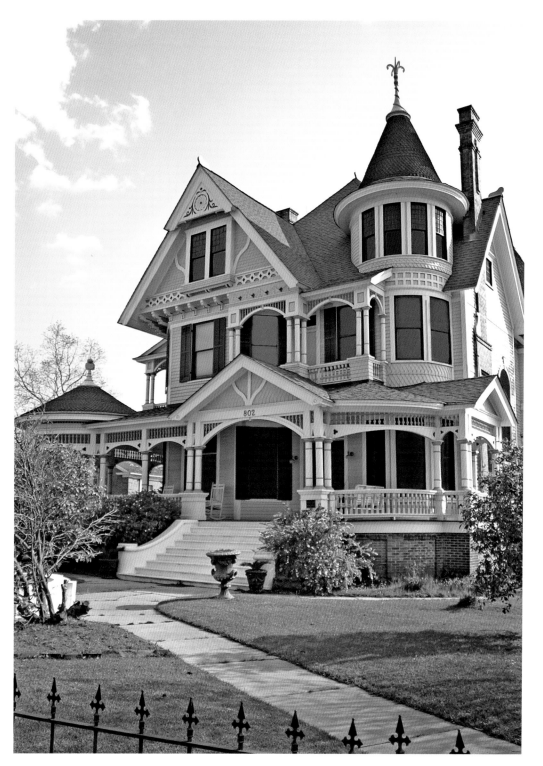

HATTIESBURG

The John A. McLeod House (1897) on Main Street
in Hattiesburg is one of the finest examples
of Victorian Queen Anne residential architecture in
Mississippi. It was designed by George F. Barber
of Chattanooga, Tennessee.

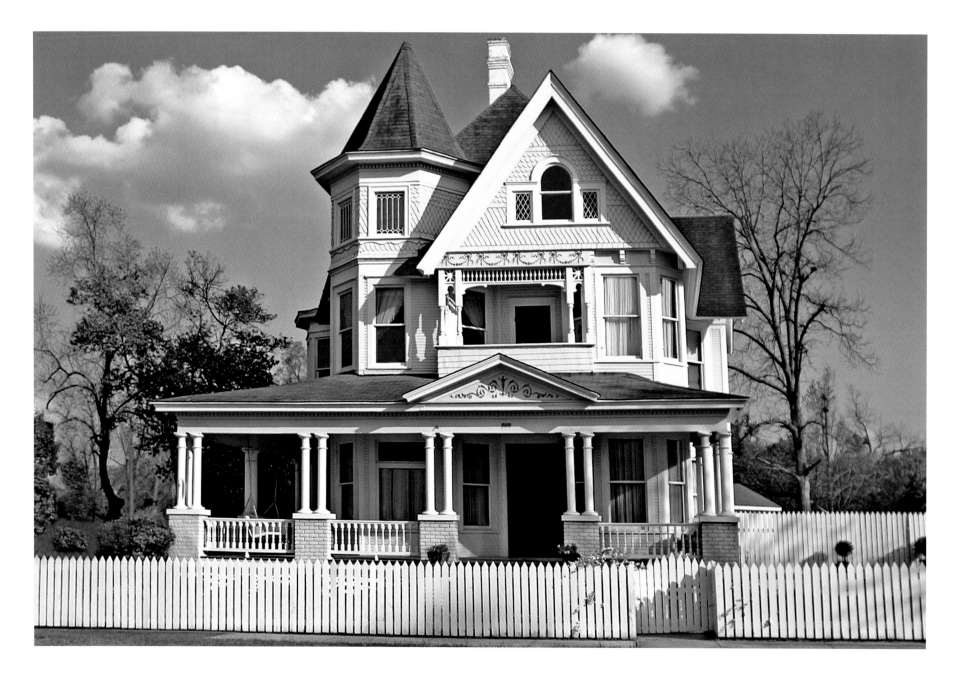

HATTIESBURG

The Dunn House on Short Bay Street is a noteworthy example of the free classical mode of the Queen Anne style.

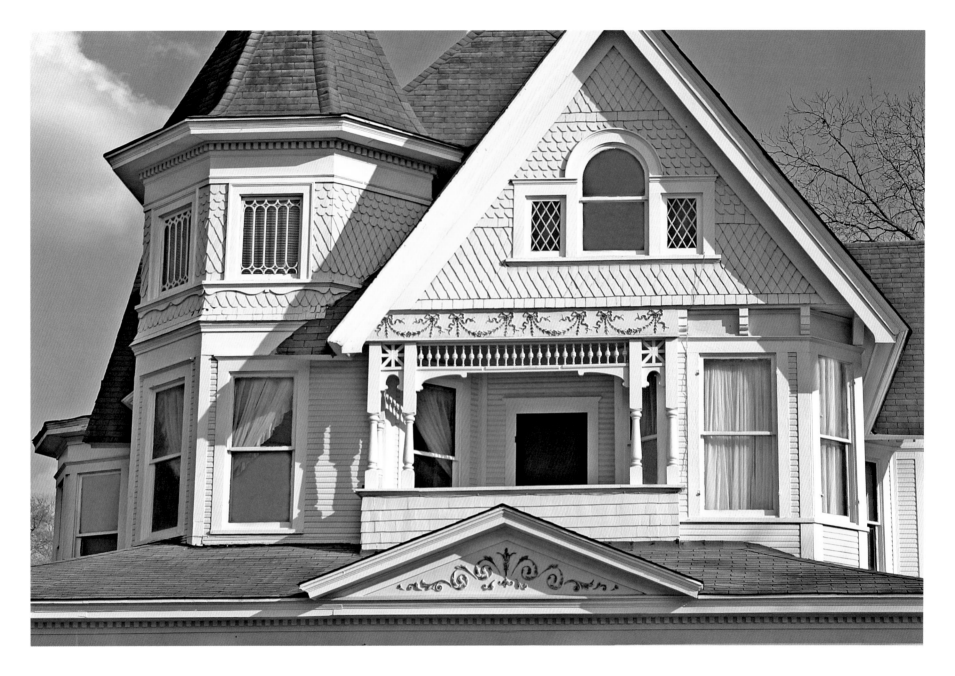

HATTIESBURG

Ornate and varied patterns of imbricated shingle siding decorate the tower and the front gable
of the Dunn House. In the gable is a Palladian window.

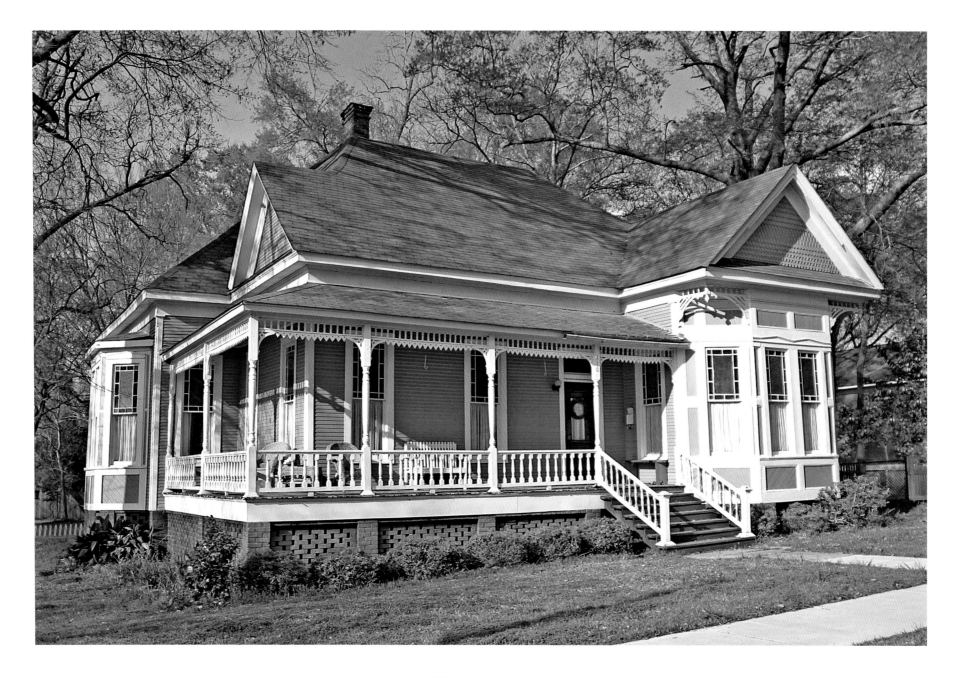

HATTIESBURG

This well-preserved Queen Anne cottage is located on Southern Avenue in Hattiesburg.
The upper sashes of its windows have colored glass borders.

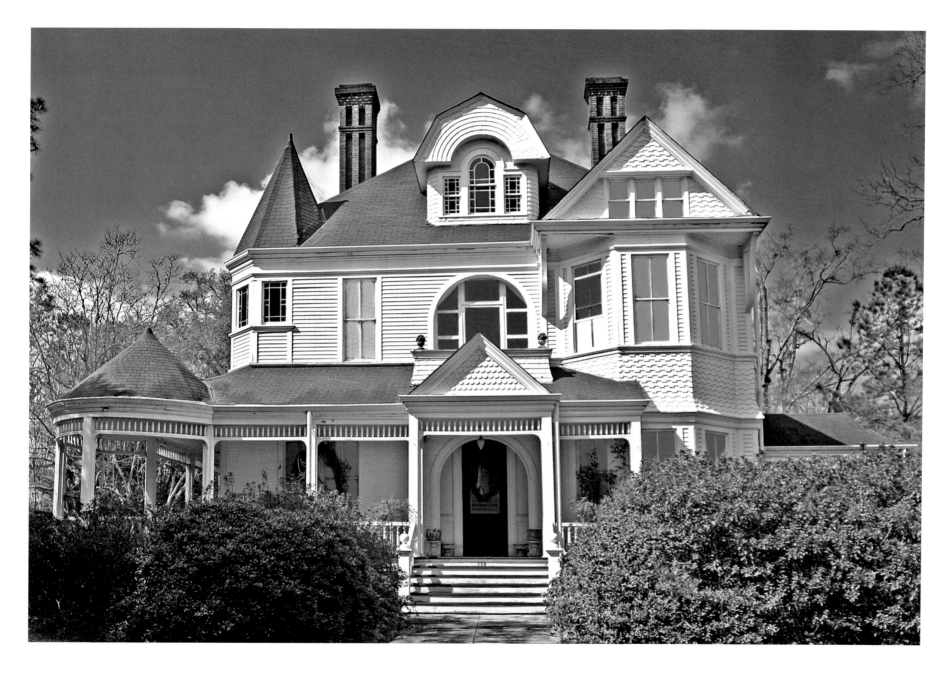

HAZLEHURST

The architect of the I. N. Ellis House (1890) on South Extension Street was George F. Barber.

HERNANDO VICINITY

Robust millwork trims the front gable of the Dockery House.

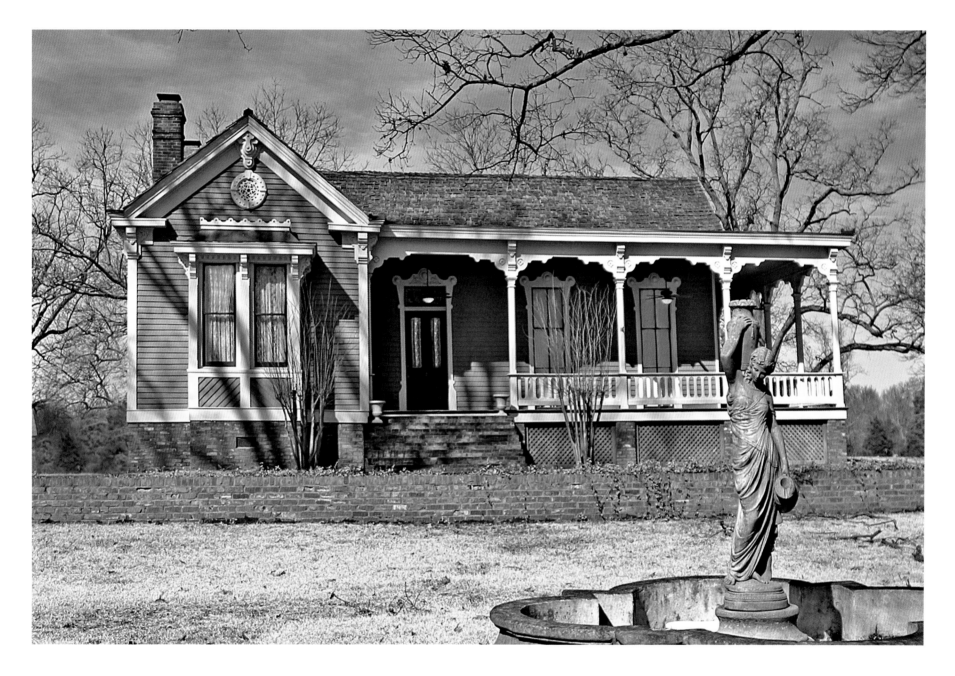

HERNANDO VICINITY

The Dockery House, located on Robertson Gin Road southwest of Hernando,
is an L-front cottage with Italianate features.

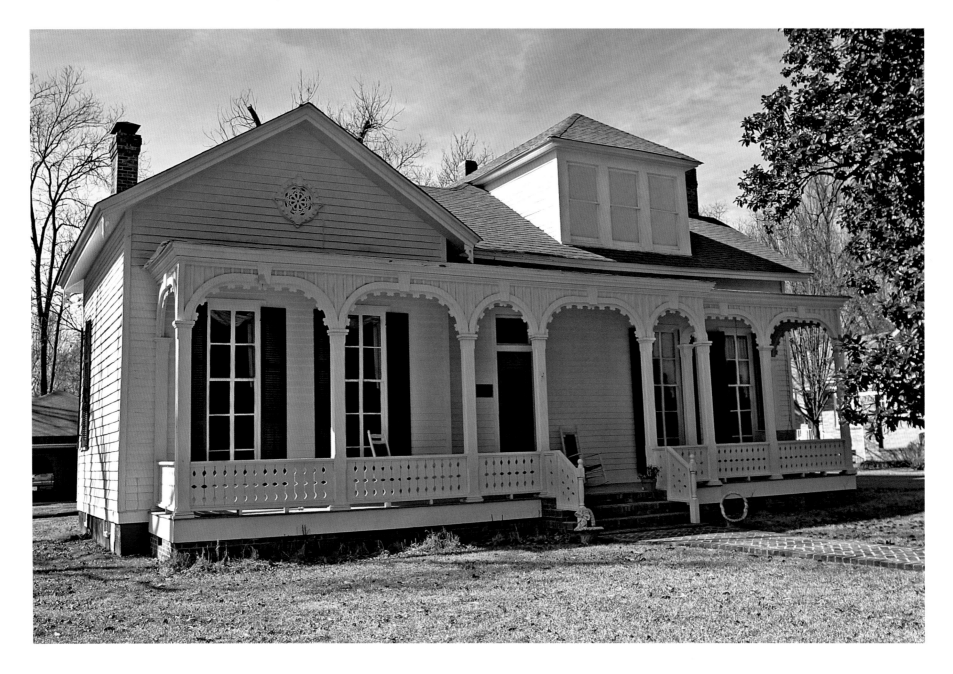

HERNANDO

The Felix Lebauve House on Magnolia Drive in Hernando is a well-preserved Victorian cottage.

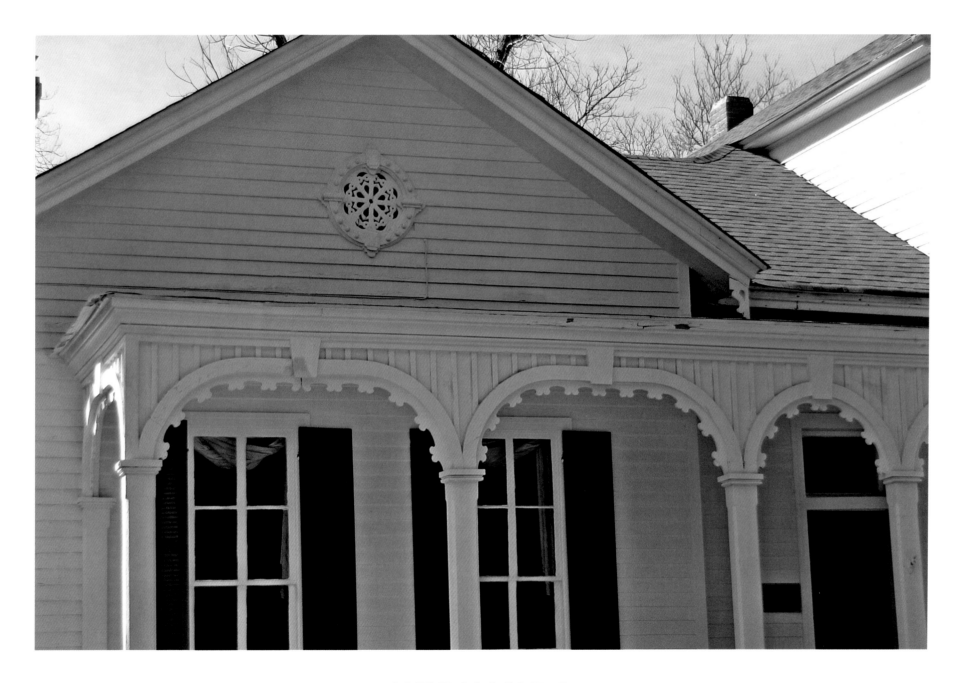

HERNANDO

The Lebauve House features distinctive porch detailing and a lacy gable ventilator.

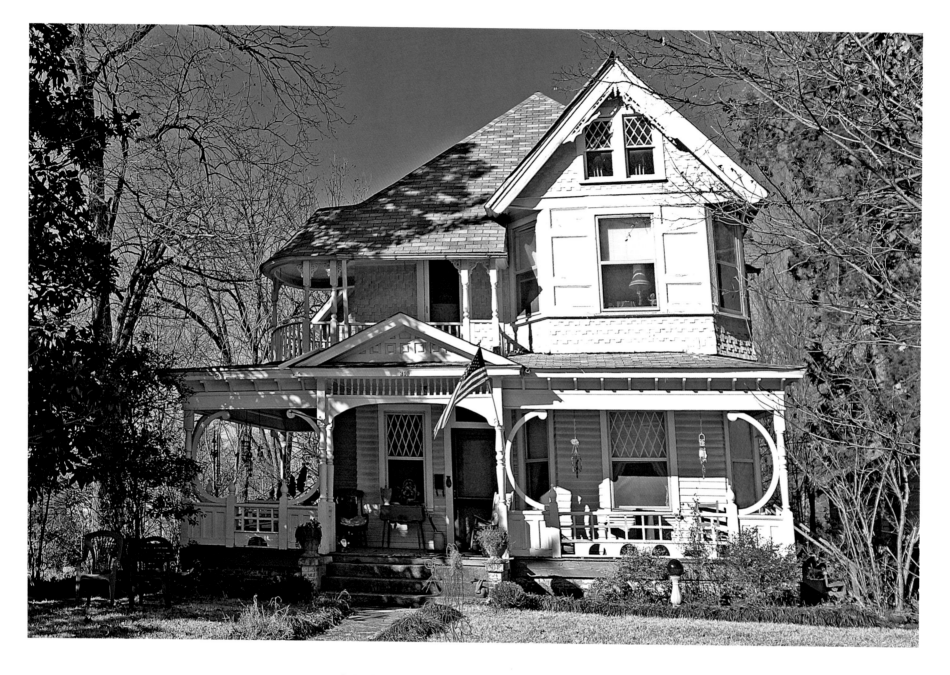

HOLLY SPRINGS

The Judge L. A. Smith House (1906) on Salem Avenue was built according
to a design published by George F. Barber.

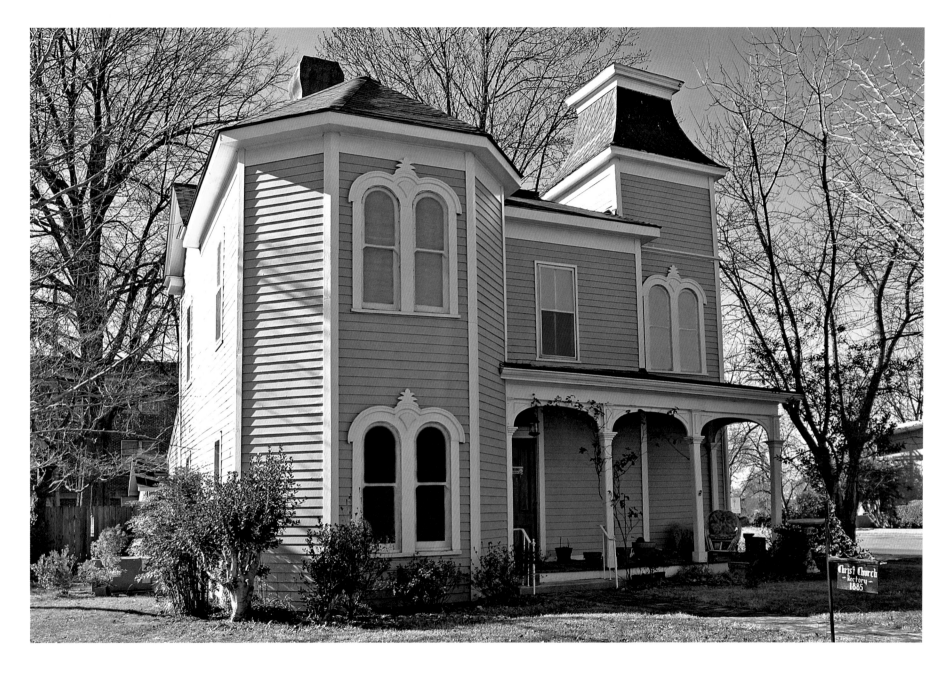

HOLLY SPRINGS

The Christ Church Rectory (1885) on South Randolph Street has a mansard-roofed tower.

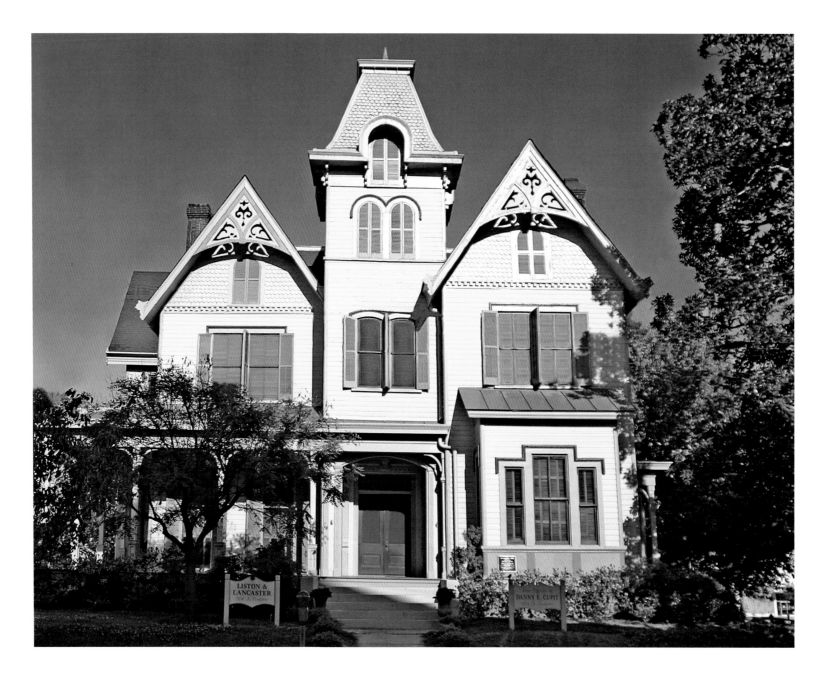

JACKSON

The Bishop Charles B. Galloway House (1889) in Jackson, designed and built by local builder W. J. McGee, combines Second Empire, Eastlake, Queen Anne, and Gothic Revival features into a cohesive design.

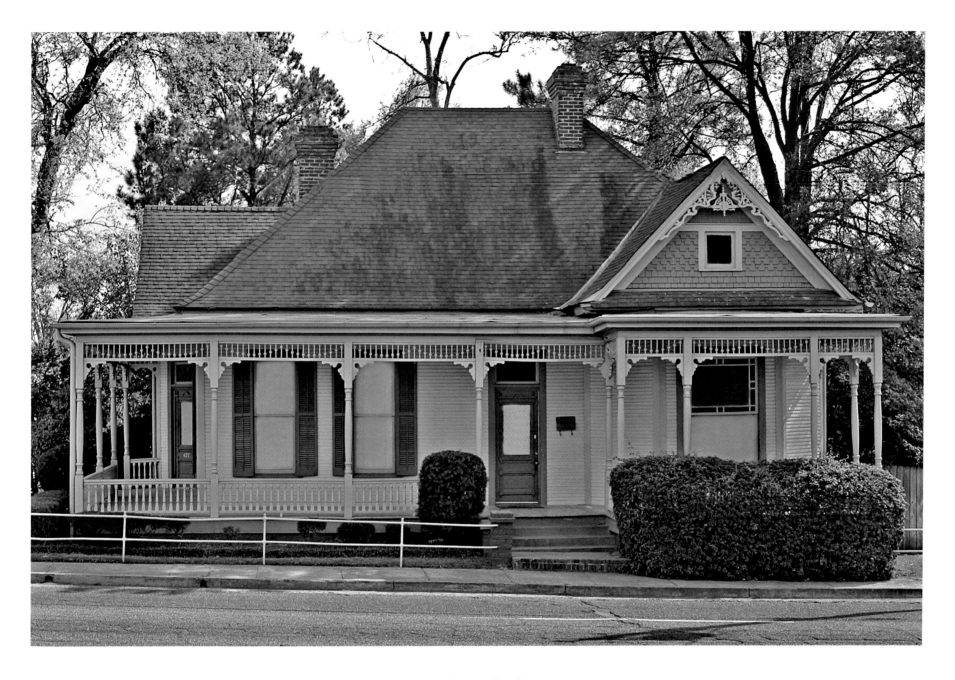

JACKSON

The Galloway-Williams House on East Fortification Street is a fine example of a Queen Anne
cottage with spindlework ornamentation.

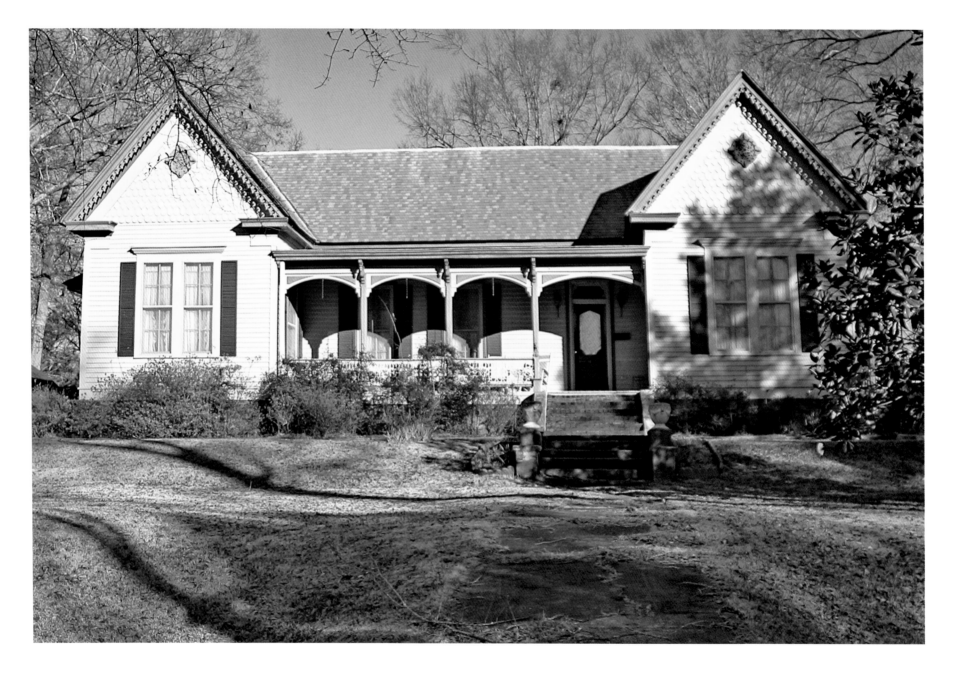

KOSCIUSKO

The Colonel Chap Anderson House (1886) on North Jackson Street was designed by Andrew Johnson, who built
many fine Late Victorian houses in north-central Mississippi.

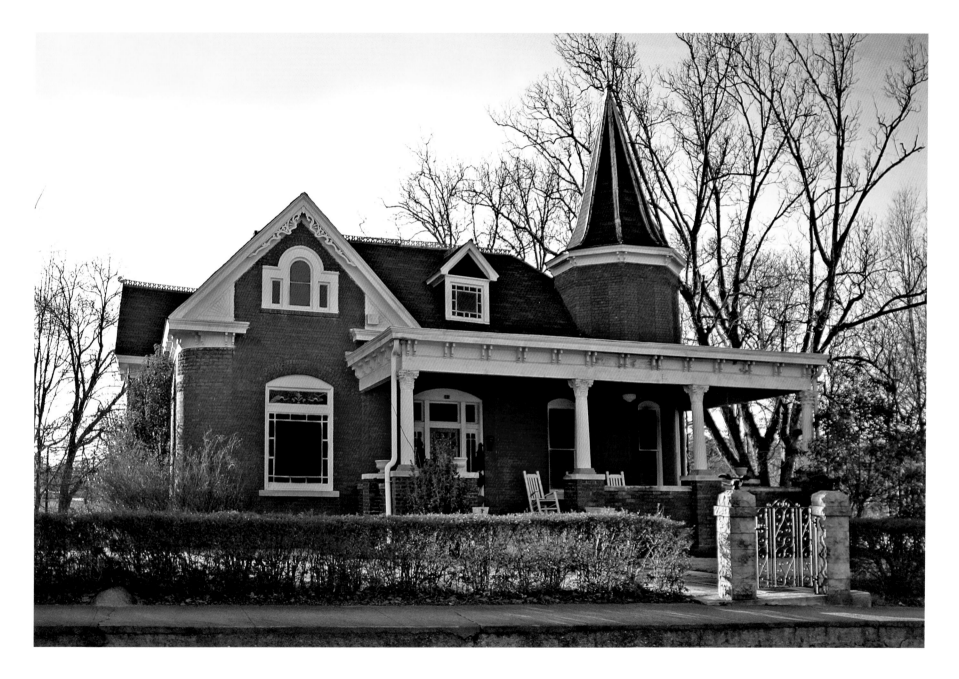

KOSCIUSKO

The Thompson-Peeler House (1898) on North Wells Street is a fine one-story Queen Anne house of brick construction. It was built by Lindamood & Puckett, contractors and brickmakers, of Columbus, Mississippi.

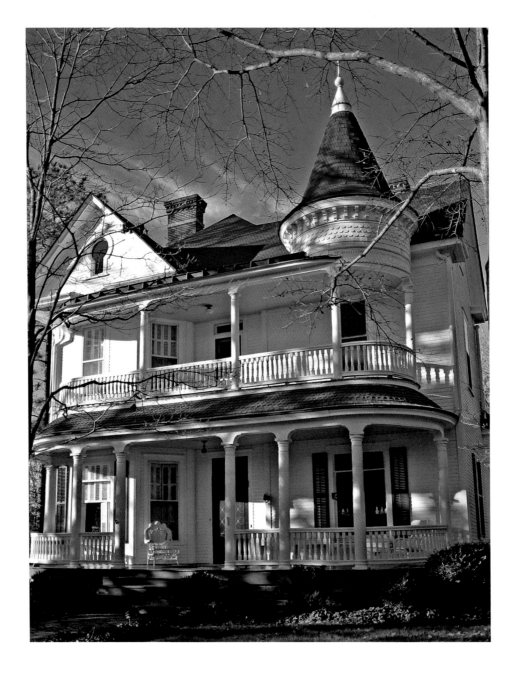

KOSCIUSKO

Free classical colonnades distinguish the David L. Brown House (1900) on East Washington Street.

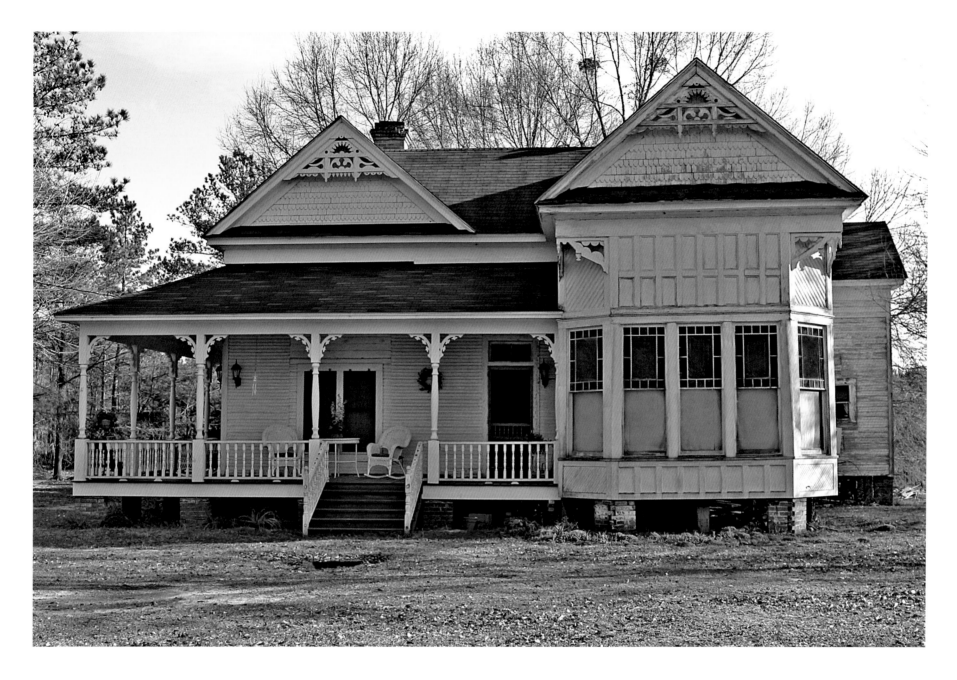

LAUREL VICINITY

This ornate Queen Anne cottage is located at Gitano in a rural area
of Jones County, northwest of Laurel.

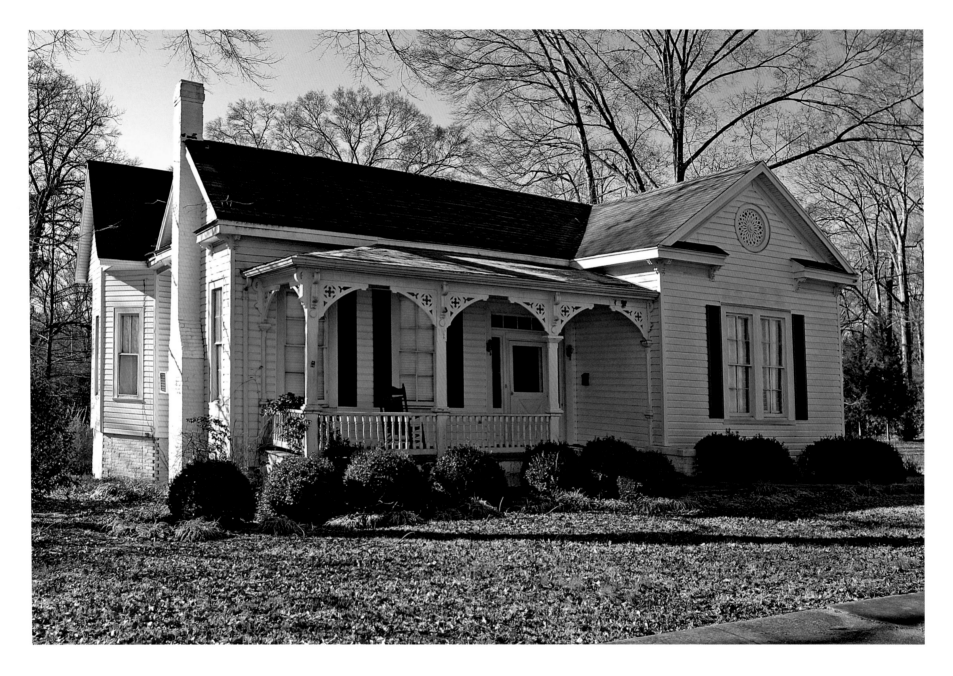

LEXINGTON

This well-preserved L-front cottage on Boulevard Street in Lexington was built in 1893.

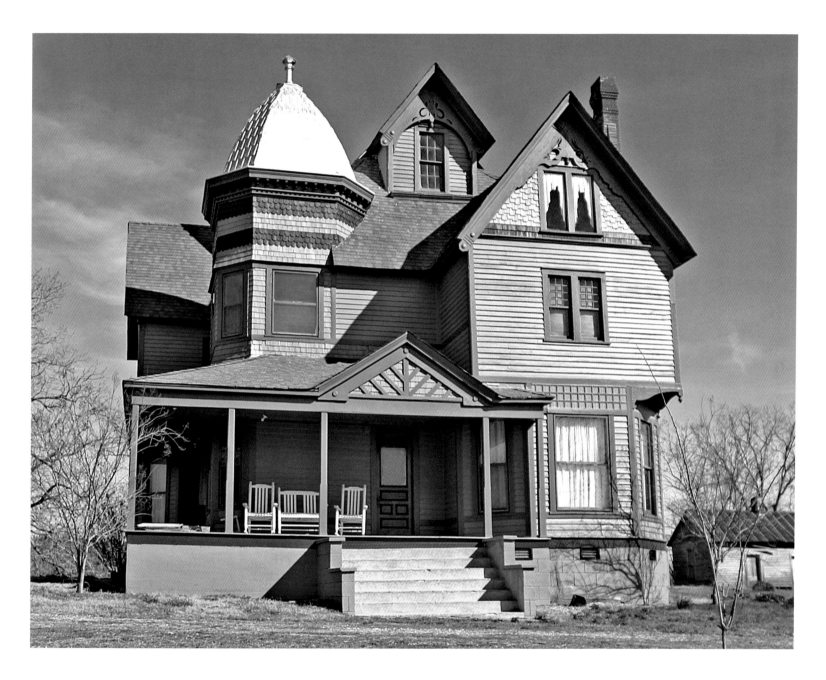

MACON

Built in 1892, the William H. Scales House is located on Magnolia Drive
on the northern outskirts of Macon.

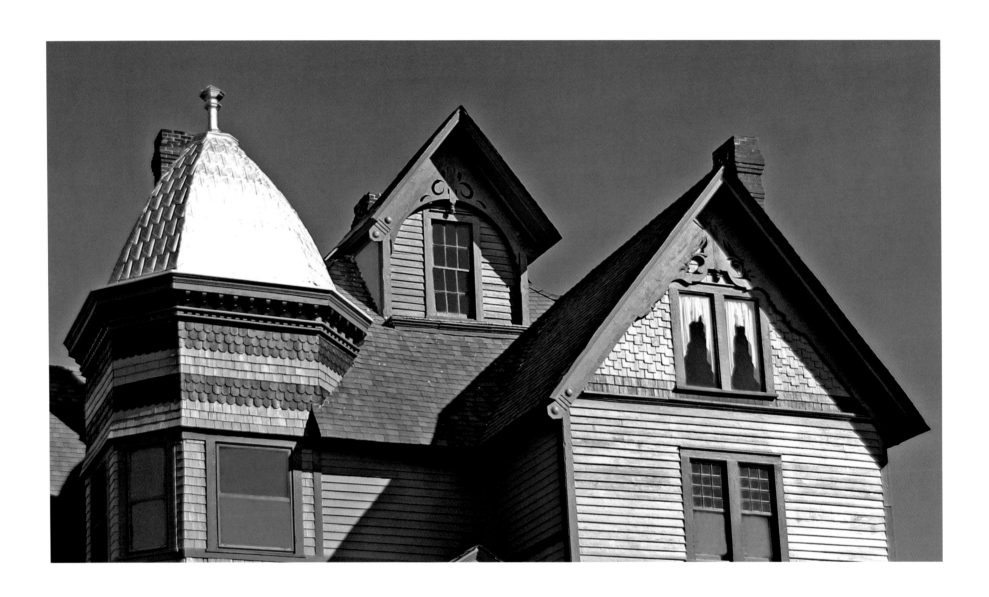

MACON

Varying patterns of wooden shingle siding decorate the main gable and turret of the Scales House.

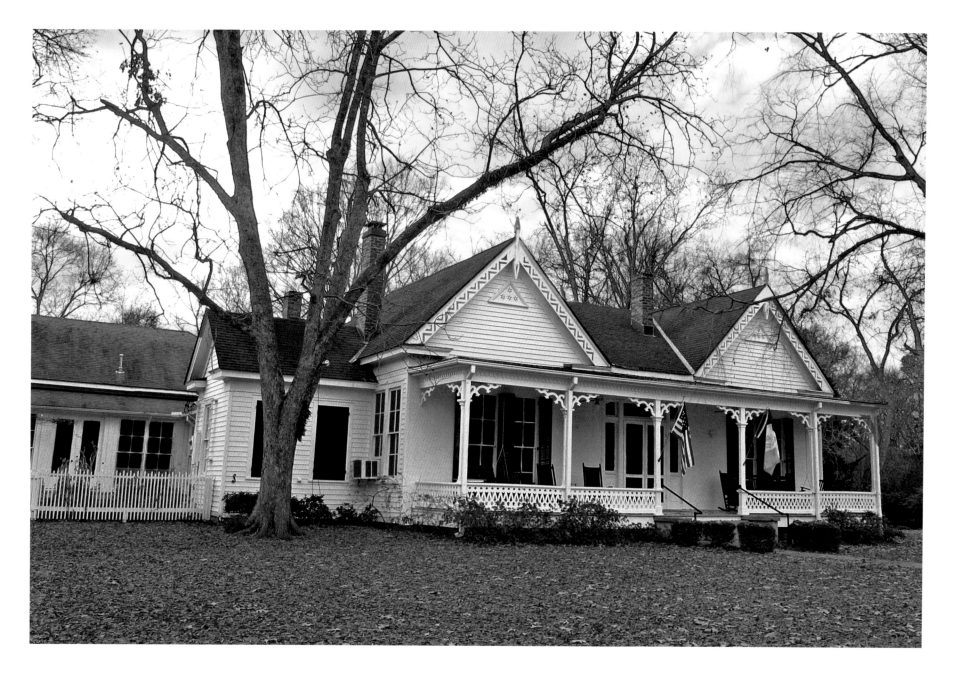

MADISON

The Montgomery House in Madison is an eclectic Late Victorian cottage
with Gothic Revival paired front gables.

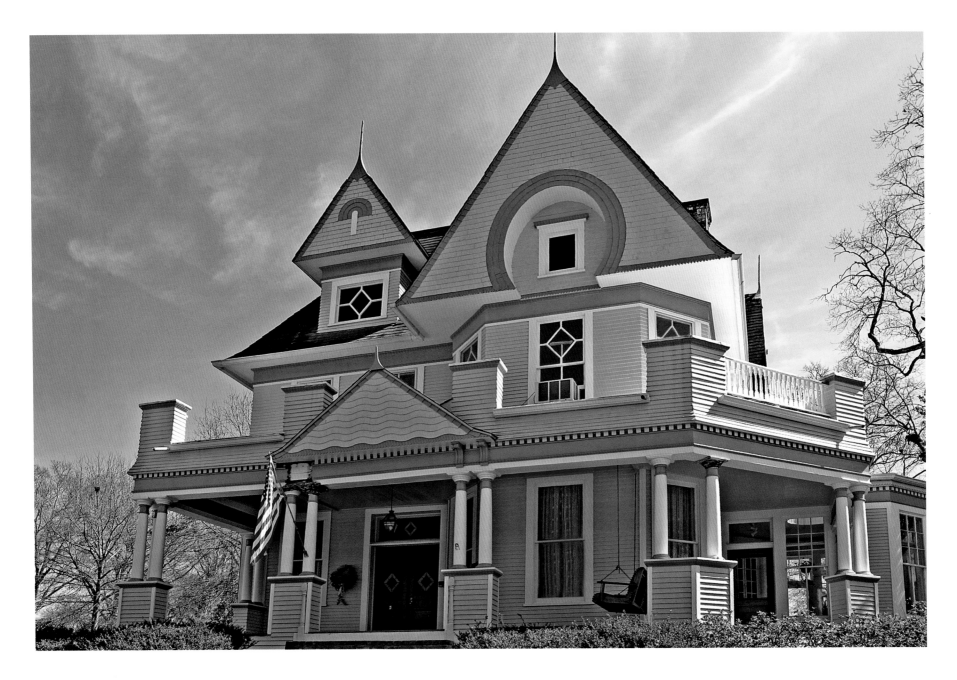

MAGNOLIA

The Walter Lampton House on Lampton Lane is a fine Queen Anne house with free classical features.

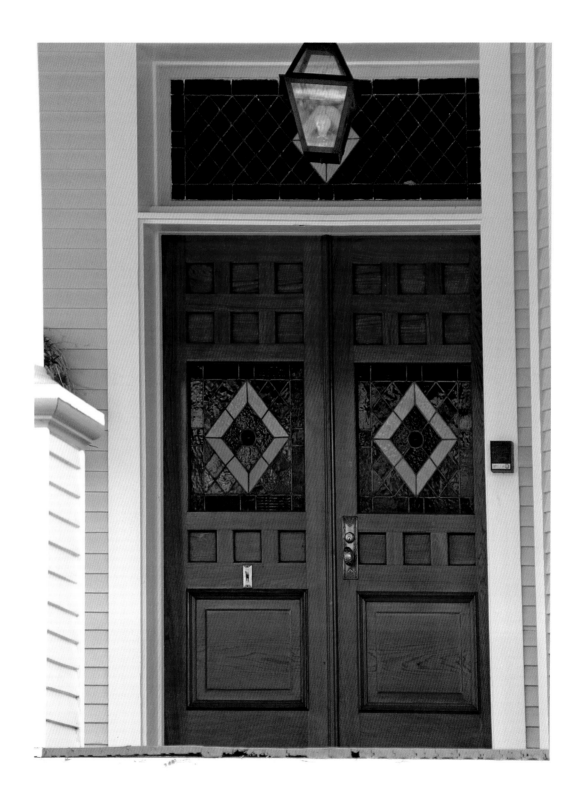

MAGNOLIA

The front doors of the Walter Lampton House
are particularly impressive.

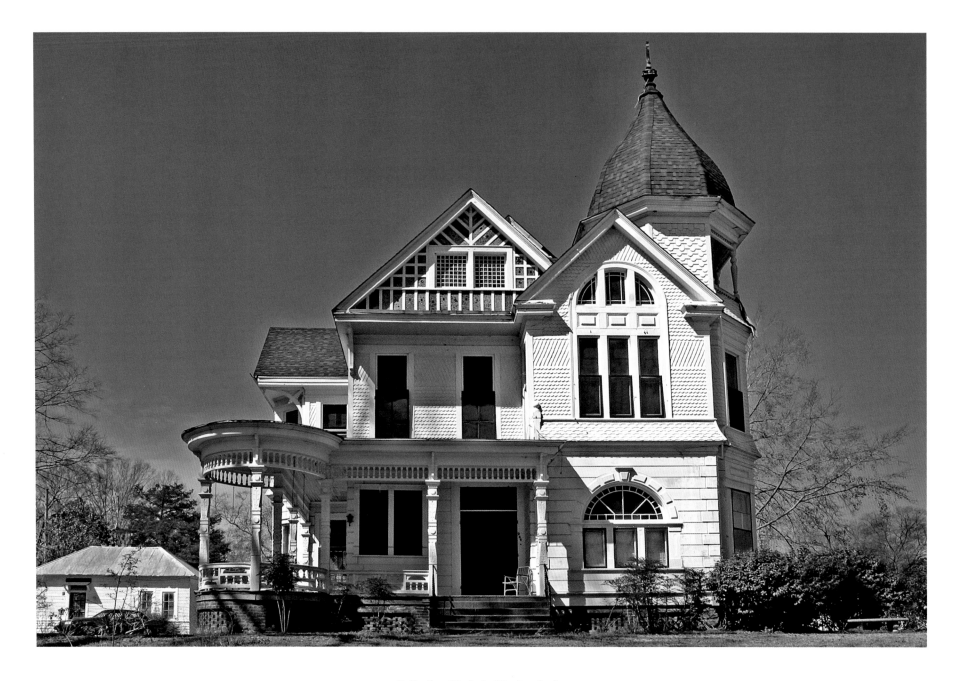

MAGNOLIA

The Lucius L. Lampton House on East Laurel Street has a rich variety of surface textures and ornamentation.

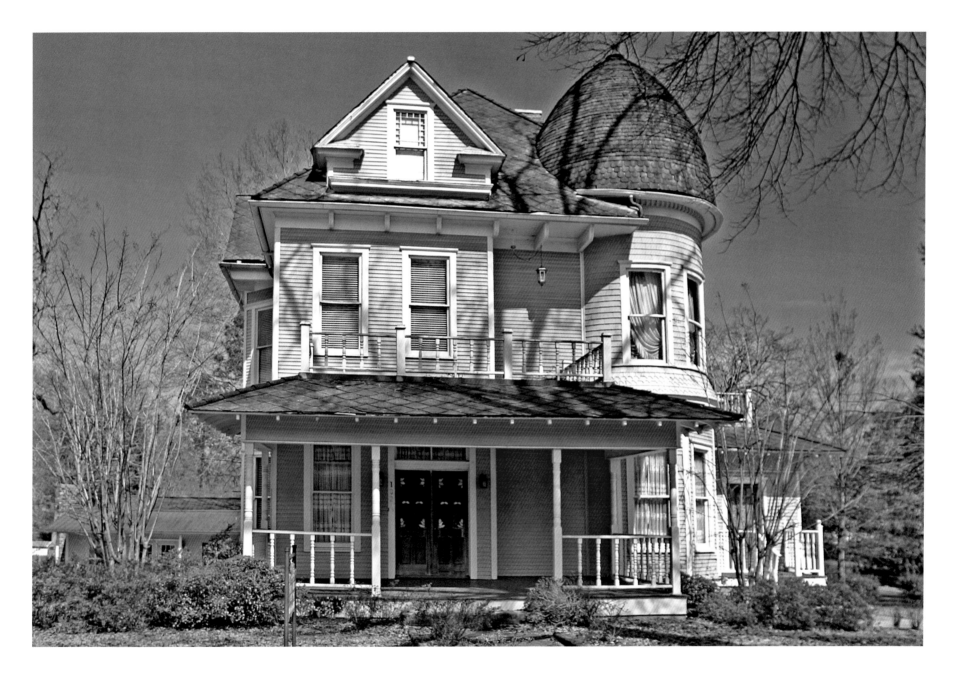

MAGNOLIA

Belle Maison on West Myrtle Street was built in 1902. The veranda was apparently reworked
at a later date, as is indicated by its exposed rafter tails and plain cornice.

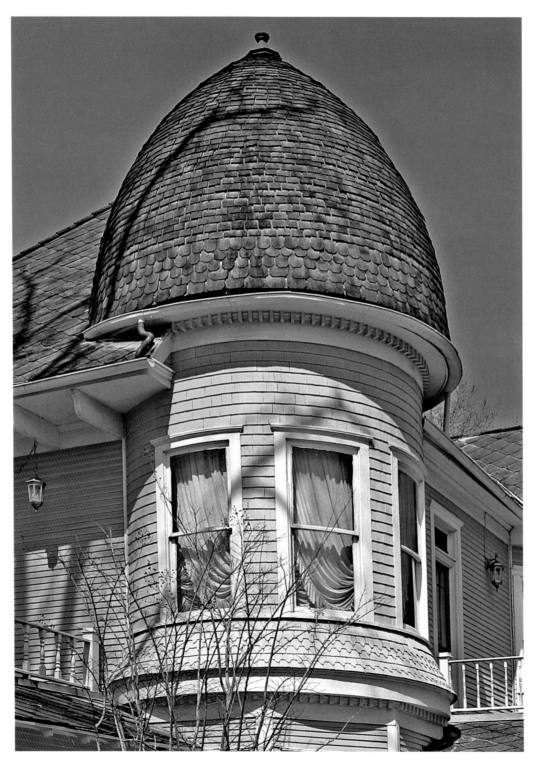

MAGNOLIA

The most distinctive feature of Belle Maison is the
round corner tower with its beehive-shaped dome,
which is similar to the bell-shaped dome on the tower
of the Sproles House in Brookhaven.

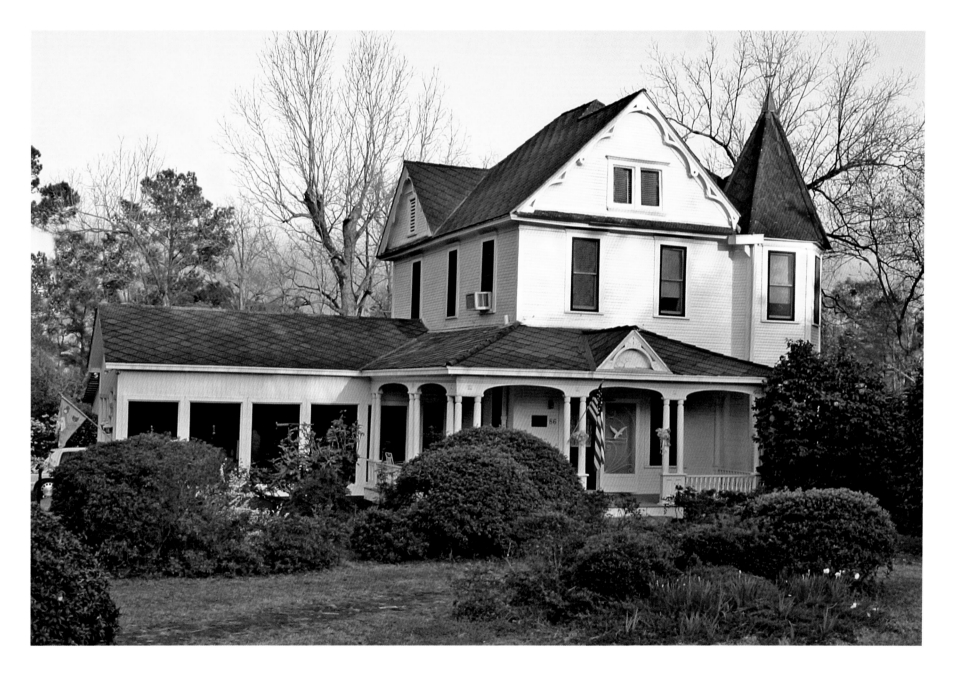

MCHENRY

The Dr. G. A. McHenry House is the most prominent architectural landmark
in the small community of McHenry in Stone County.

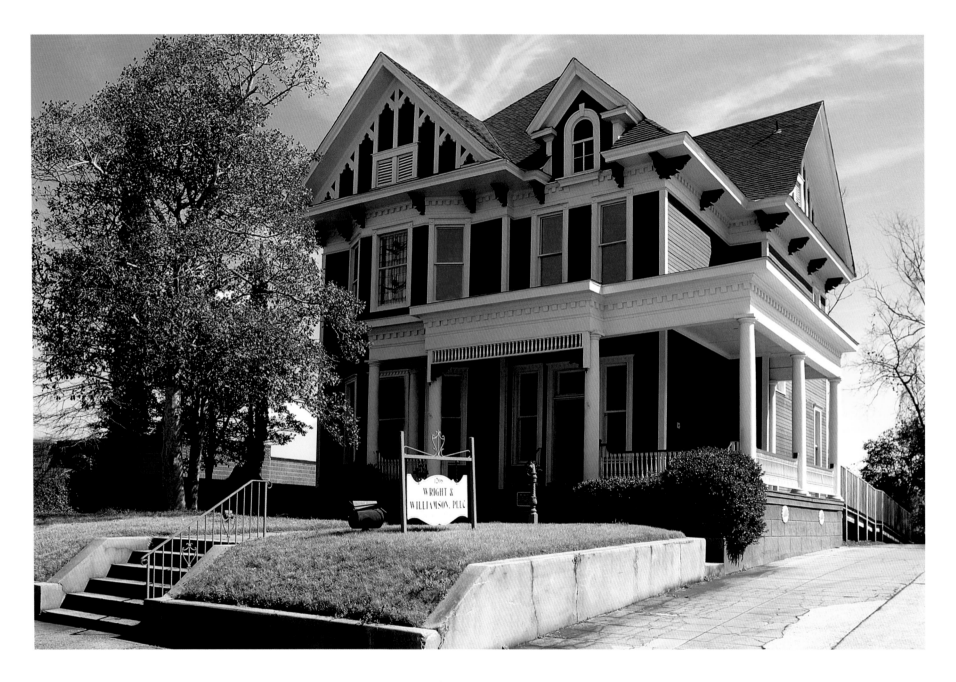

MERIDIAN

The Porter-Crawford House on Twenty-second Avenue is a Queen Anne house
with free classical and Old English detailing.

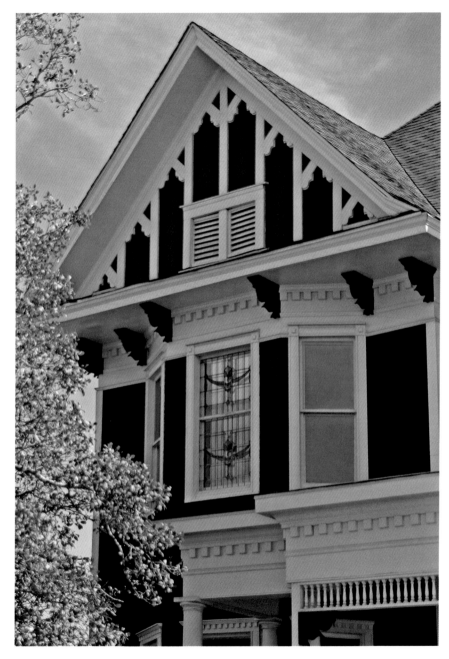

MERIDIAN

The front gable of the Porter-Crawford House is trimmed with false timber framing that is a characteristic of the Old English or half-timbered mode of the Queen Anne style. Old English features are rare among Mississippi's Queen Anne houses, but they are widely seen on Tudor Revival houses of the 1920s.

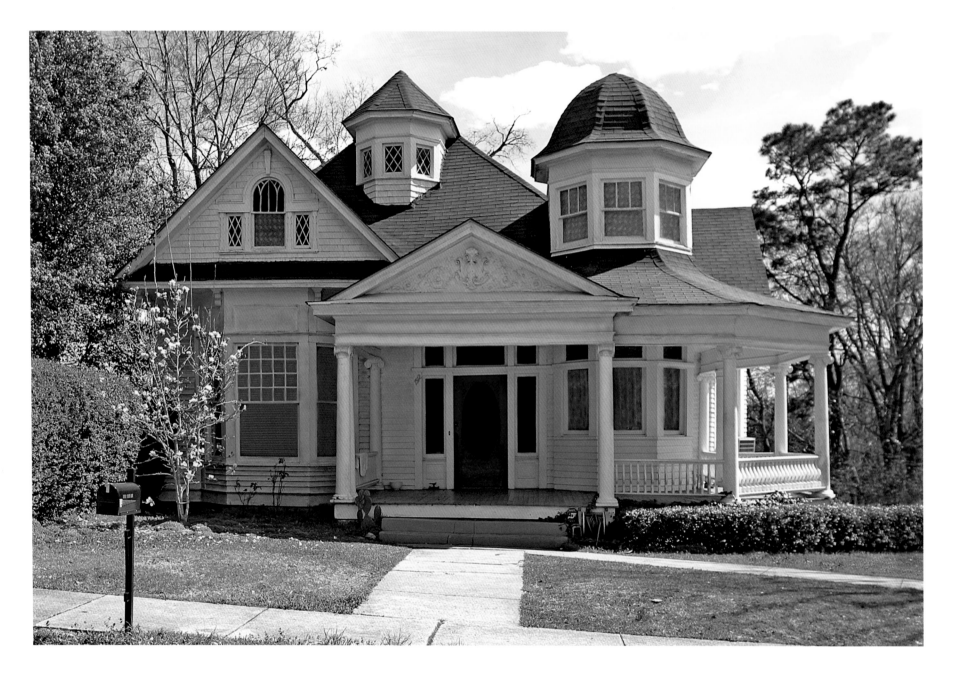

MERIDIAN

This nicely detailed free classical Queen Anne cottage is located on Fourteenth Avenue in Meridian.

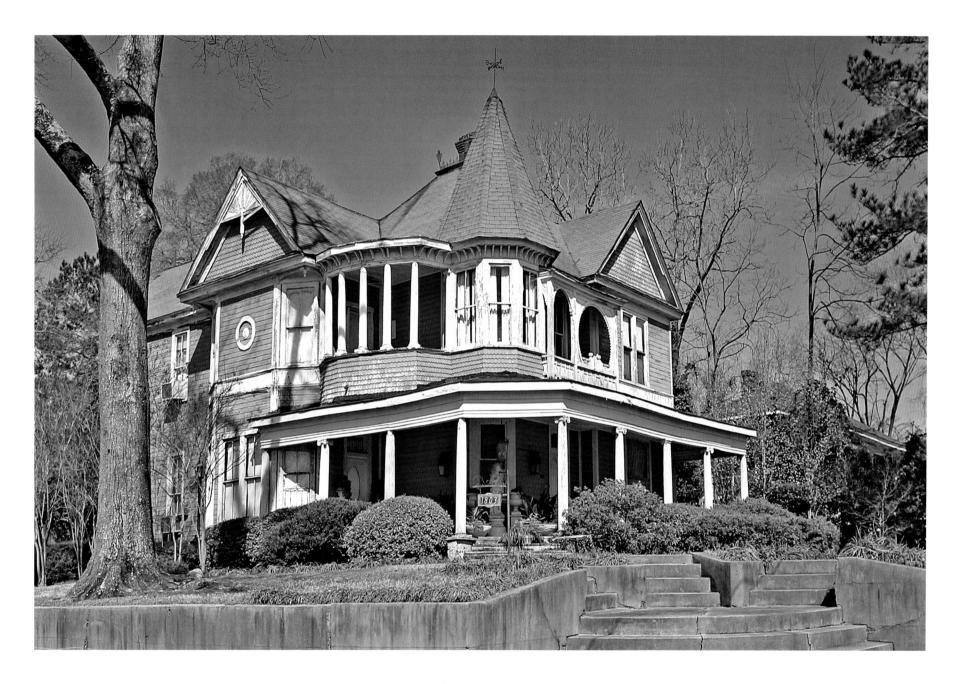

MERIDIAN

Like many of Mississippi's larger Queen Anne houses, the E. E. McMorries House on
Thirty-fifth Avenue in Meridian has a corner tower surmounted by a spire.

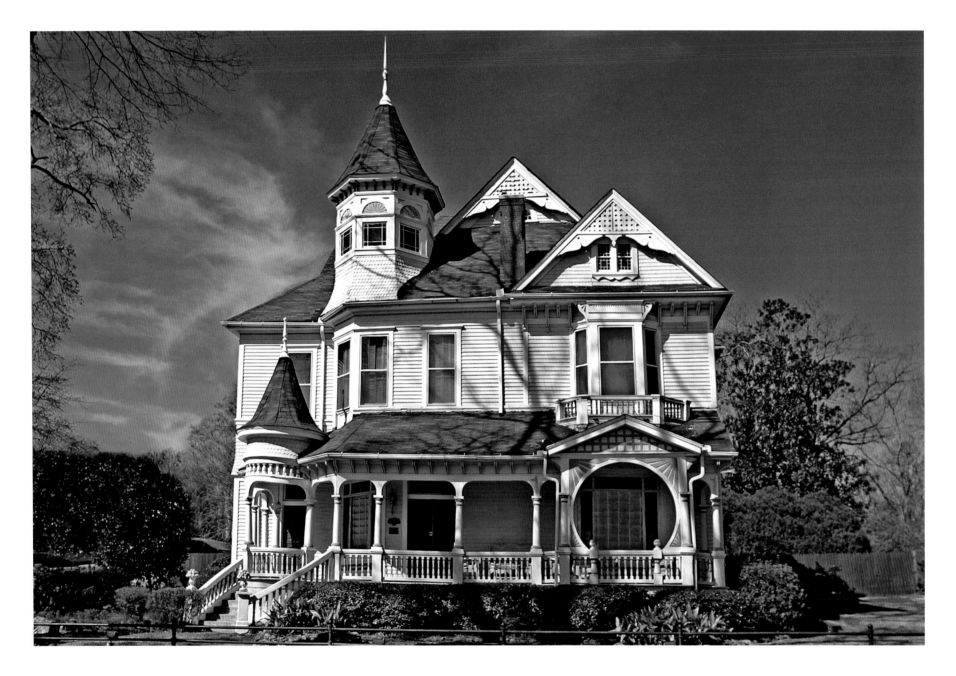

MERIDIAN

One of the finest surviving Queen Anne houses in Meridian is the Elson-Dudley House on Twenty-ninth Avenue.

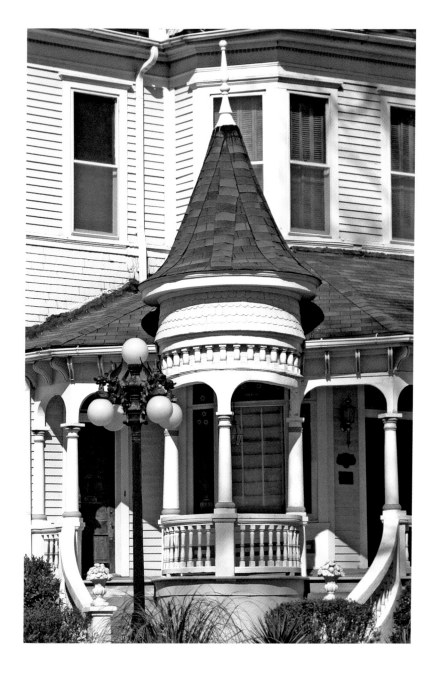

MERIDIAN

The veranda of the Elson-Dudley House features this charming little
round pavilion roofed with a flared conical spire.

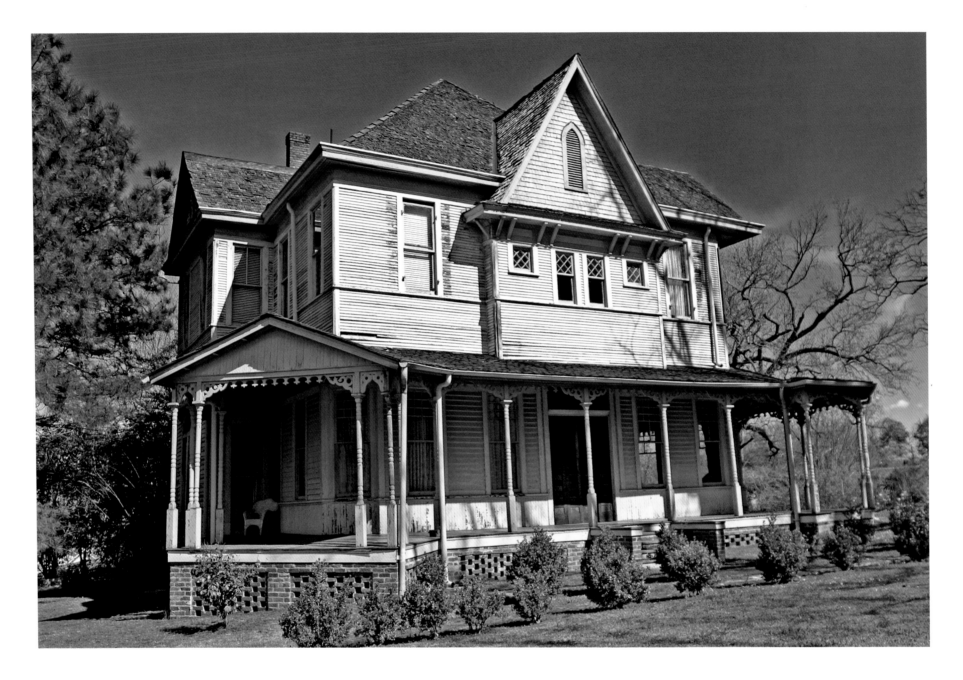

MERIDIAN

The Frank W. Williams House (circa 1886) is primarily Queen Anne in character, although
the centered cross-gable, with its pointed-arched ventilator, is a Gothic Revival feature.

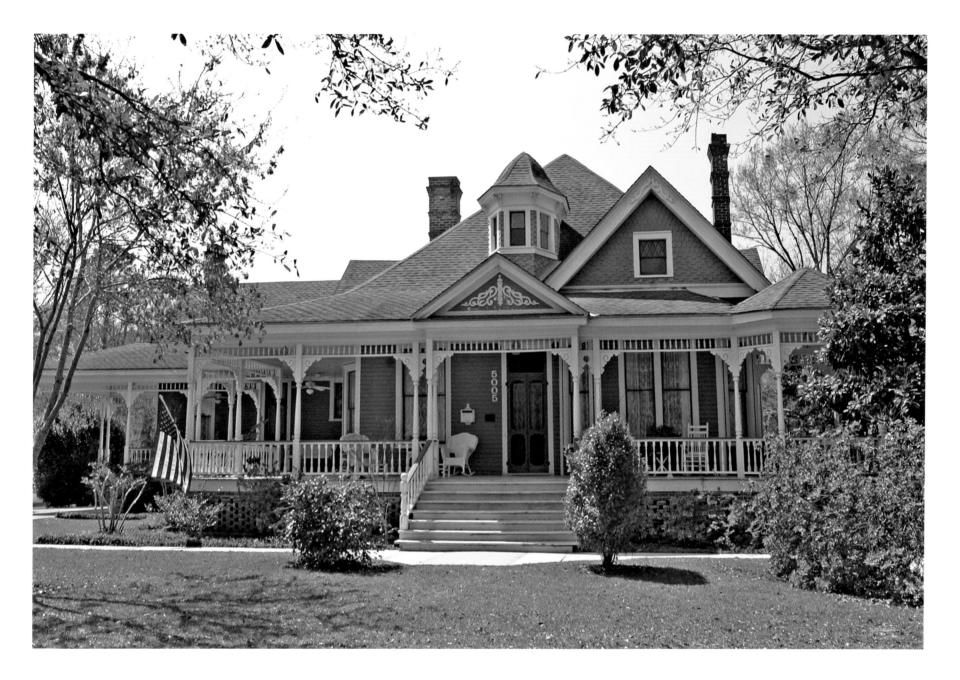

MOSS POINT

Built in 1906, the A. F. Dantzler House on Griffin Street in Moss Point illustrates the continuing popularity
of the Queen Anne style into the early years of the twentieth century.

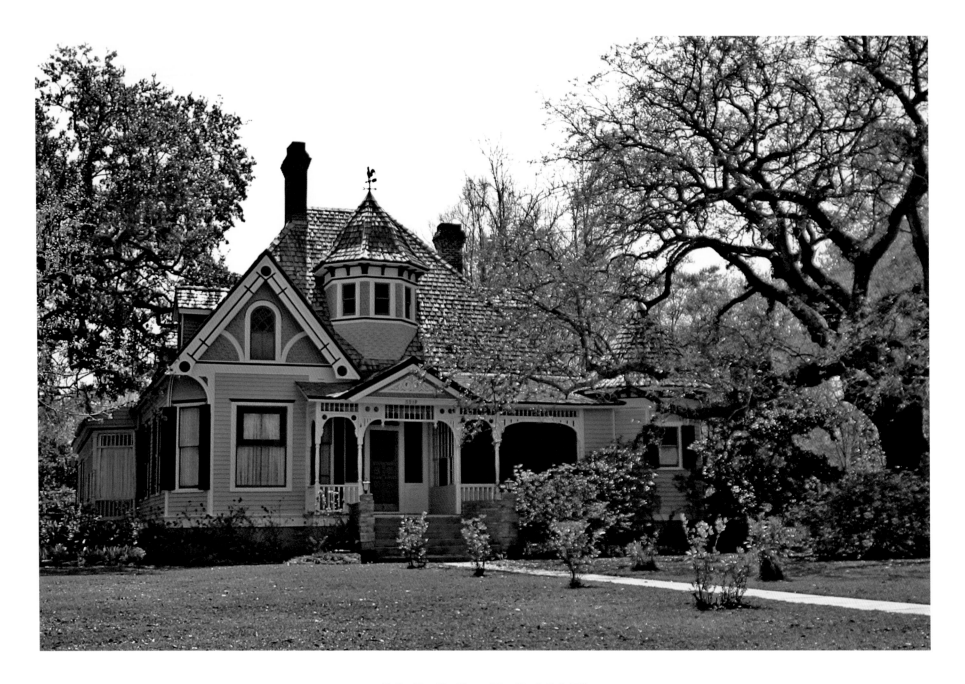

MOSS POINT

The C. W. Jackson House is a turreted Queen Anne cottage located on Dantzler Avenue in Moss Point.

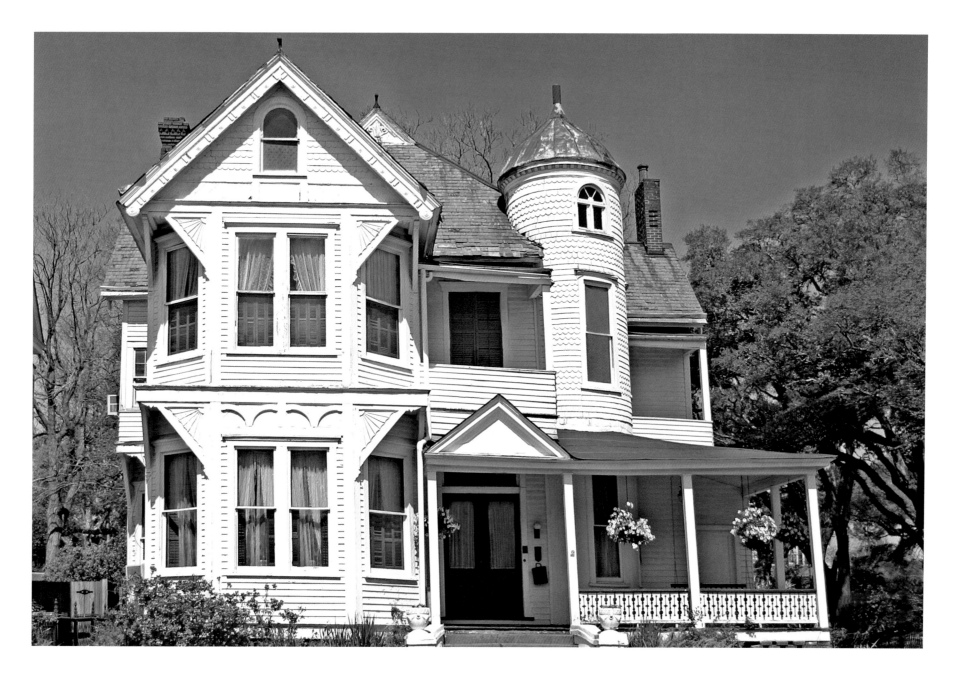

NATCHEZ

A variety of surface textures adorn this Queen Anne house on North Commerce Street in Natchez.

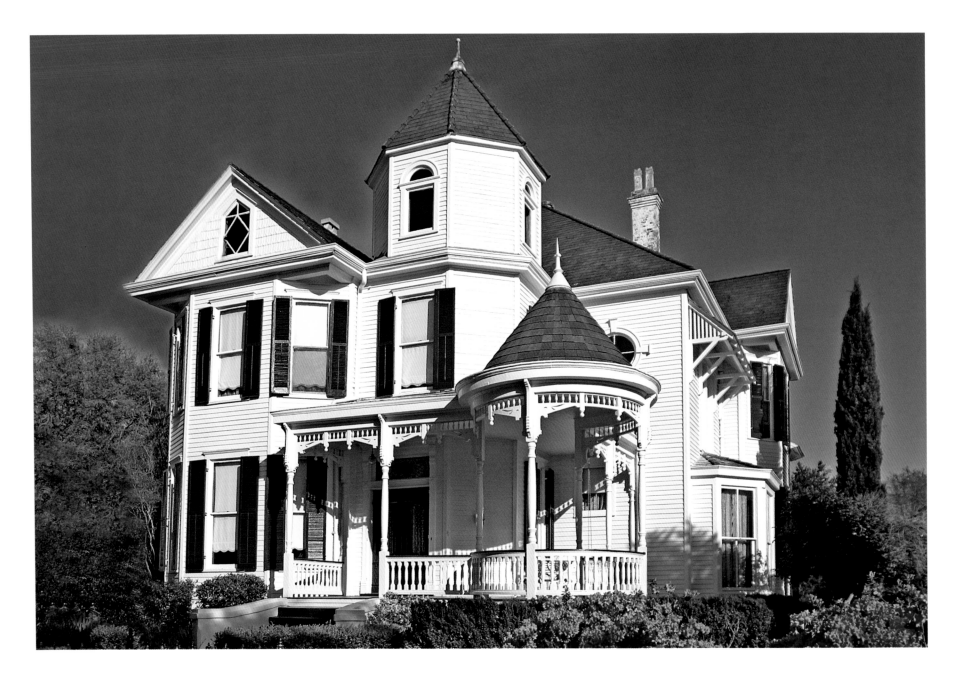

NATCHEZ

This house on North Commerce Street has an octagonal tower and a veranda trimmed with spindlework.

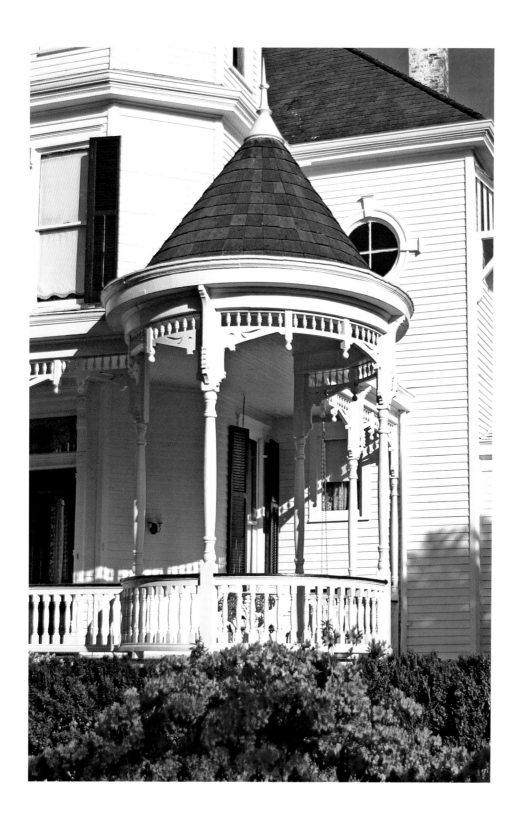

NATCHEZ

On the veranda is a round corner pavilion
with a spindlework frieze.

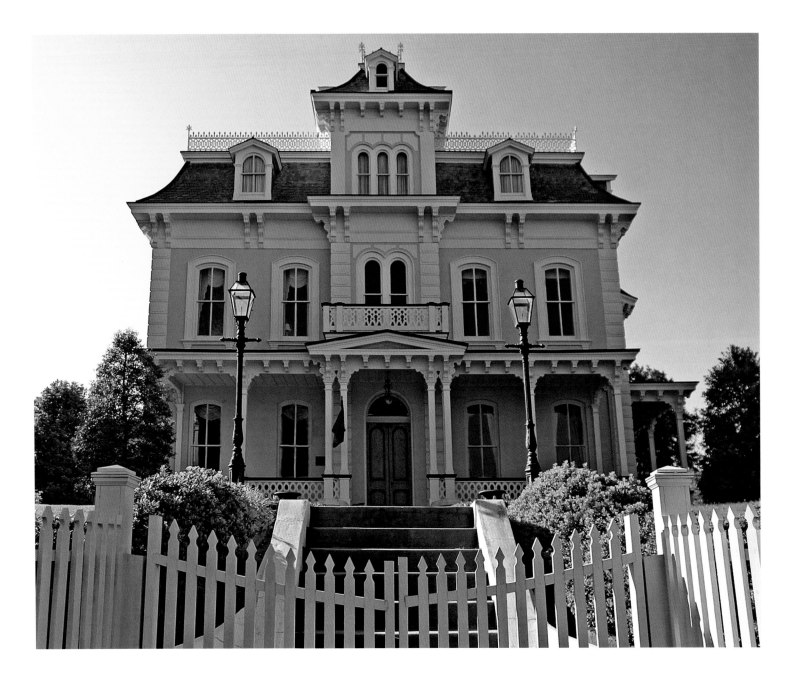

NATCHEZ

The Christian Schwartz House (Glen Auburn) (1873–75) is the finest surviving example
of the Second Empire style in Mississippi.

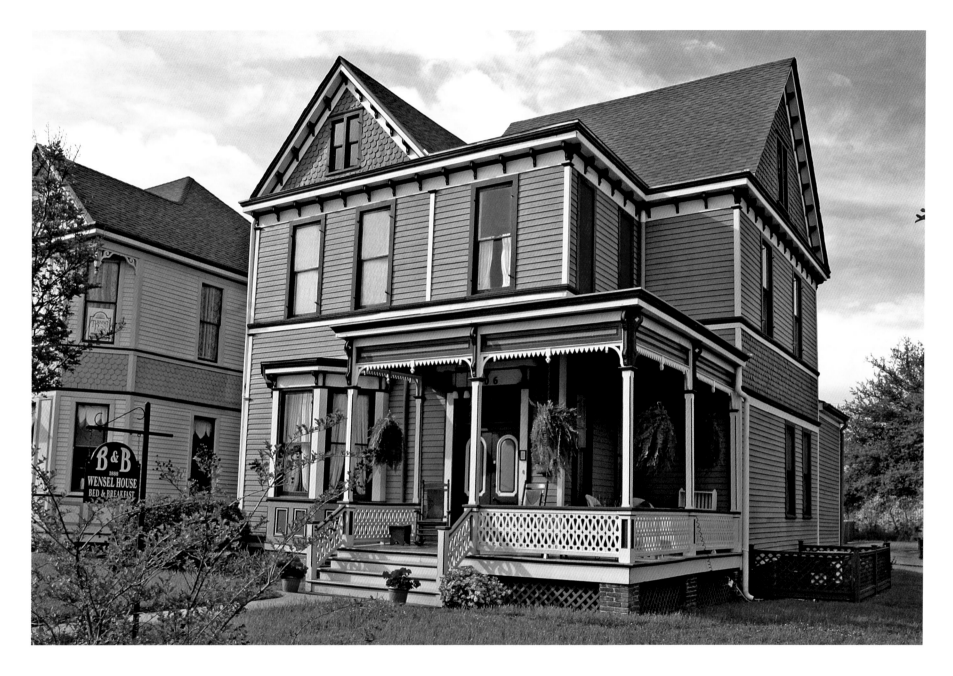

NATCHEZ

A skillfully applied Victorian color scheme enhances the detailing of the Wensel House (1888),
a rectilinear Queen Anne residence on Washington Street in Natchez.

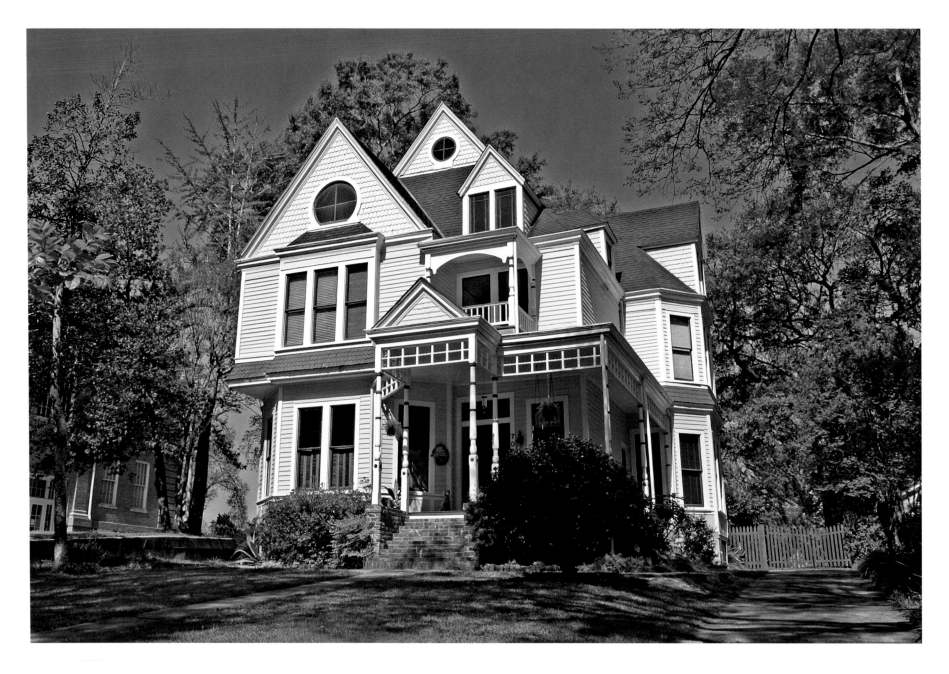

NATCHEZ

The Gerard Brandon IV House (1890) on North Union Street exemplifies
the rectilinear mode of the Queen Anne style.

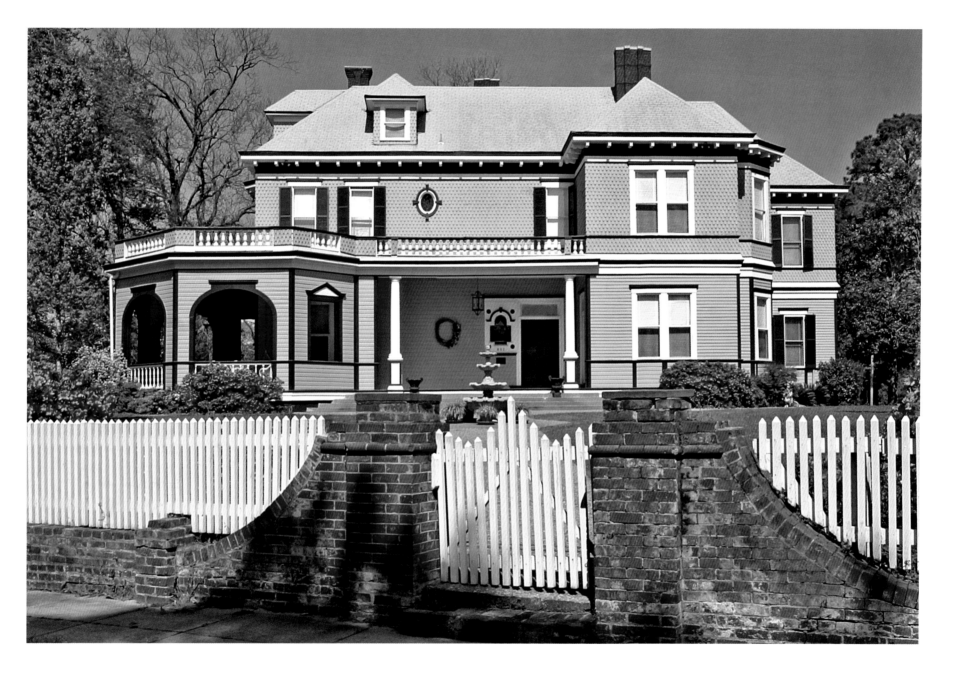

NATCHEZ

The John Dicks House (circa 1888), located on North Union Street, has Shingle style and
Colonial Revival features. It was designed by Stanley V. Stratton, a native of Natchez who worked as
an architect with the prestigious firm of McKim, Mead, and White of New York.

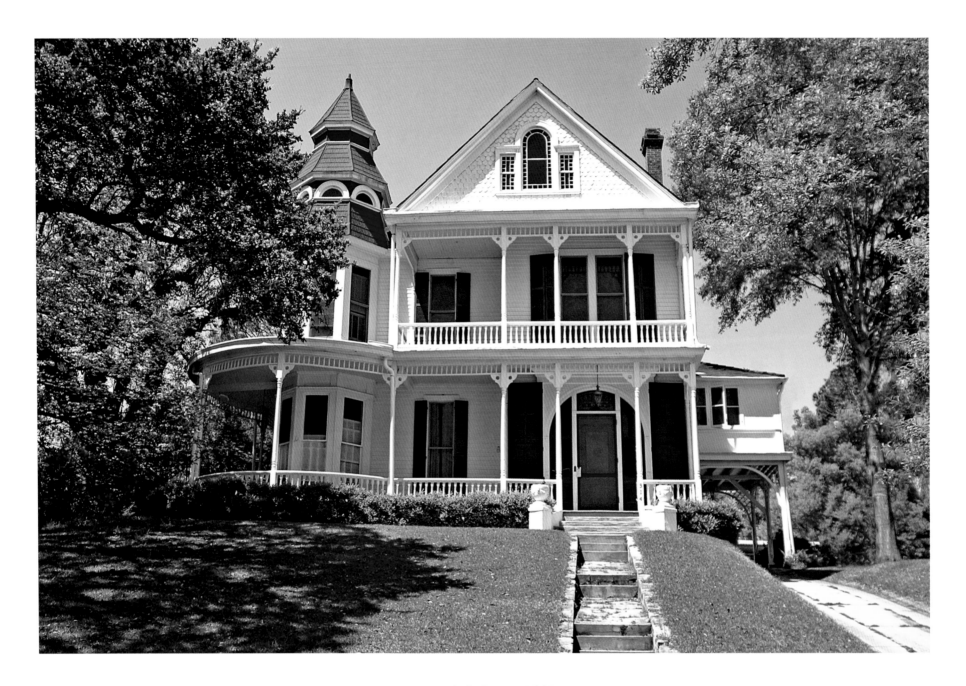

NATCHEZ

A Palladian window graces the front gable of this Queen Anne house on Linton Avenue.

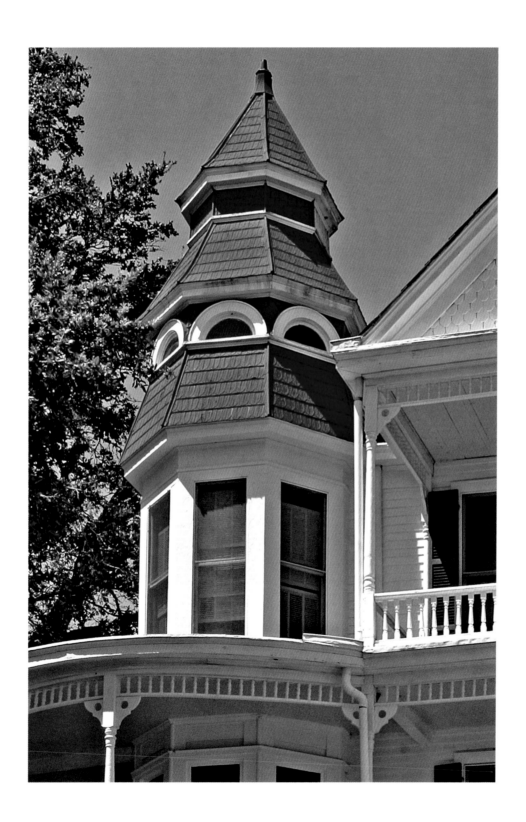

NATCHEZ

The octagonal corner tower is crowned
by a three-tiered roof.

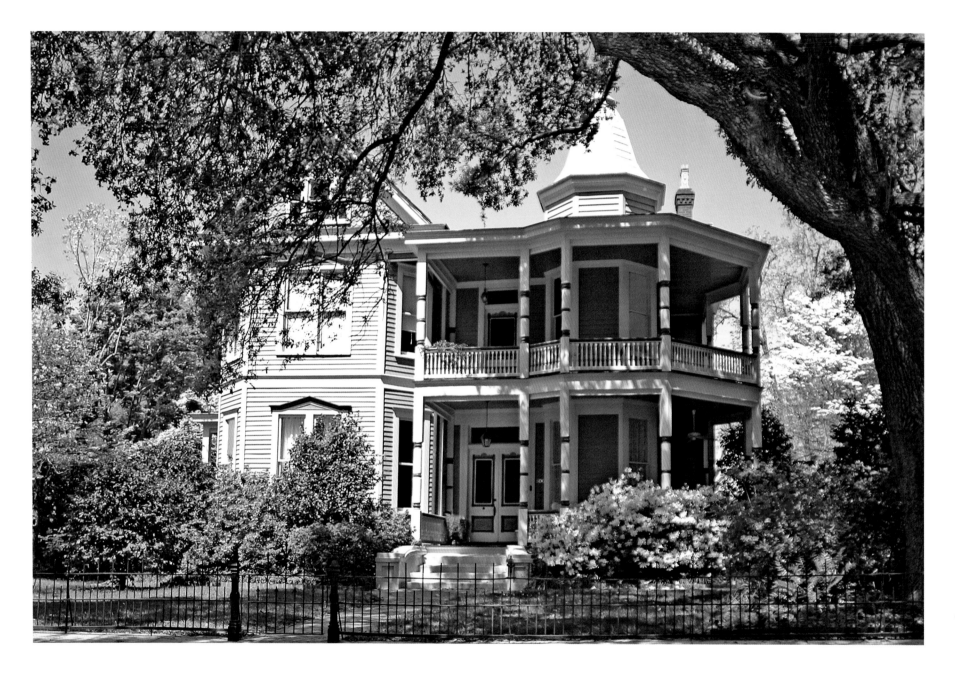

NATCHEZ

A double-tiered veranda wraps around the octagonal corner tower of the Charles Patterson House (Camellia Gardens) on South Union Street, a Queen Anne house built in 1898.

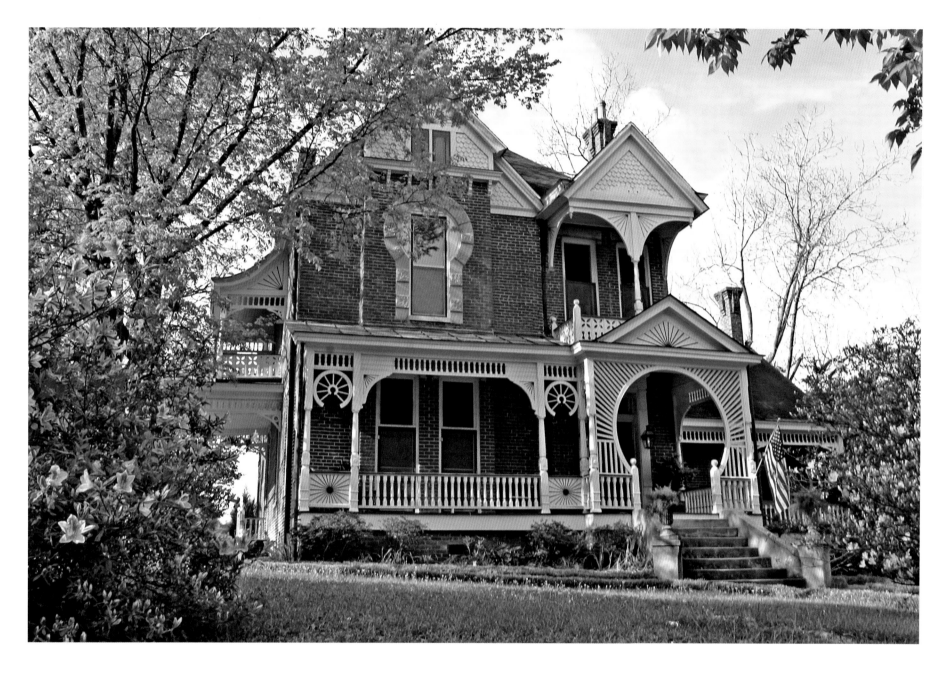

NATCHEZ

The Keyhole House in Natchez is an especially fine brick Queen Anne house with spindlework detailing.

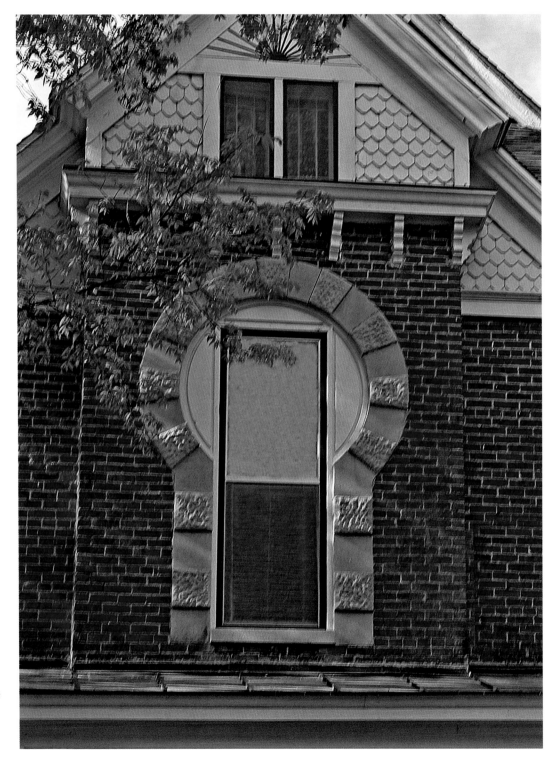

NATCHEZ

The distinctive shape of this window surround gives the
Keyhole House its nickname.

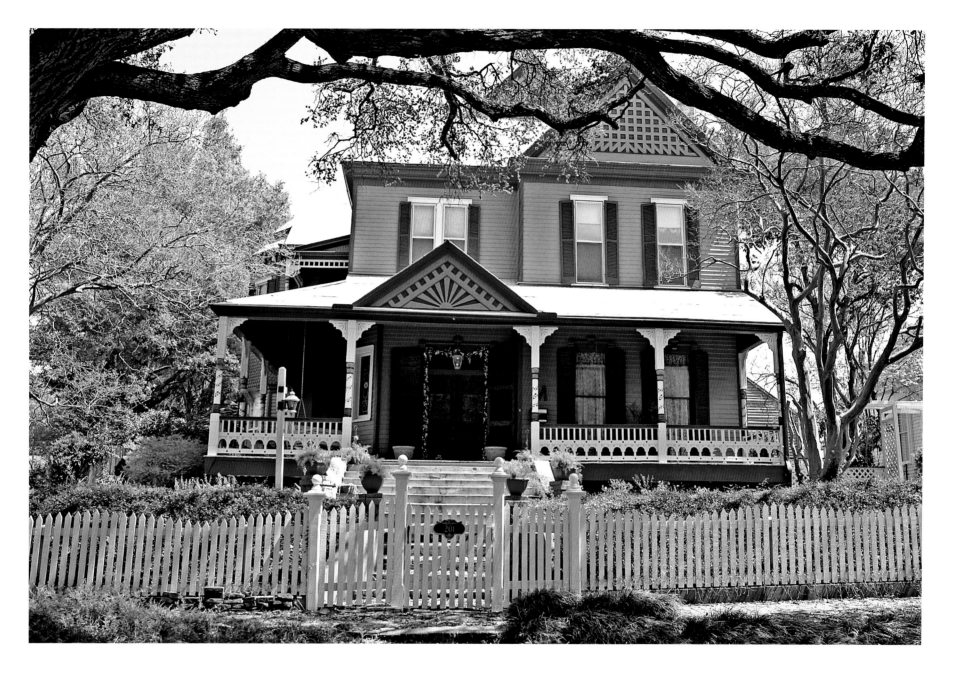

NATCHEZ

The Harper House is a rectilinear Queen Anne residence located on Arlington Avenue.

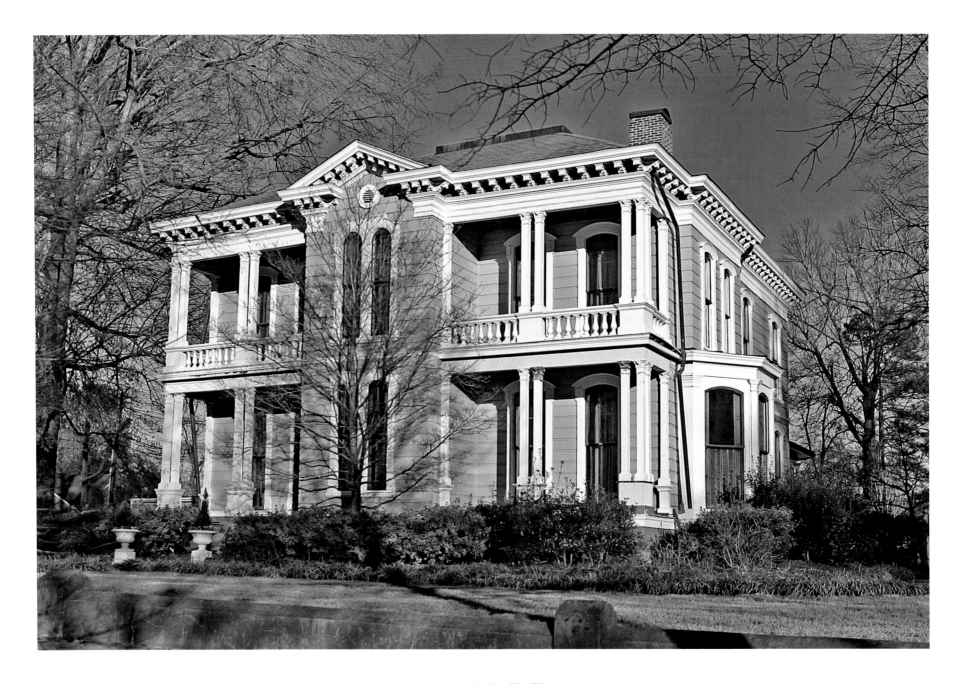

OXFORD

The Howry-Hull House (Fiddler's Folly) on North Lamar Boulevard in Oxford is an
exceptionally fine Late Victorian Italianate residence.

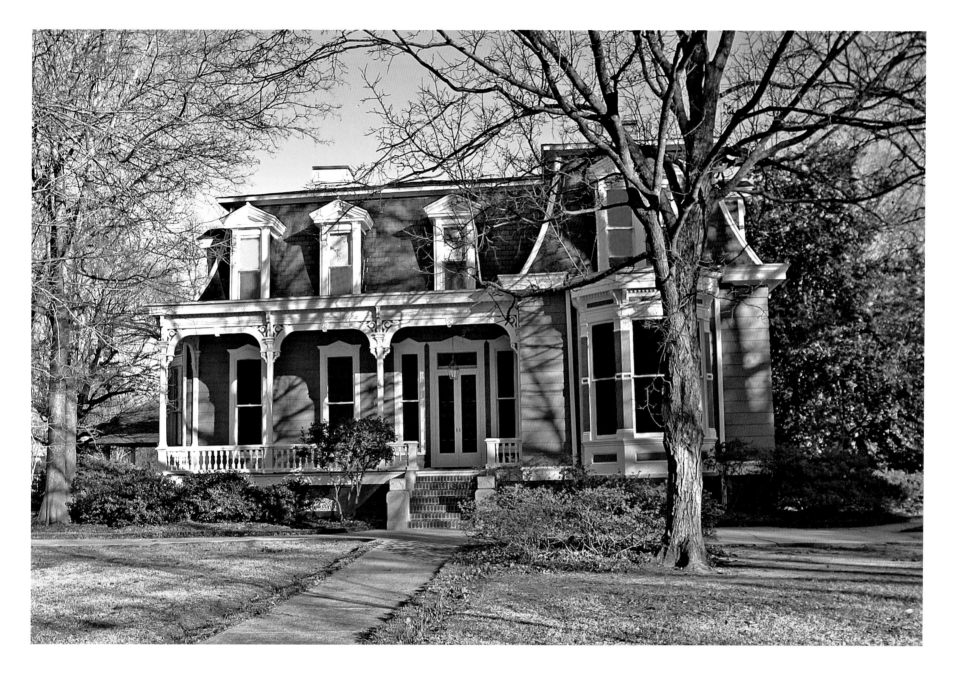

OXFORD

The Roberts-Neilson House on South Lamar Boulevard is a Second Empire–style house notable
for its patterned slate mansard roof.

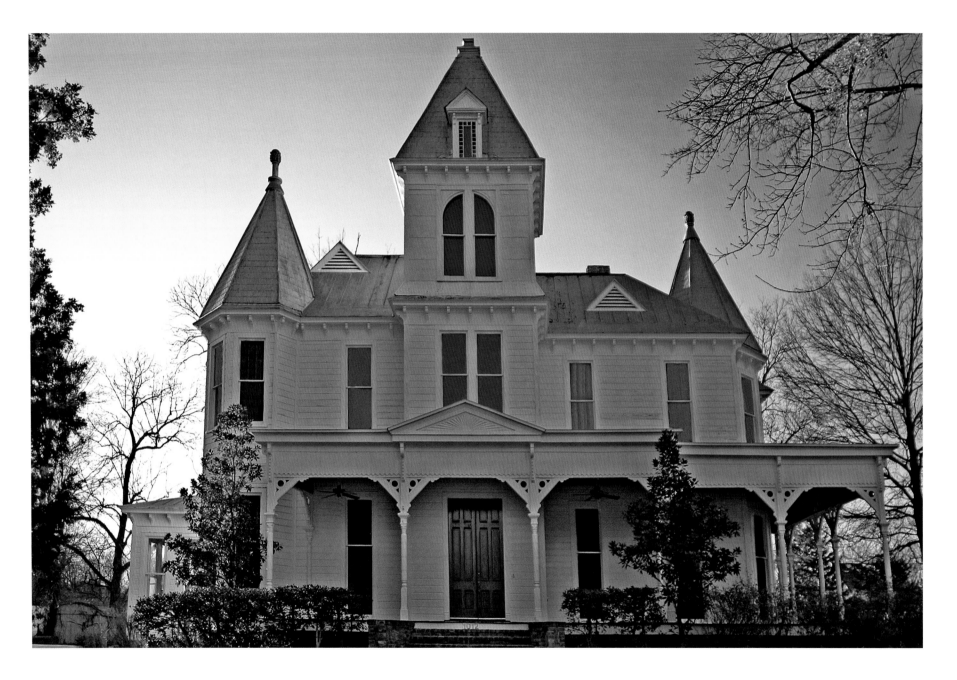

OXFORD

Its façade dominated by a three-story square tower capped by a pyramidal roof, this house on South Lamar
Boulevard, built around 1885, shows a stylistic kinship to the Romanesque Revival civic buildings of that era.

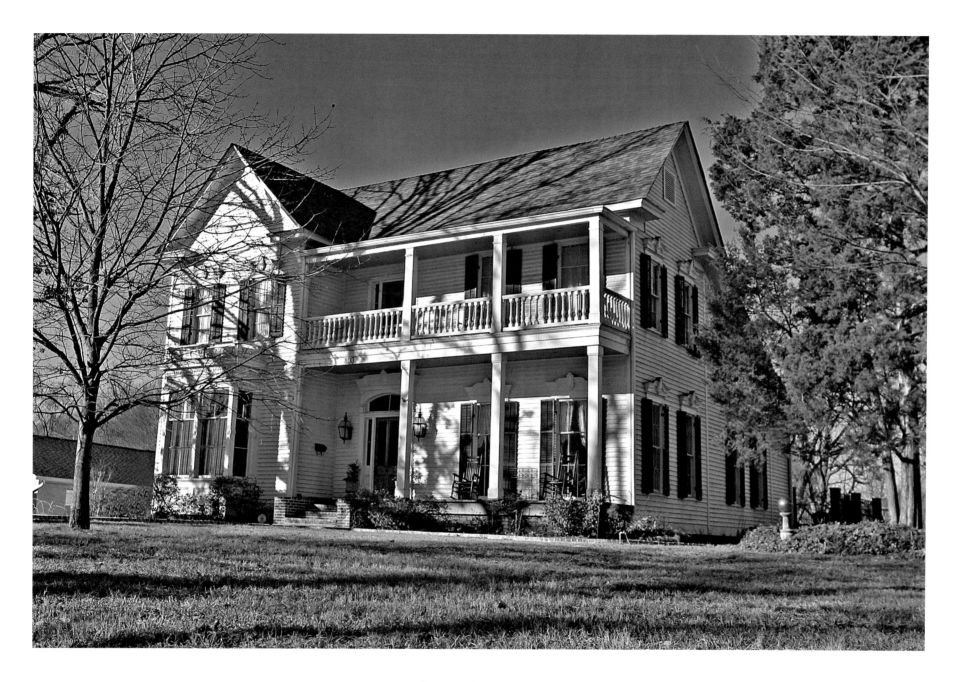

OXFORD

The Meek-Duvall House (circa 1879) on University Avenue is an L-front house
with a double-tiered front porch.

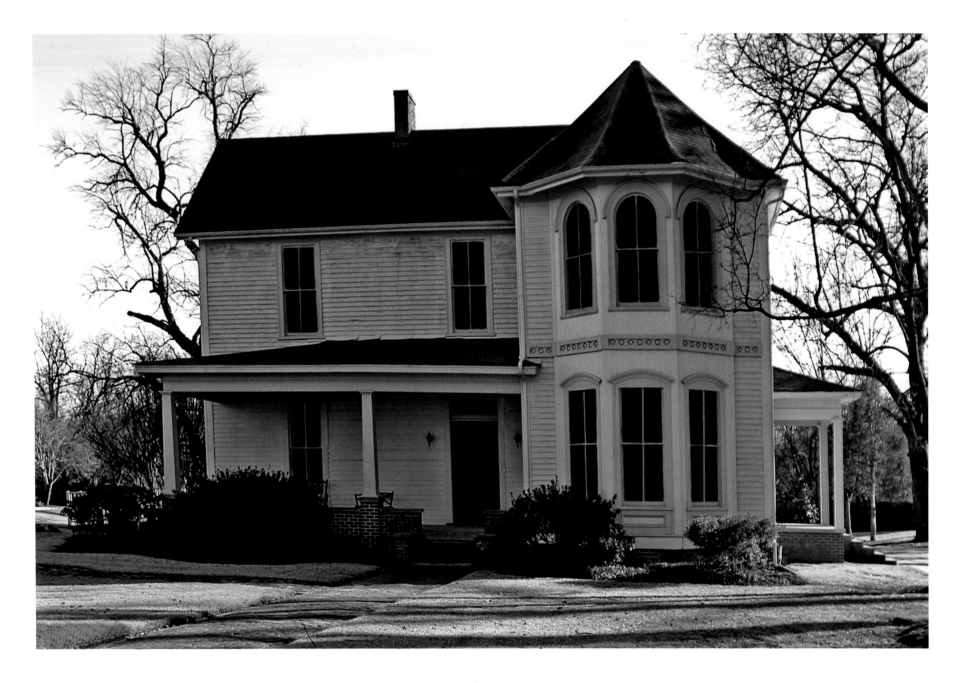

OXFORD

The Walton-Young House (Stark Young House) on University Avenue is a Late Victorian Italianate L-front residence.
The tapered square columns on brick piers indicate that the front porch was later reworked, probably in the 1920s.

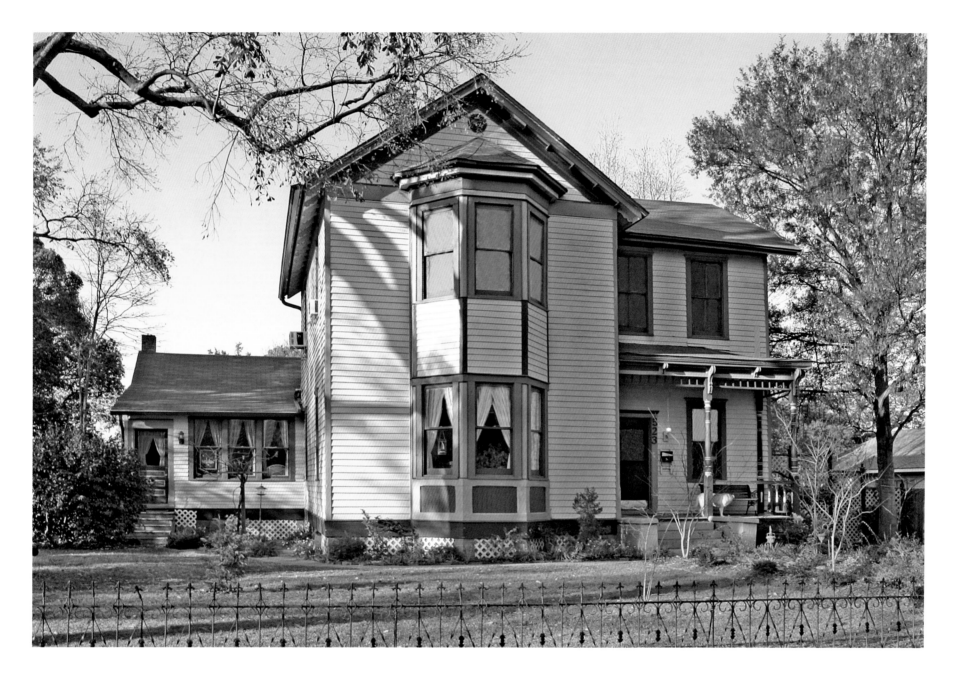

PASCAGOULA

The detailing of the Thompson-Bugge House (1890) on Orange Avenue in Pascagoula
is accentuated by its Victorian color scheme.

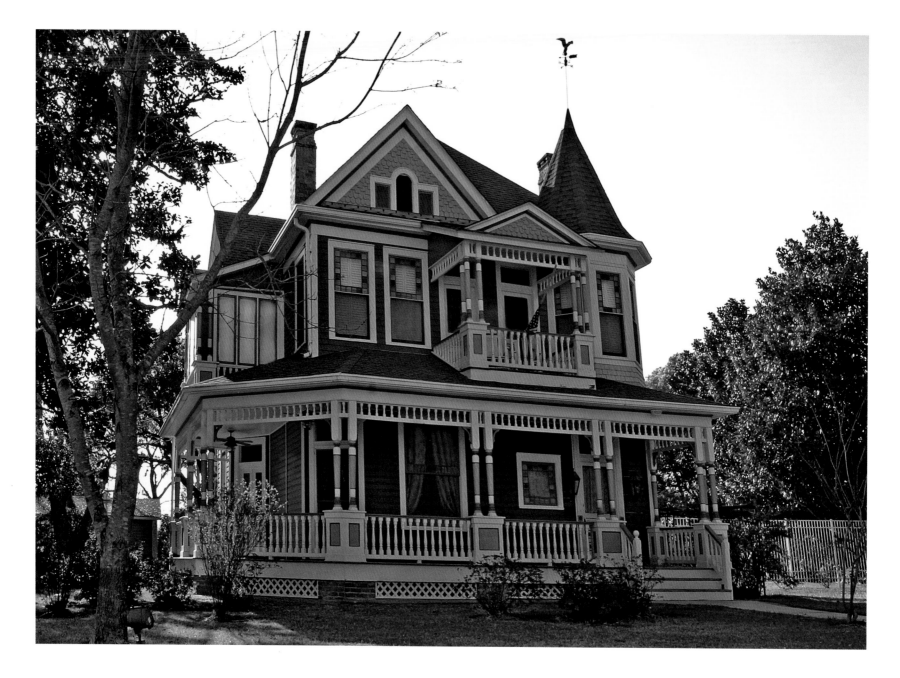

PASCAGOULA

The W. D. Hughes House, an attractively restored Queen Anne residence on Pascagoula Street, was built in 1899.

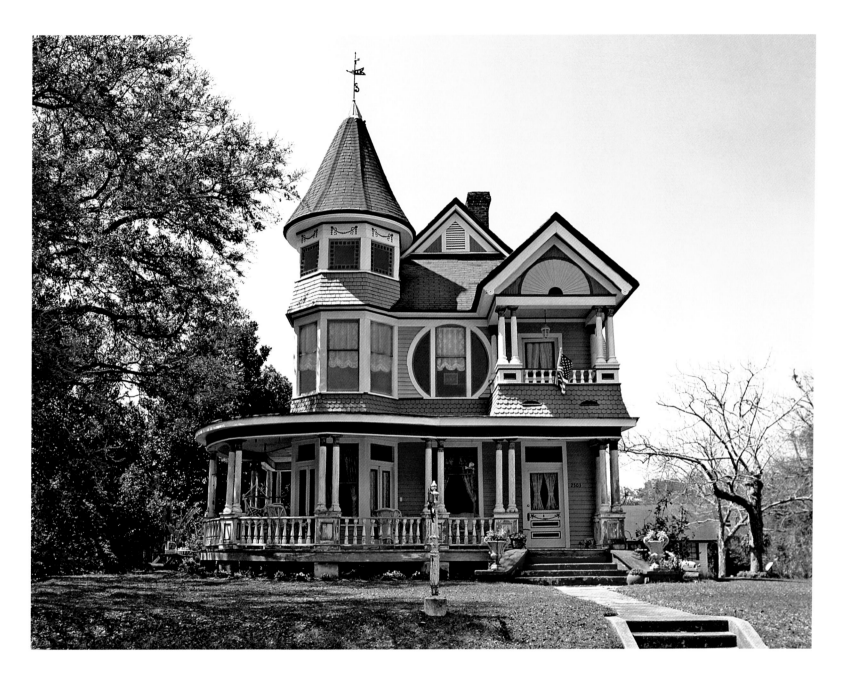

PASCAGOULA

The L. D. Herrick House on Pascagoula Street, built in 1899, is a notable example of the free
classical mode of Queen Anne architecture.

PASCAGOULA

The windows in the octagonal corner tower of the Herrick House have colored glass borders.
The conical spire is topped by a weather vane.

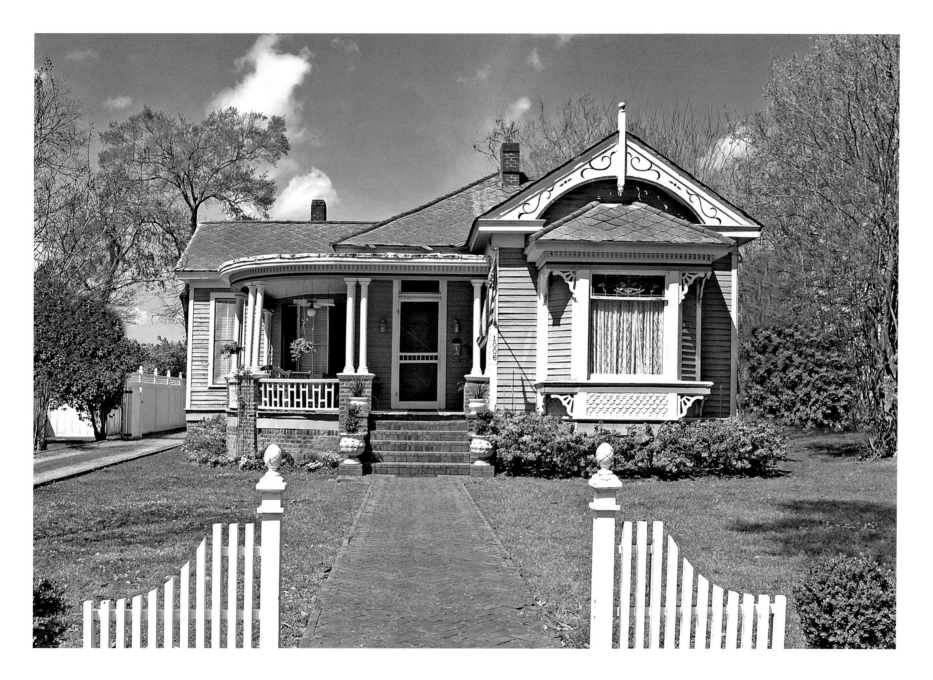

PORT GIBSON

Pairs of classically inspired columns on the veranda impart a free classical character to this Queen Anne cottage on Church Street in Port Gibson, built about 1900. The window under the front gable is of a type often seen on later Queen Anne houses, consisting of a large, broad single pane in the lower sash and decorative stained glass in a much smaller upper sash.

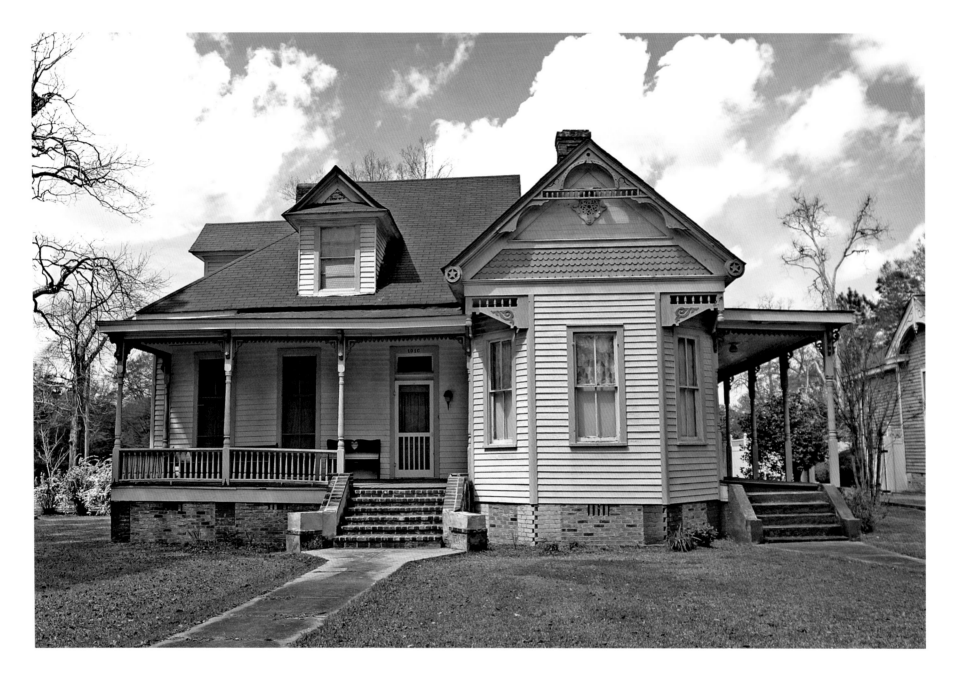

PORT GIBSON

An elaborately ornamented front gable adorns this Queen Anne house on Church Street.

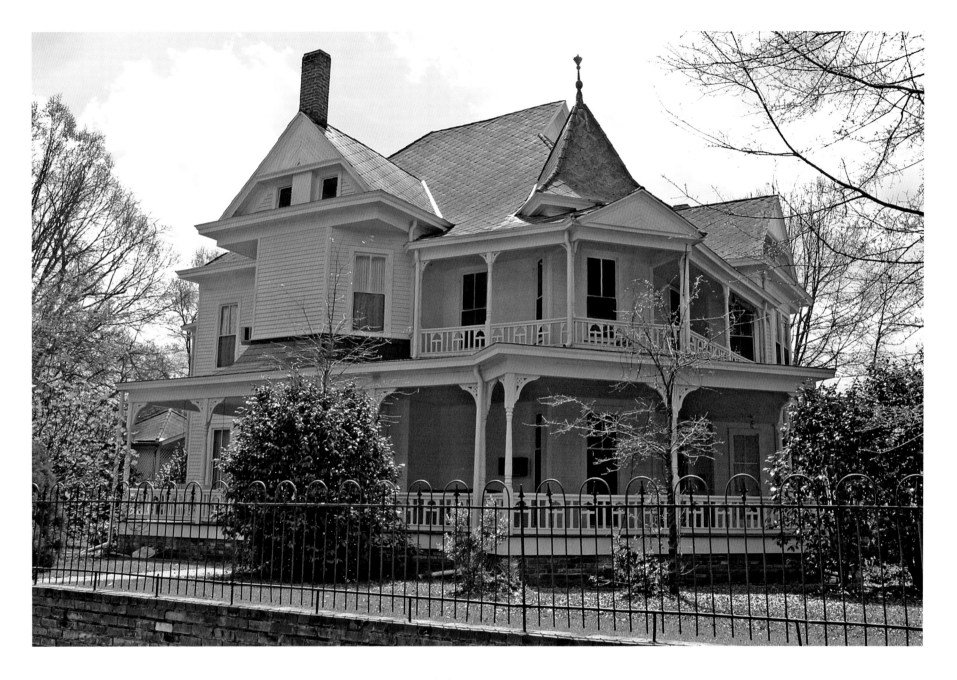

PORT GIBSON

The Schillig Home on College Street is a large Queen Anne house built in 1896.

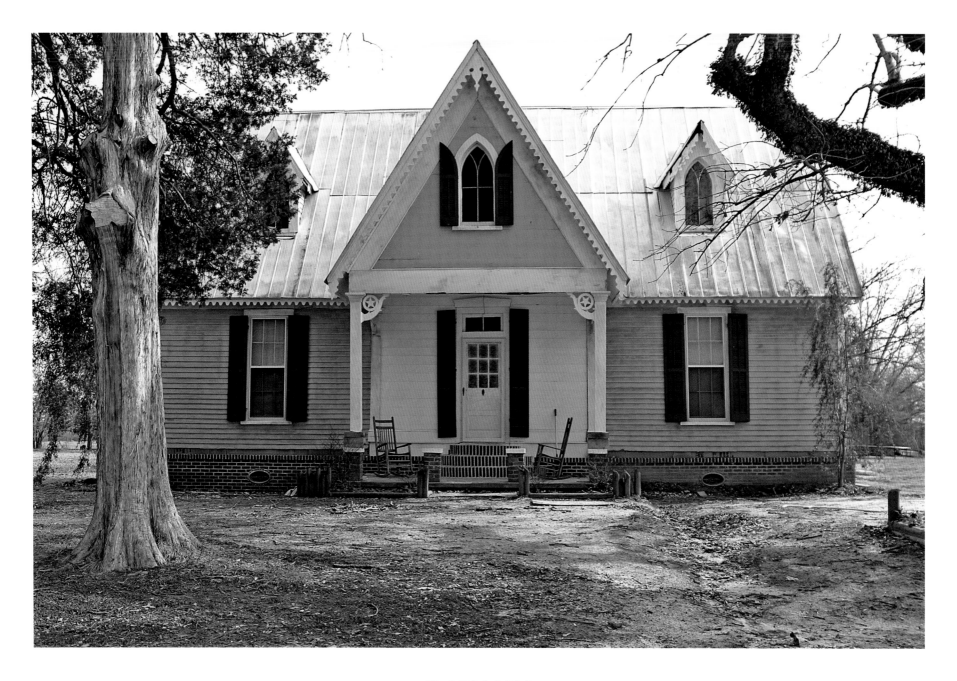

RIENZI

The Dr. Joseph M. Bynum House (1876–77) is one of only a few notable surviving
Late Victorian Gothic Revival houses in Mississippi.

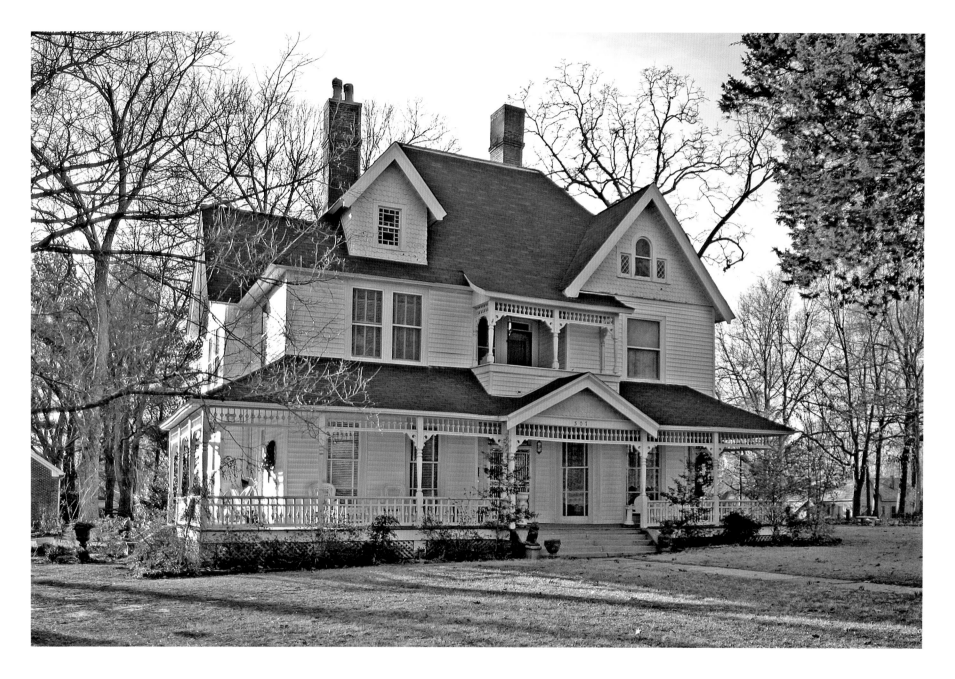

RIPLEY

This fine Queen Anne house is located at the corner of Jackson and Mulberry streets in Ripley.

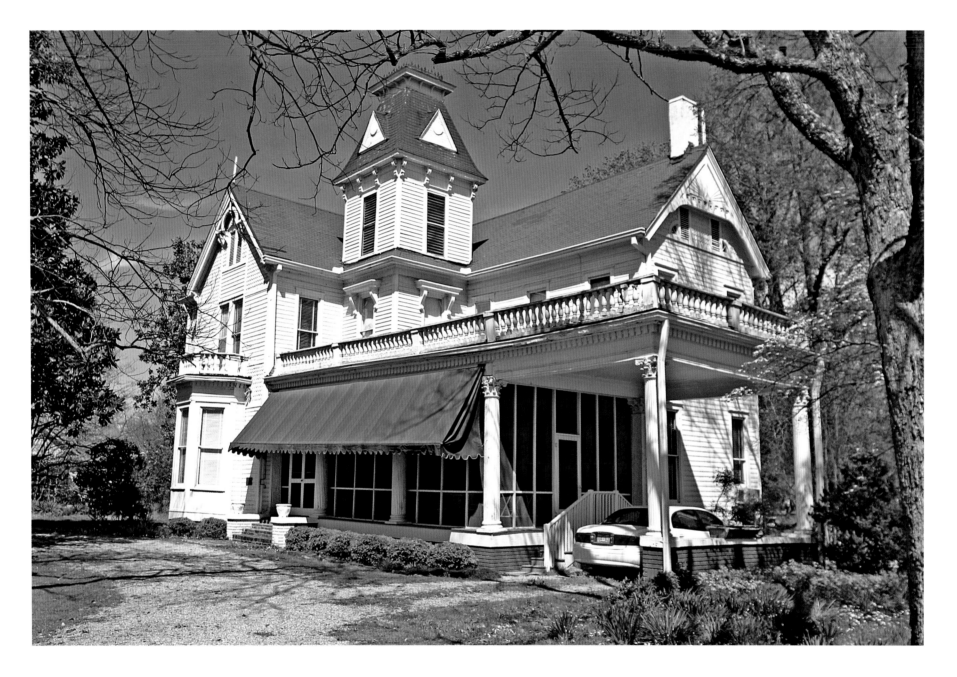

ROSEDALE

The Walter Sillers, Sr., House on Levee Street in Rosedale has eclectic Late Victorian features,
including a mansard-roofed square tower.

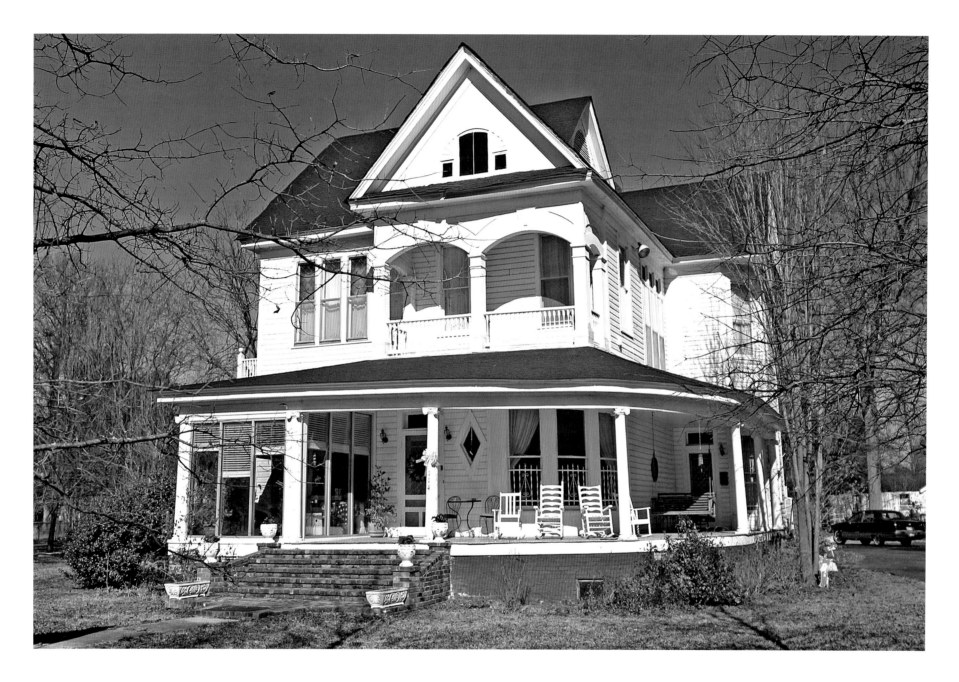

SARDIS

The Taylor-Wall-Yancy House (circa 1899) on Sycamore Street in Sardis is one of many Late Victorian houses
in and around Panola County that were designed and built by Andrew Johnson.

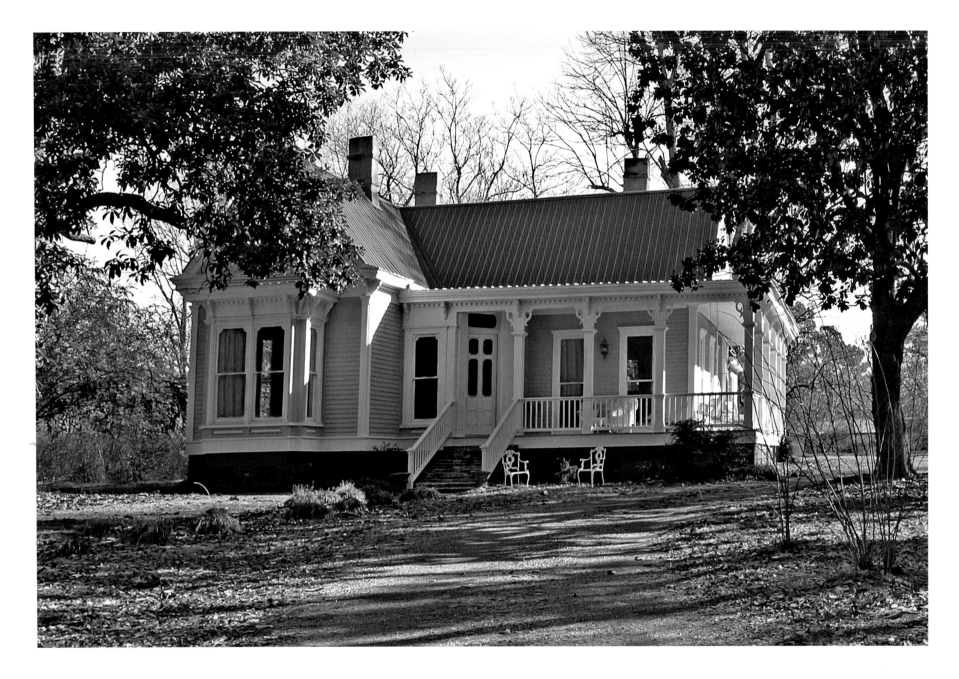

SARDIS

The Hall-Robertson House (Magnolia Manor) on South Main Street in Sardis is an L-front cottage
with Italianate features, built by Andrew Johnson in 1885.

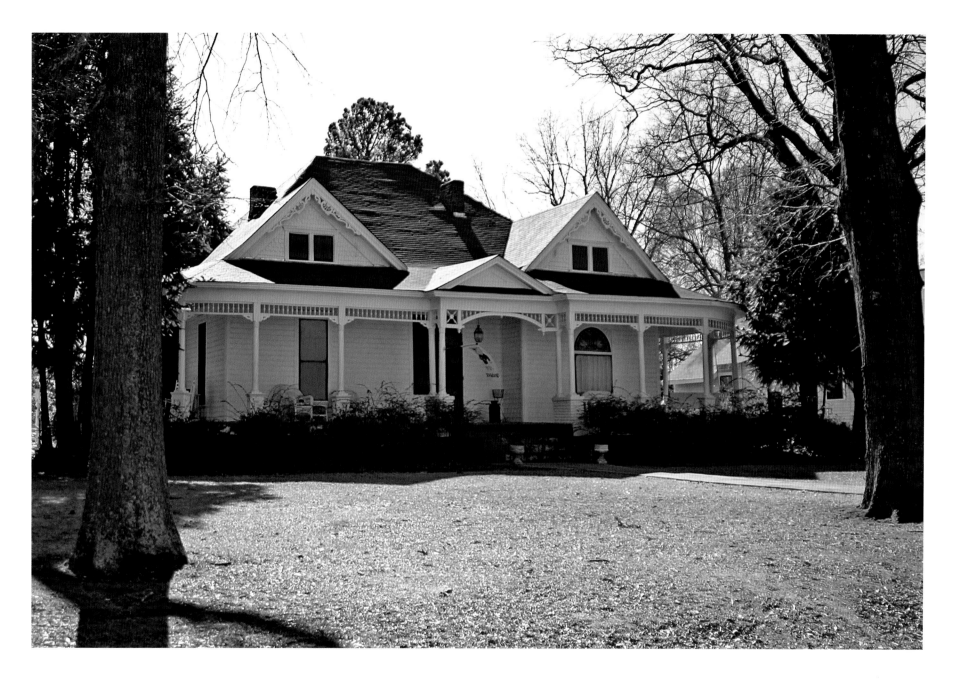

SENATOBIA

This house on Church Street in Senatobia has twin front gables and a broad veranda
trimmed with spindlework.

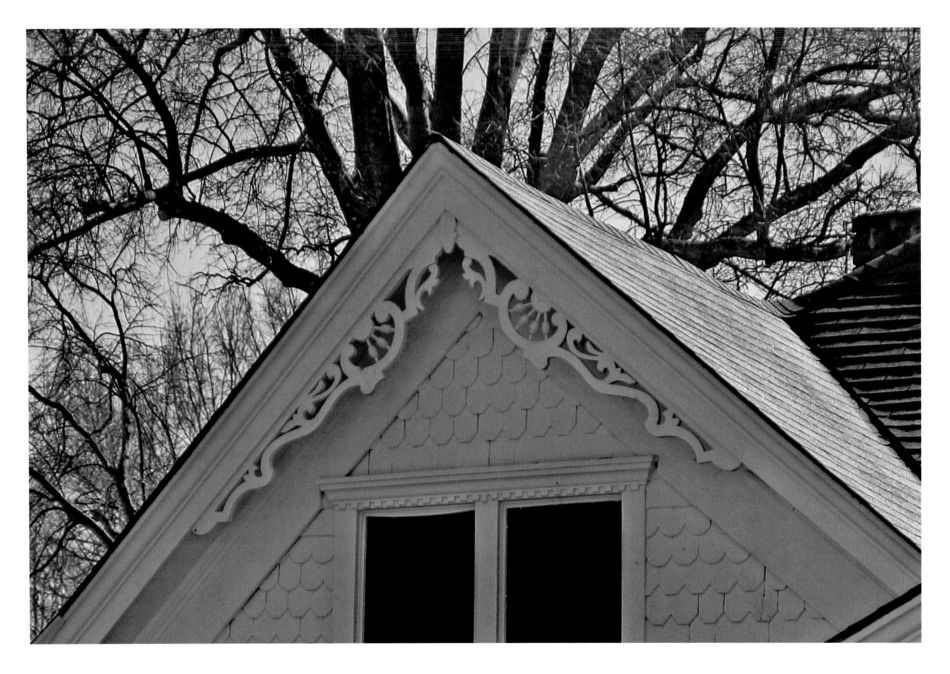

SENATOBIA

Each of the identical front gables is ornamented with jigsawn millwork and decorative shingles.

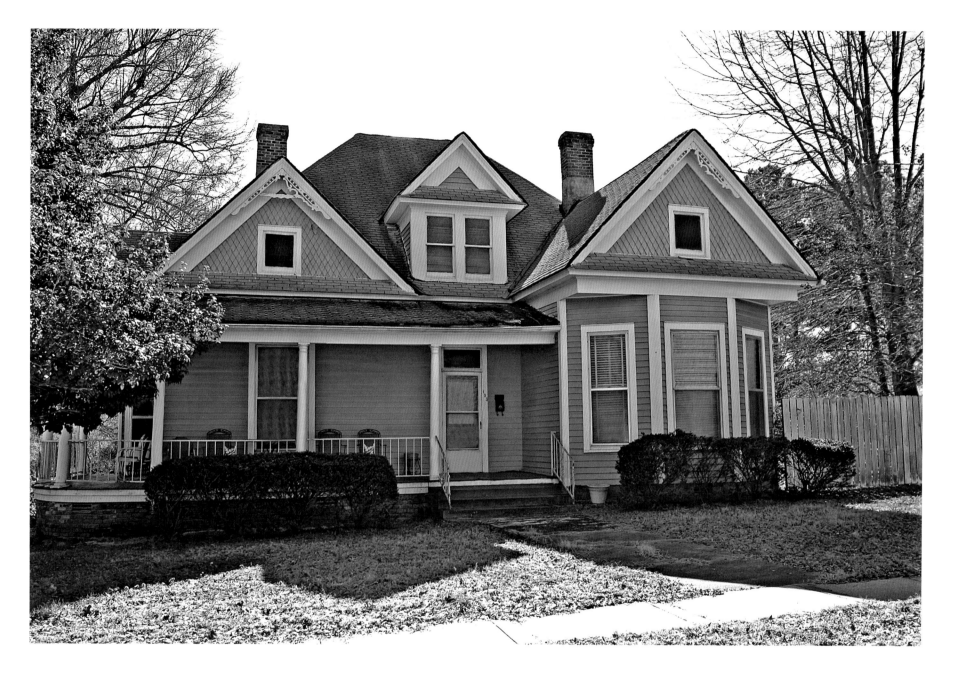

SENATOBIA

This Queen Anne cottage on East Gilmore Street has free classical columns on its veranda, instead of the turned posts and spindlework typically seen on earlier Queen Anne houses.

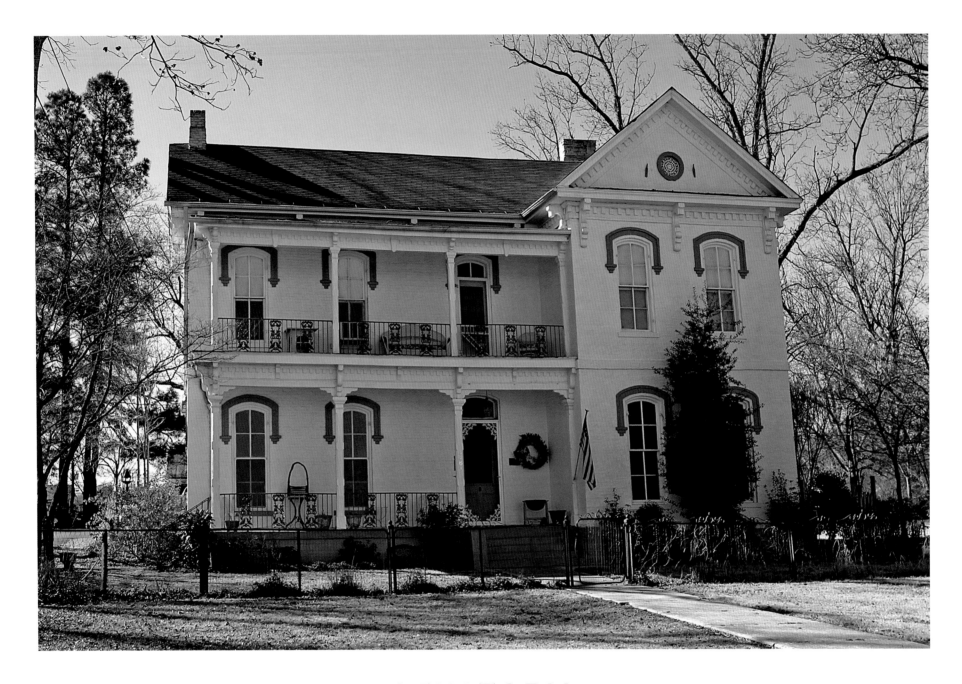

SENATOBIA

The Chambless-Carlock-Veazey-Varner House on South Panola Street (Highway 51)
is a two-story brick L-front house in the Italianate style.

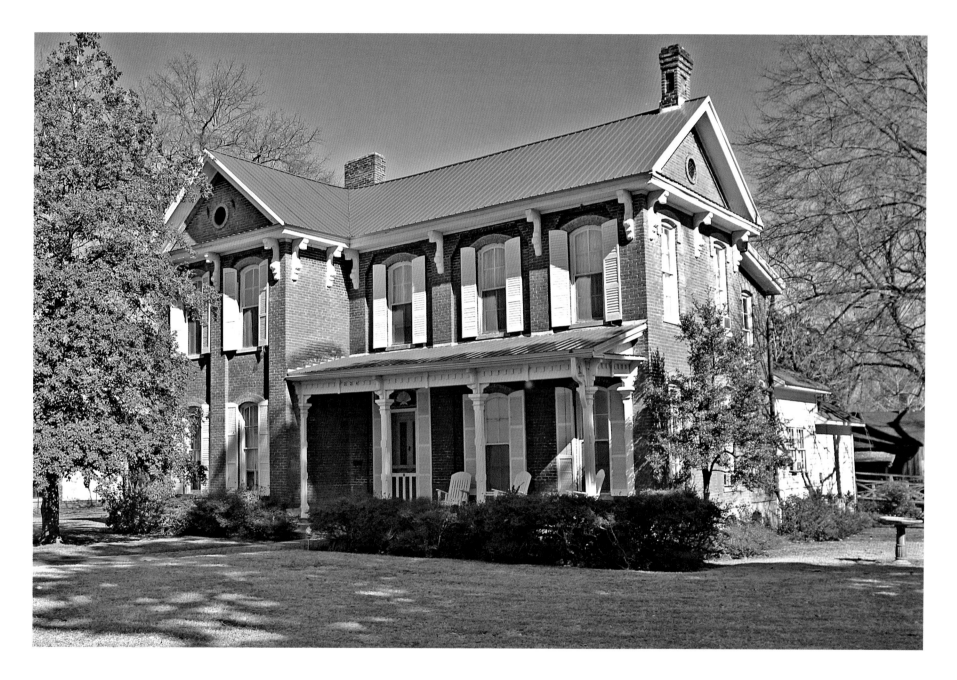

SENATOBIA

Another two-story brick Italianate L-front house is the Lieutenant Governor G. D. Shands House
(circa 1875–80) on Ward Street.

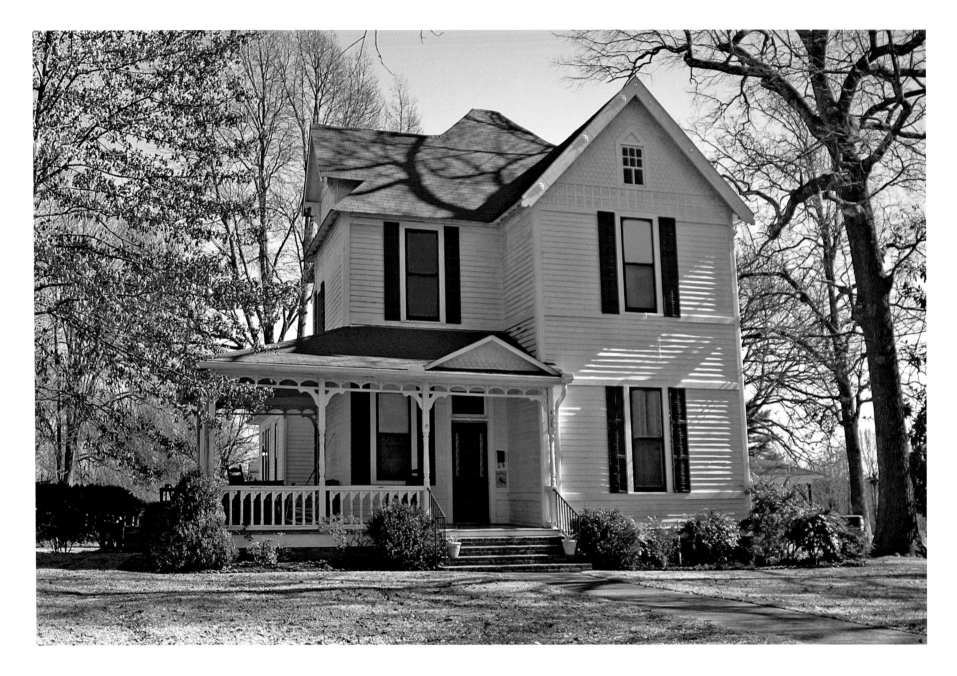

SENATOBIA

This house on South Ward Street is a very intact example of the rectilinear mode of the Queen Anne style.

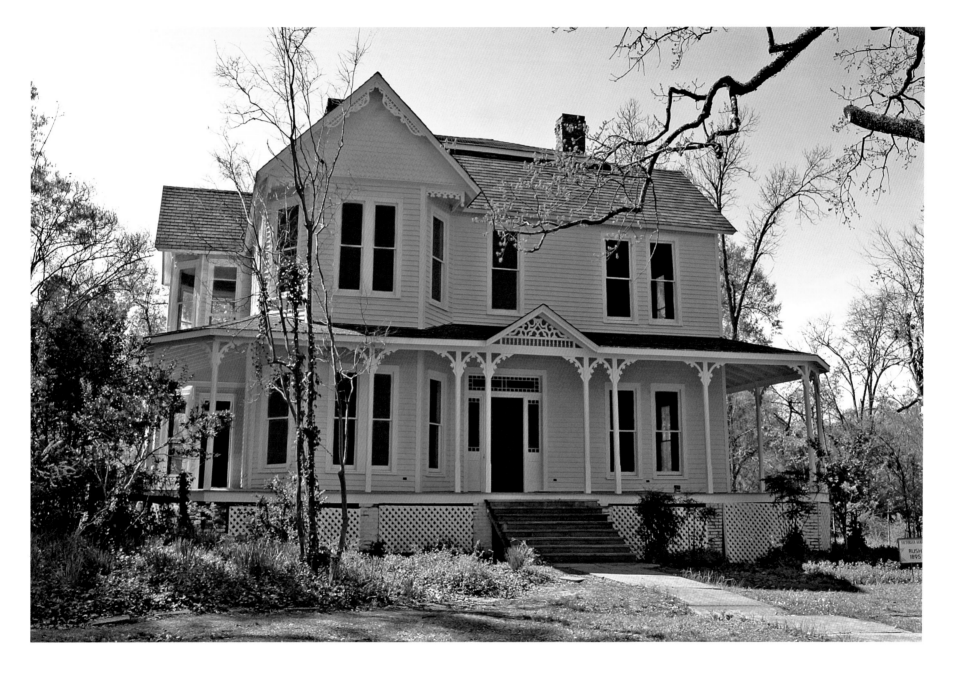

STARKVILLE

The C. E. Gay House on West Gillespie Street in Starkville was built in the Queen Anne style about 1895.

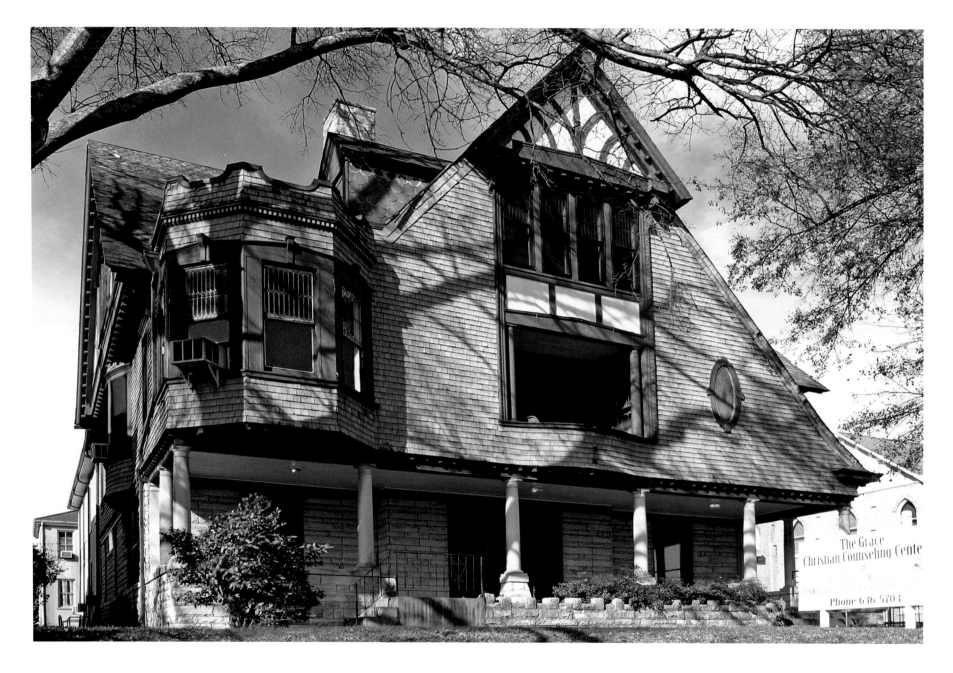

VICKSBURG

The Adolph Rose House (1897) in Vicksburg is the finest example of Shingle style architecture in Mississippi.

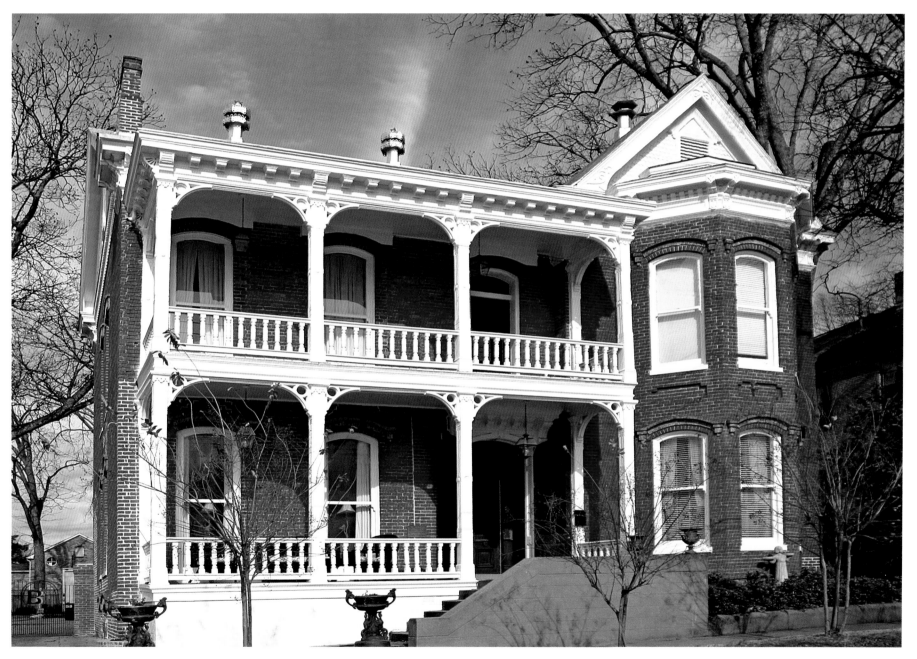

VICKSBURG

The Baer House, an Italianate L-front house of brick construction located on Grove Street,
is distinguished by a double-tiered Italianate porch and a two-story polygonal projecting window bay.

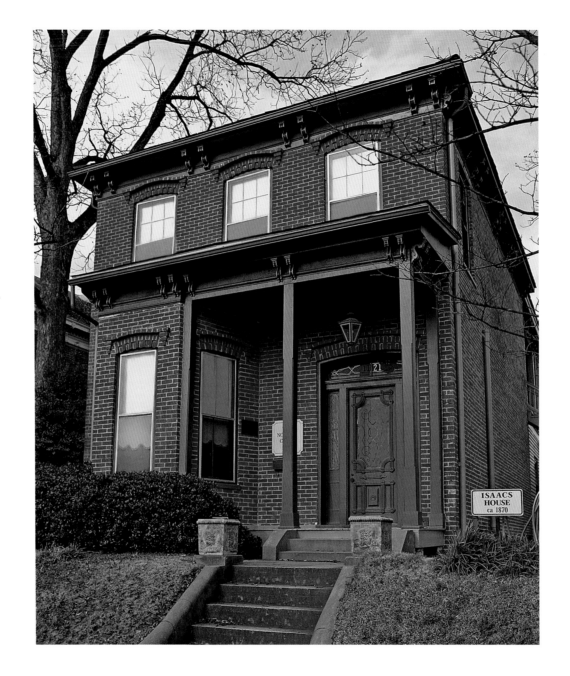

VICKSBURG

The Isaacs House (circa 1870) on Grove Street is a brick town house in the Italianate style.

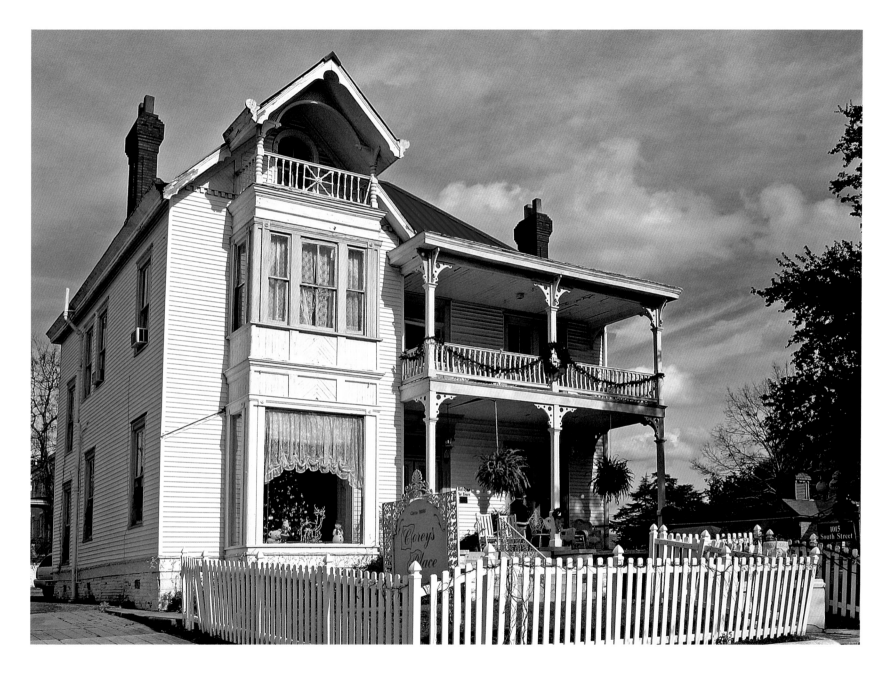

VICKSBURG

The Swartz House on South Street, built about 1885, features a distinctive balcony in its front-facing gable.

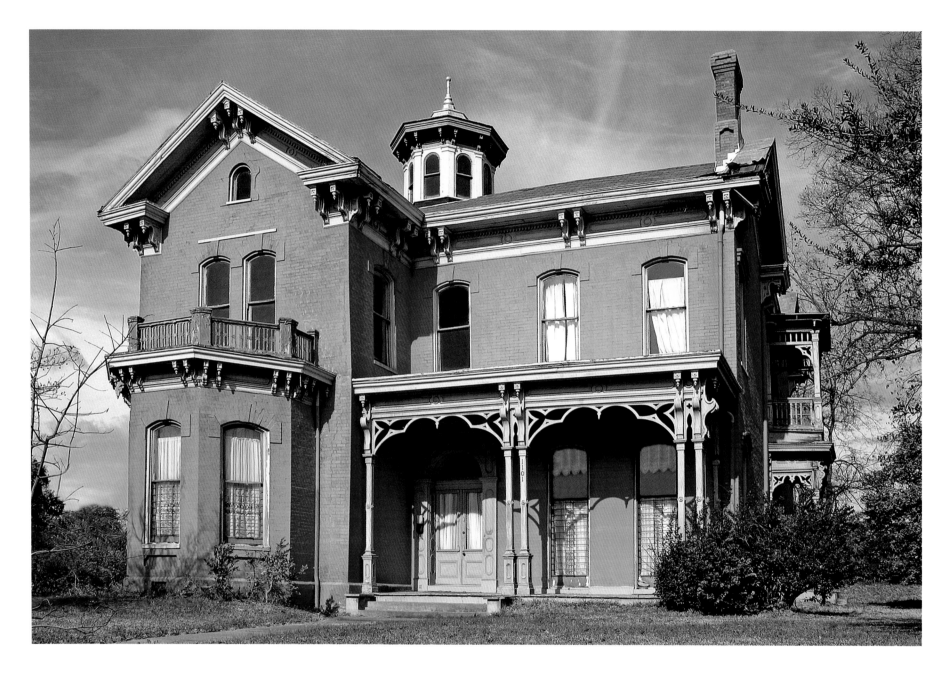

VICKSBURG

The Beck House (1875) on South Street, a brick two-story L-front house with a one-story porch,
is one of the state's finest surviving examples of postbellum Italianate residential architecture.

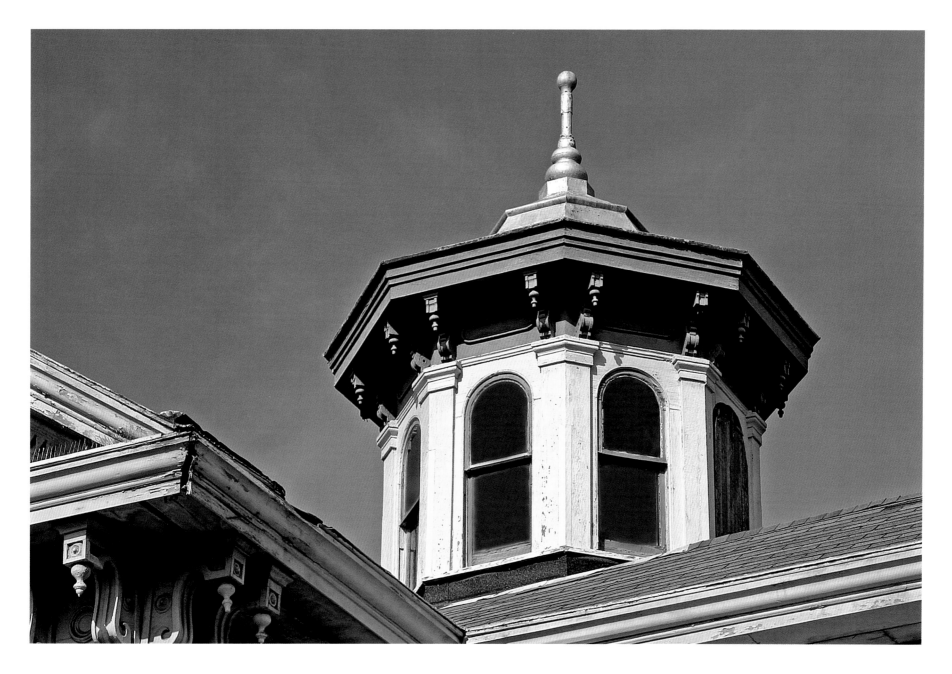

VICKSBURG

Surmounting the roof of the Beck House is an octagonal cupola with round-arched windows
and a bracketed cornice.

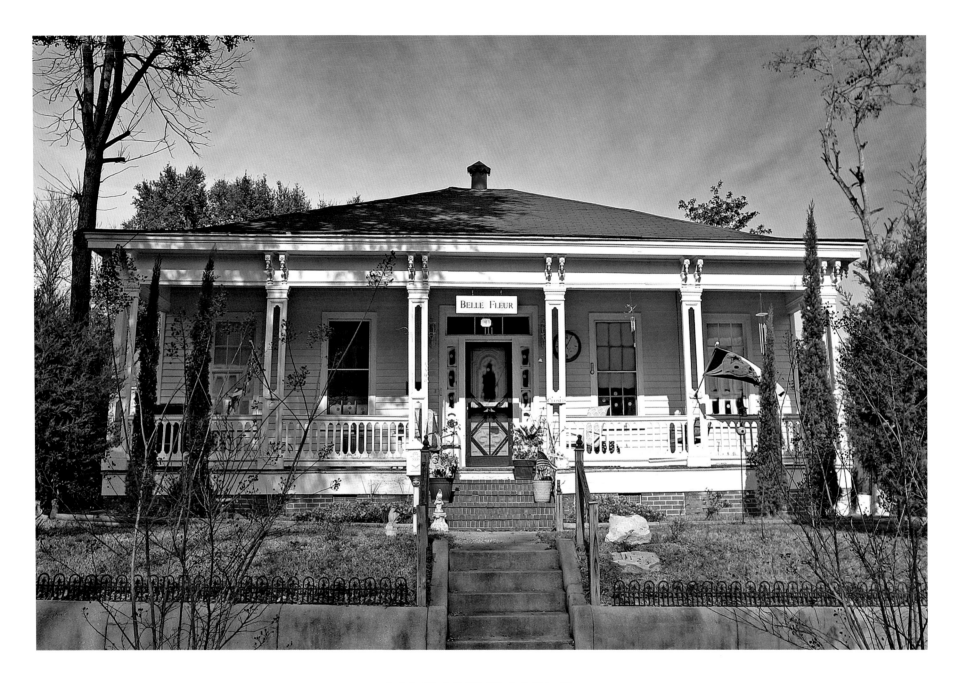

VICKSBURG

Belle Fleur (circa 1870), on South Street, illustrates the application of Italianate brackets and distinctive openwork porch supports (locally known as "pierced columns") to a traditional hip-roofed galleried cottage.

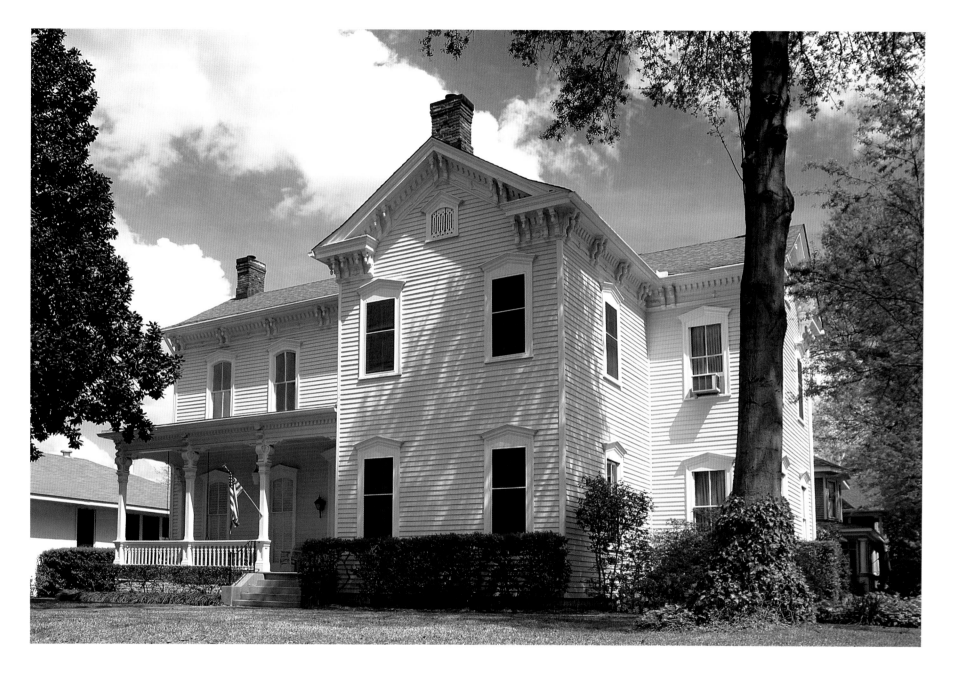

VICKSBURG

The Collins House on Cherry Street is an Italianate L-front house with an ornate bracketed cornice.

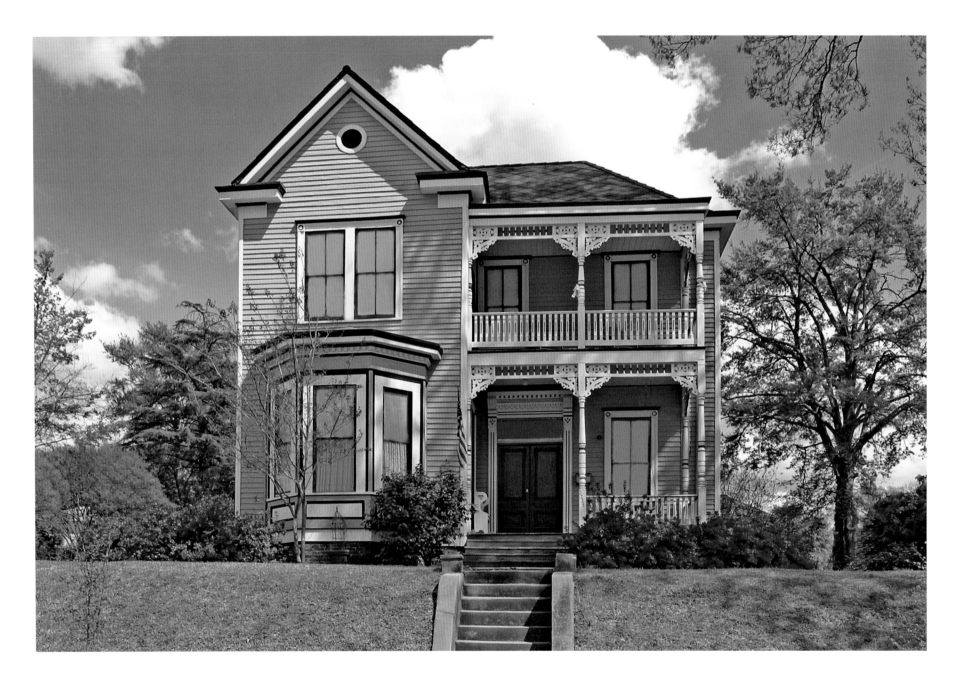

VICKSBURG

Among the many fine Late Victorian houses in Vicksburg is this beautifully restored L-front house
on Drummond Street.

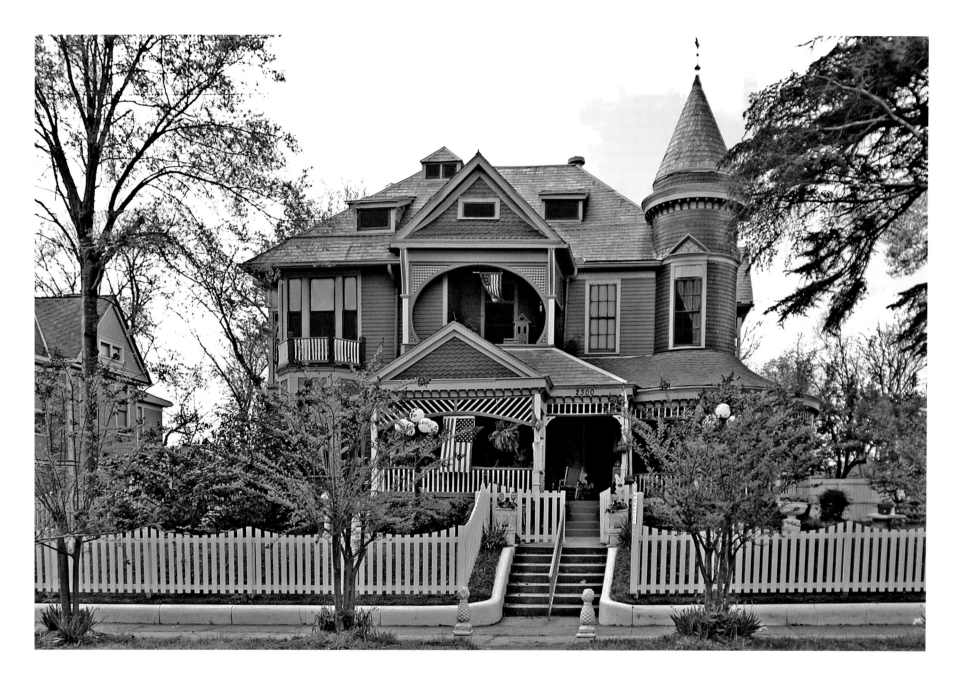

VICKSBURG

The E. M. Lawrence House (circa 1890) on Drummond Street is an exuberant Queen Anne design.

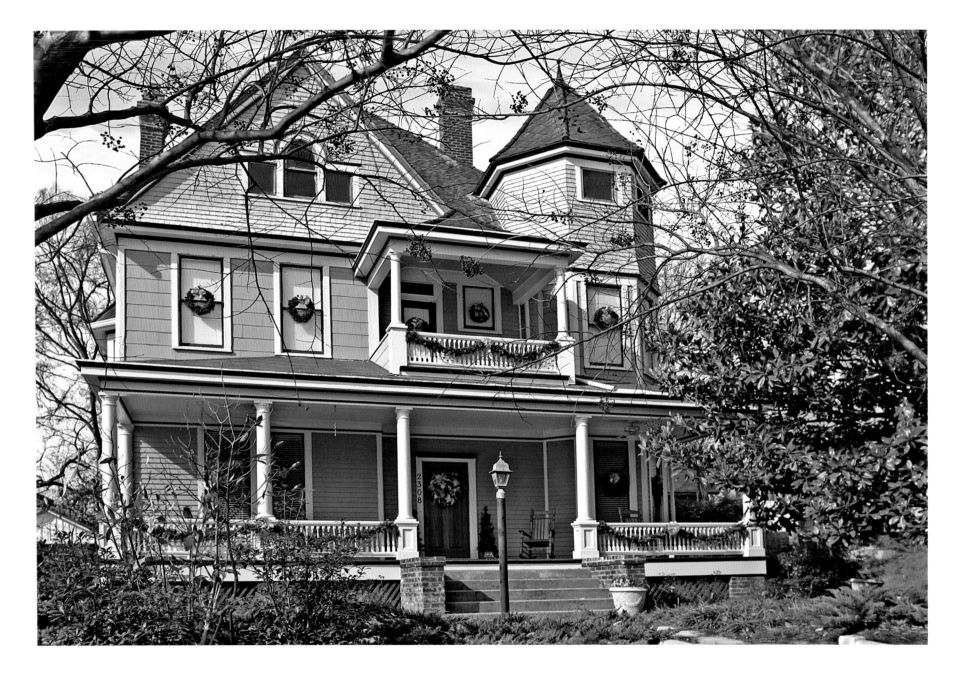

VICKSBURG

This free classical Queen Anne house on Drummond Street was built about 1896.

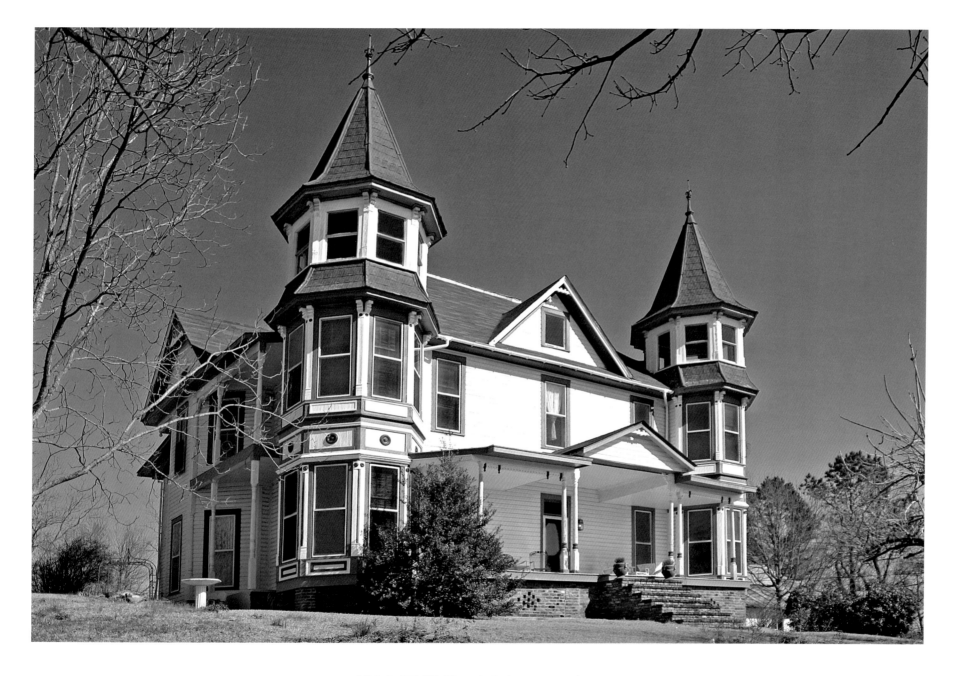

WATER VALLEY

Located upon a hill overlooking downtown Water Valley, the Captain G. W. Price House on Church Street,
with its twin towers, is a prominent local landmark. It is not at all uncommon for a Queen Anne house to have
one corner tower, but having two identical towers is quite unusual.

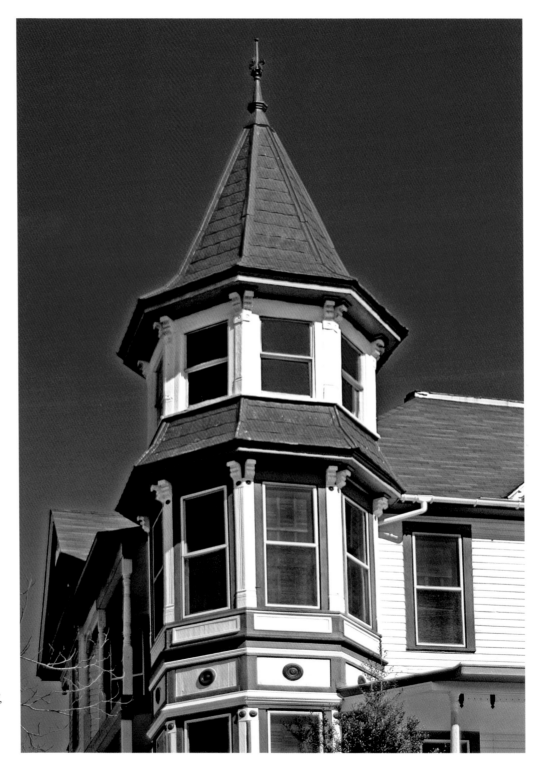

WATER VALLEY

Each tower of the Price House has a double-tiered roof,
culminating in an octagonal spire with flared eaves.

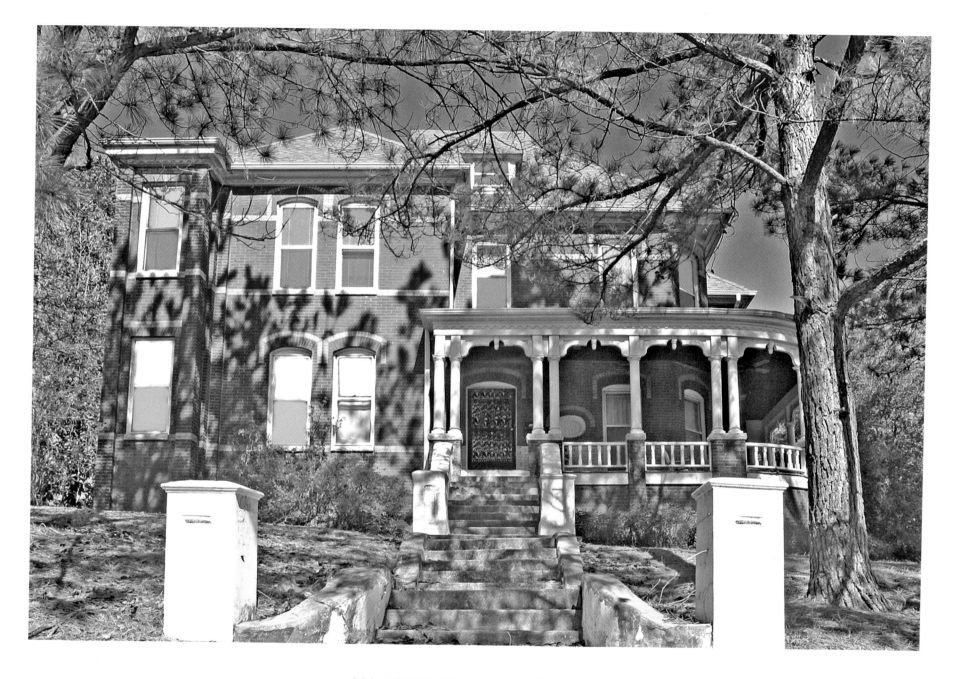

WATER VALLEY

The T. O. Gore House on Panola Street (Kimmons Street) is a two-story brick house
with an eclectic design combining Italianate and free classical elements.

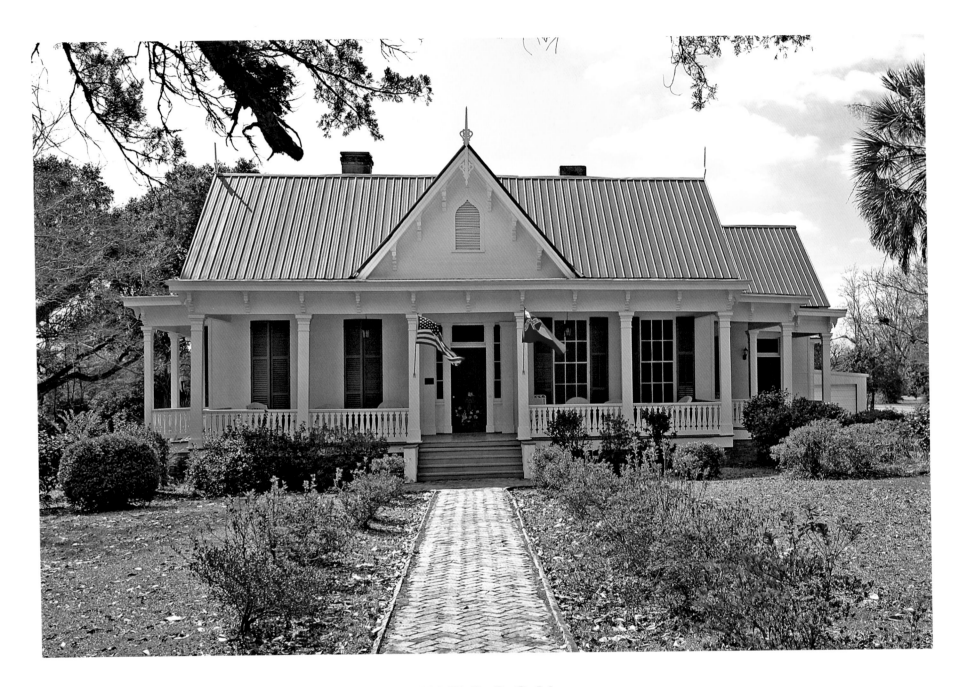

WESSON

The Dr. R. W. Rea House (1874) in Wesson combines Greek Revival, Italianate,
and Gothic Revival elements.

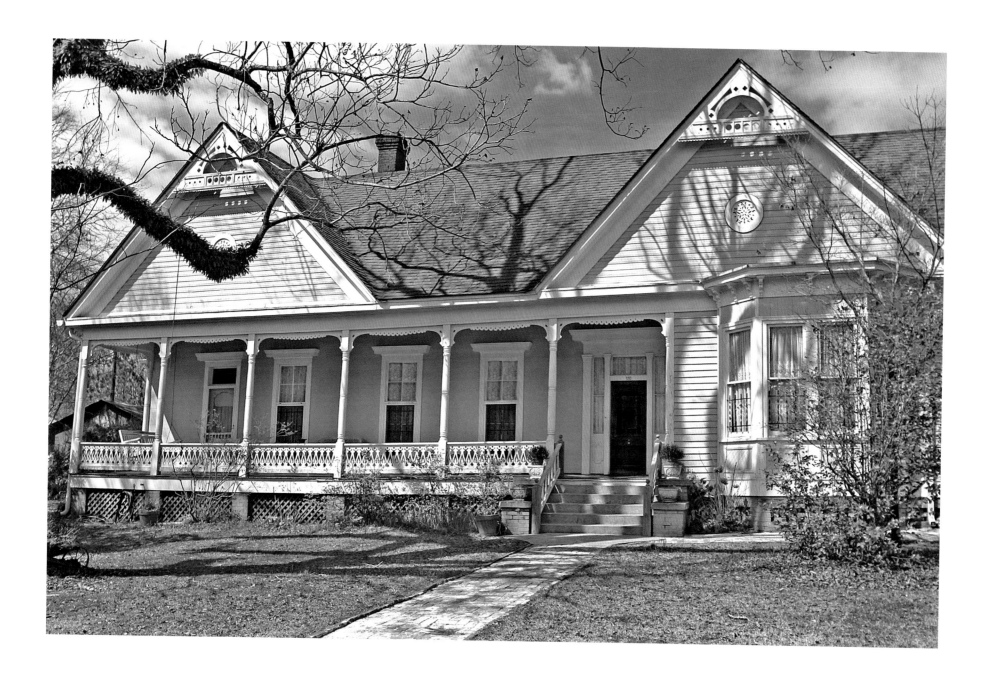

WESSON

The James S. Rea House in Wesson has an eclectic design including Italianate and Eastlake stylistic features. It is
distinguished by twin front-facing gables, an Italianate window bay, and a recessed gallery.

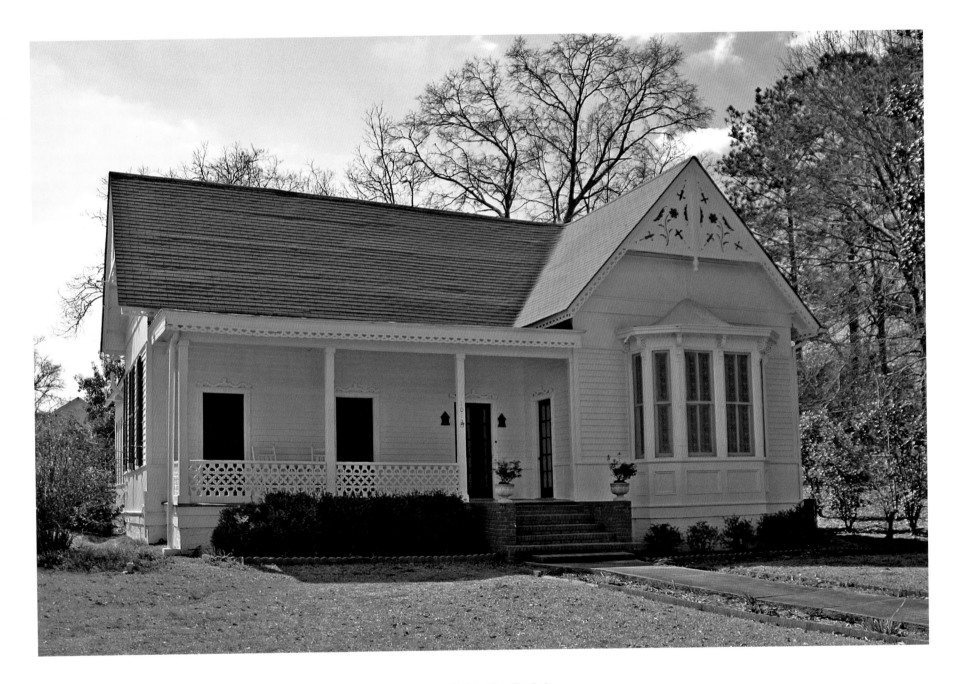

WESSON

This L-front cottage is located on Grove Street.

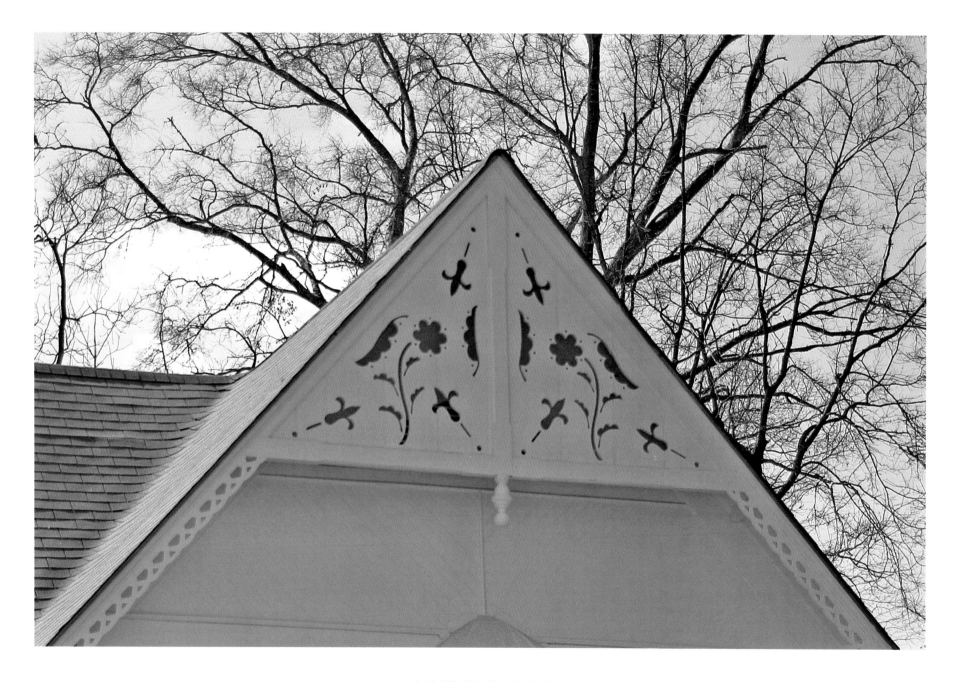

WESSON

The gable ornament features ornate cutout patterns.

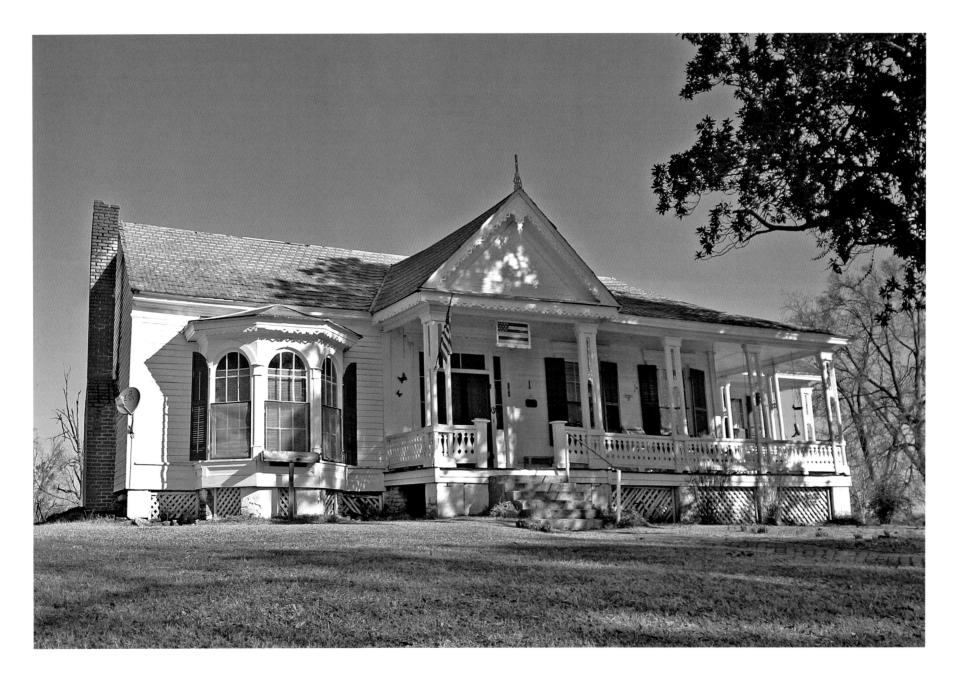

WEST

The Brock-Foster House on Brown Street in West is a picturesque combination of Italianate and Gothic Revival features. Of particular interest are the "pierced columns" on its porch.

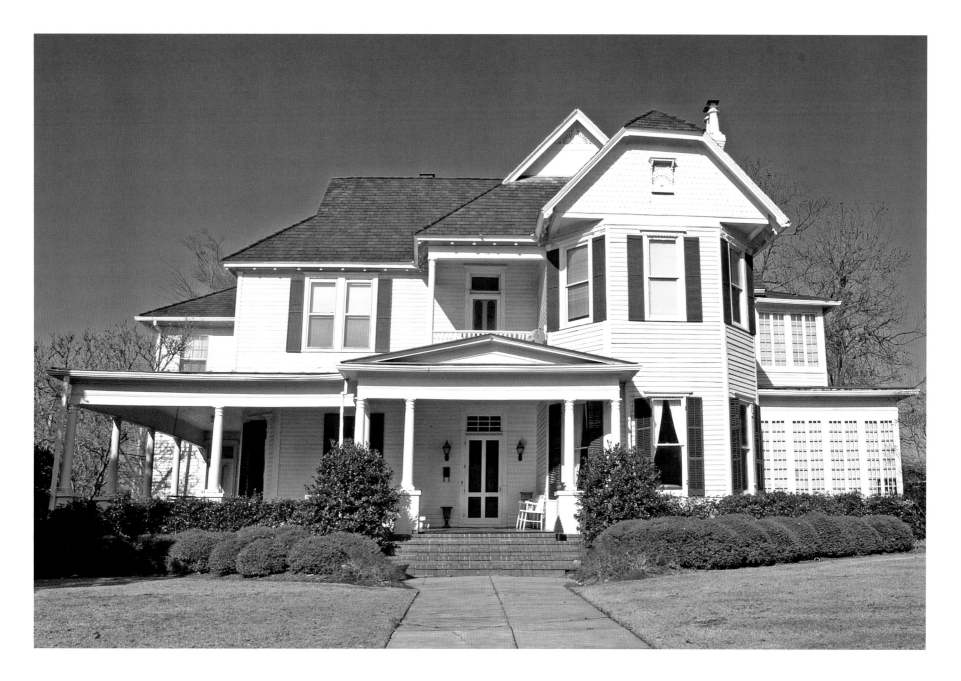

WEST POINT

This Queen Anne house on East Main Street has a free classical veranda.

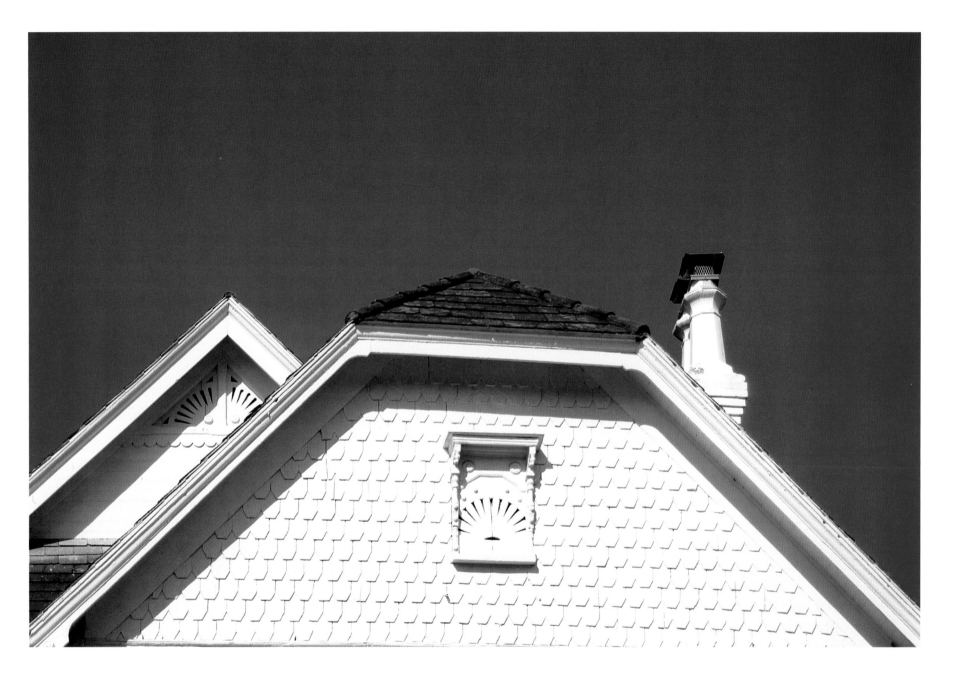

WEST POINT

The peak of the gable is cut back and hipped, resulting in what is called a "clipped gable" or a "jerkinhead" roof.
The main front gable is clad in imbricated shingles and ornamented with a decorative ventilator.

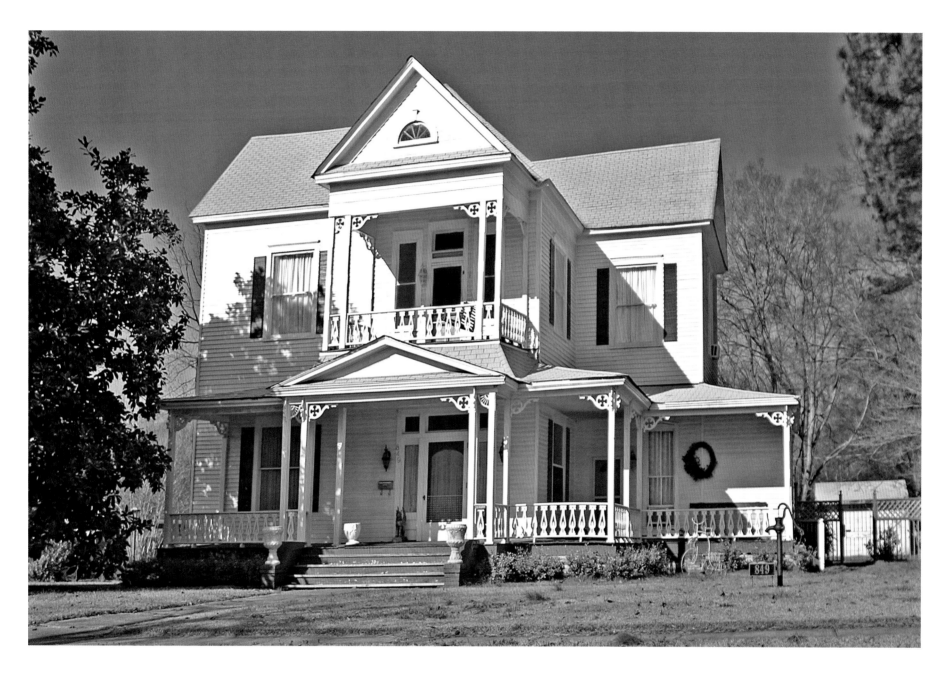

WEST POINT

This two-story house on East Main Street features a veranda with a smaller porch above,
both trimmed with jigsawn millwork.

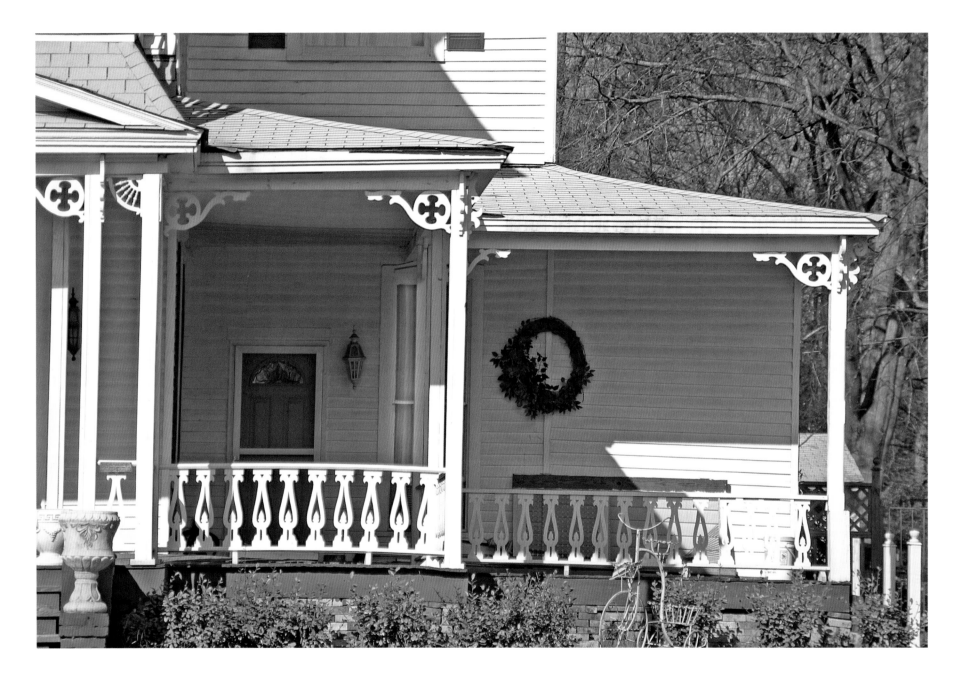

WEST POINT

The veranda is ornamented with jigsawn wooden balusters and brackets with cutout quatrefoils.

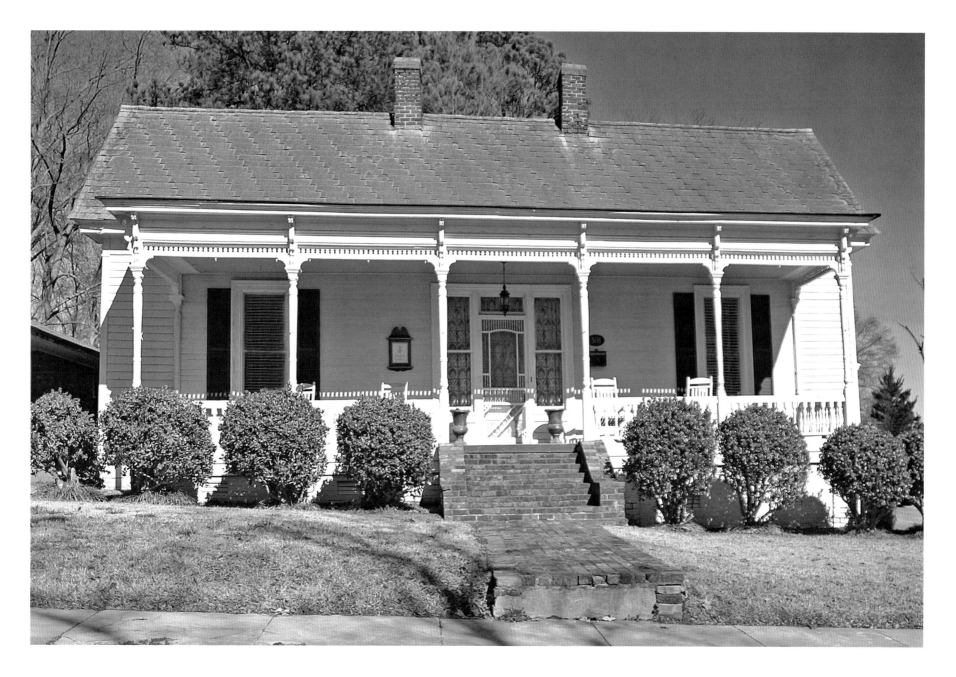

WINONA

This one-story house on Jones Street has a bracketed Italianate porch.

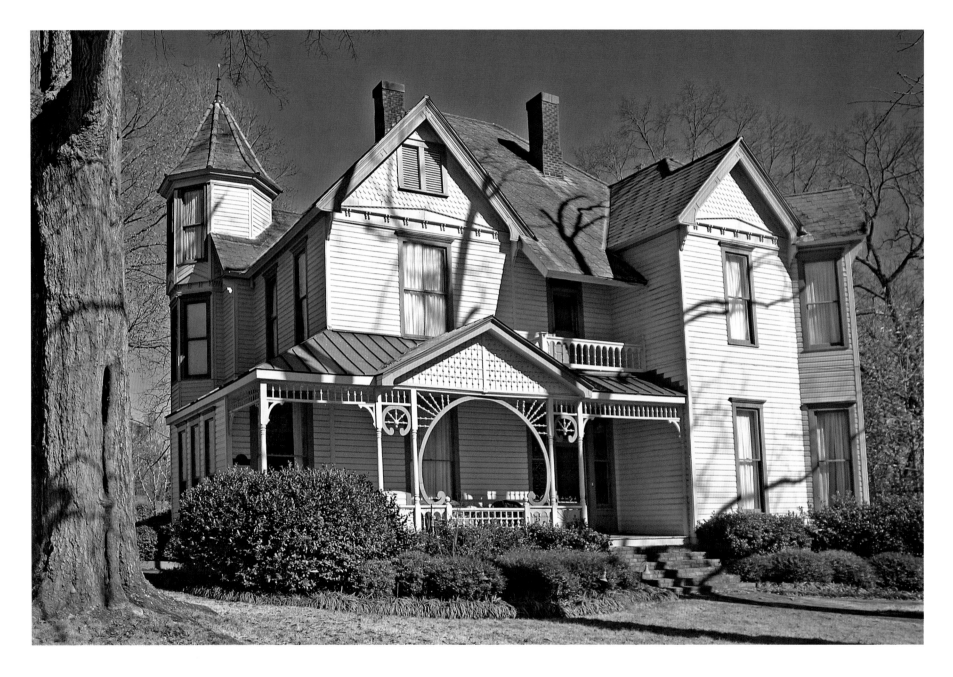

WINONA

The Liston House is a two-story Queen Anne–style house located at the corner
of Jones and Fairground streets in Winona.

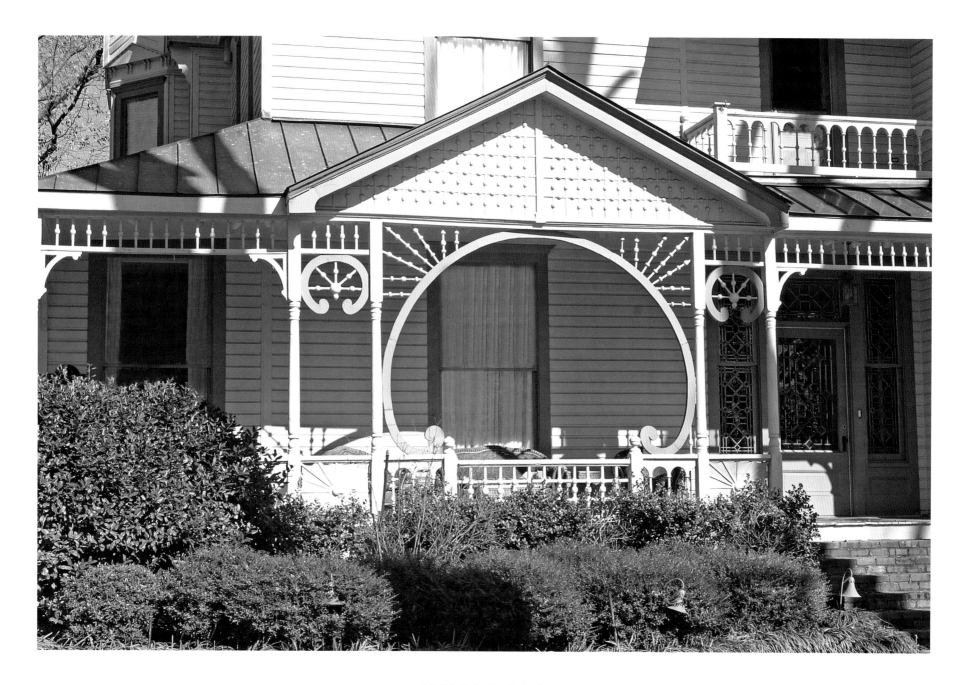

WINONA

The veranda of the Liston House has complex spindlework trim and an intricately patterned pediment.

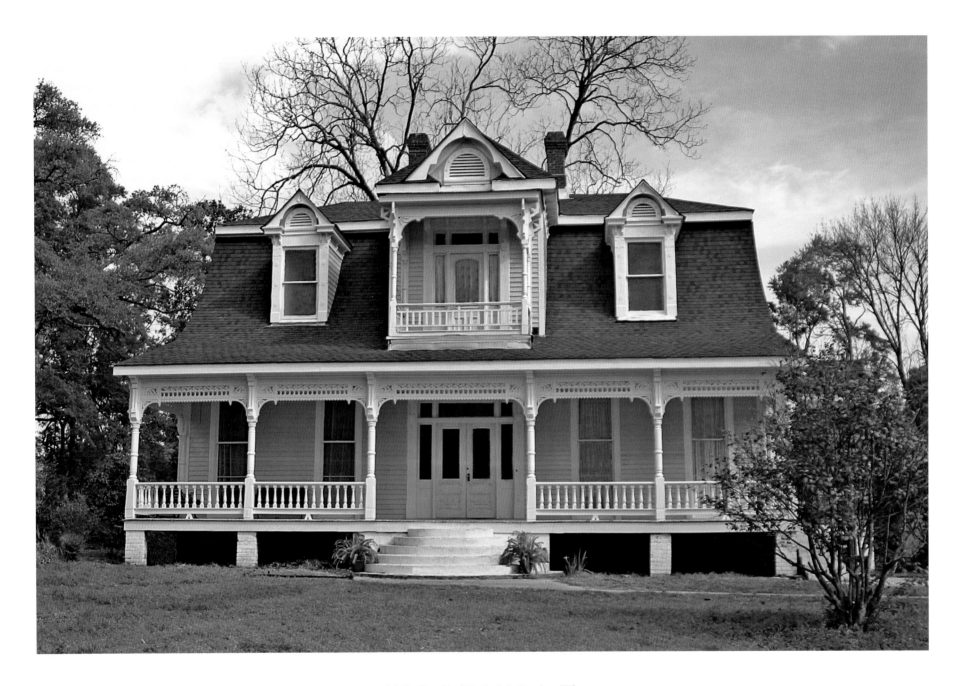

WOODVILLE

A mansard roof with flared eaves imparts a distinctive character to the Johnson-Catchings House
(1898) on College Street.

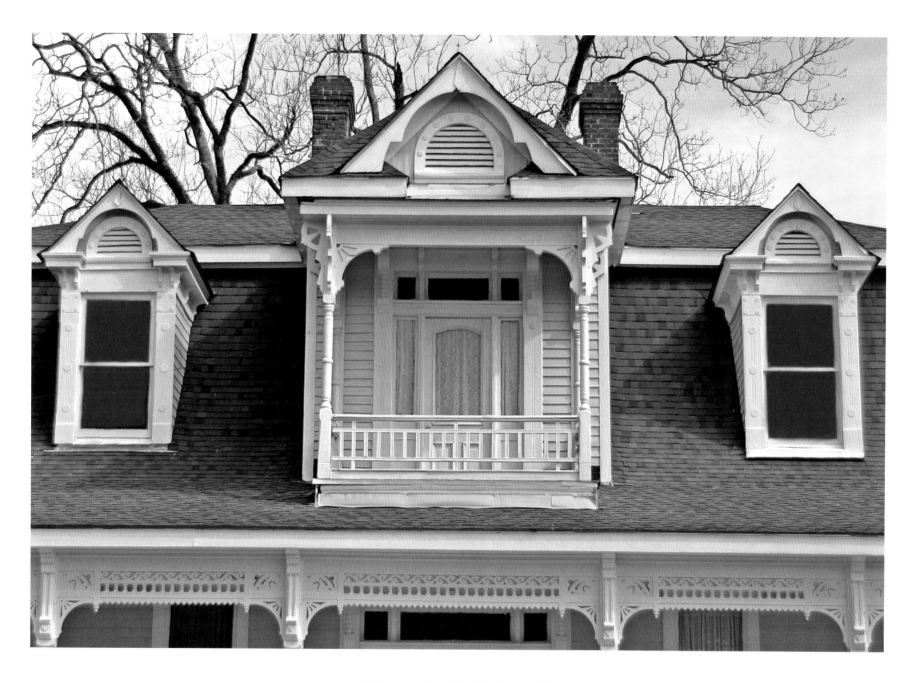

WOODVILLE

Centered on front of the mansard roof of the Johnson-Catchings House is a gabled balcony
trimmed with spindlework.

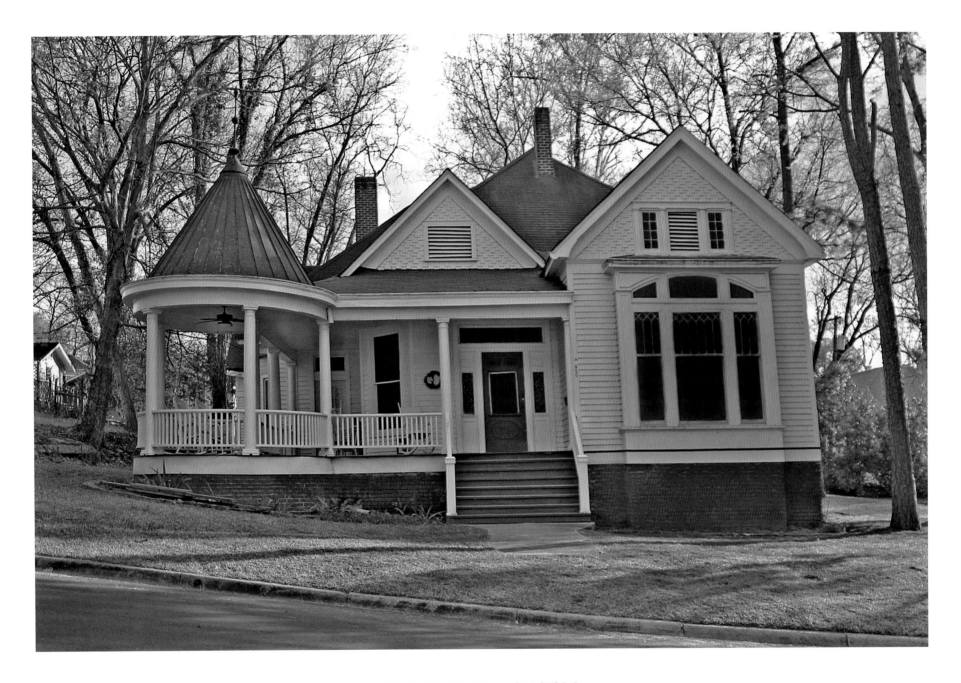

YAZOO CITY

The O. H. Swayze House on East Madison Street features a broad veranda with a round,
conical-roofed corner pavilion. Similar round corner pavilions can be seen on the McLeod House
in Hattiesburg and the Ellis House in Hazlehurst.

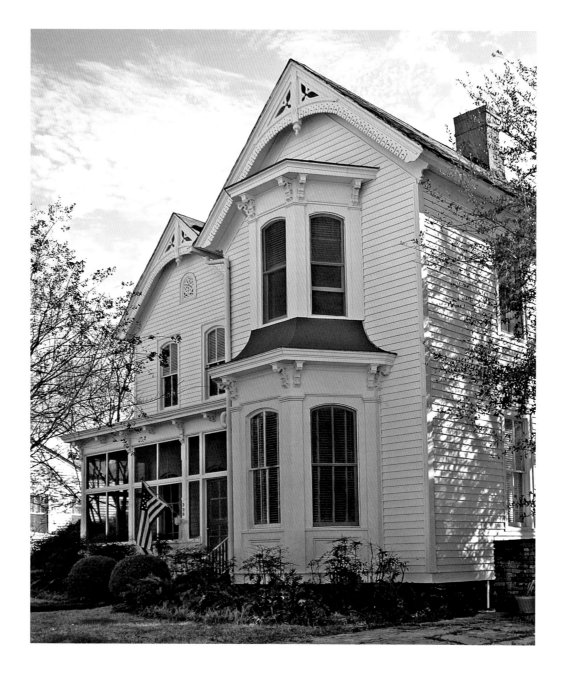

YAZOO CITY

This house on East Madison Street, built in 1880, combines Late Victorian Italianate and Gothic Revival features.

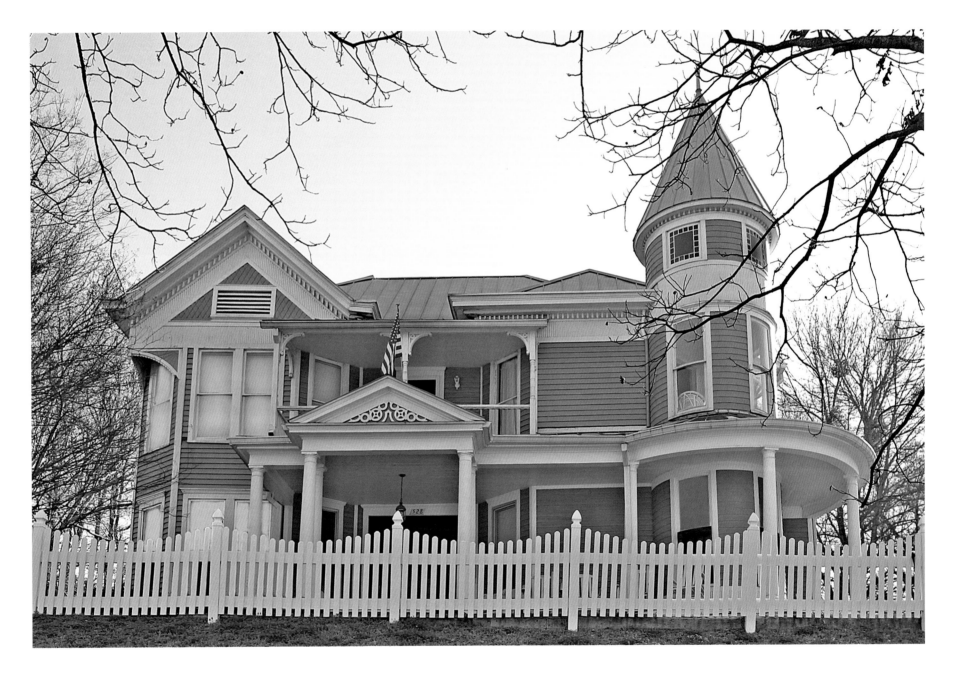

YAZOO CITY

The Parker-Roark House on East Broadway is an example of the free classical mode of the Queen Anne style.
Like many other Queen Anne houses, its most eye-catching feature is a round corner tower with a conical roof.

Index of Town Names